E D V A R D M U N C H

The Frieze of Life

HYDRO

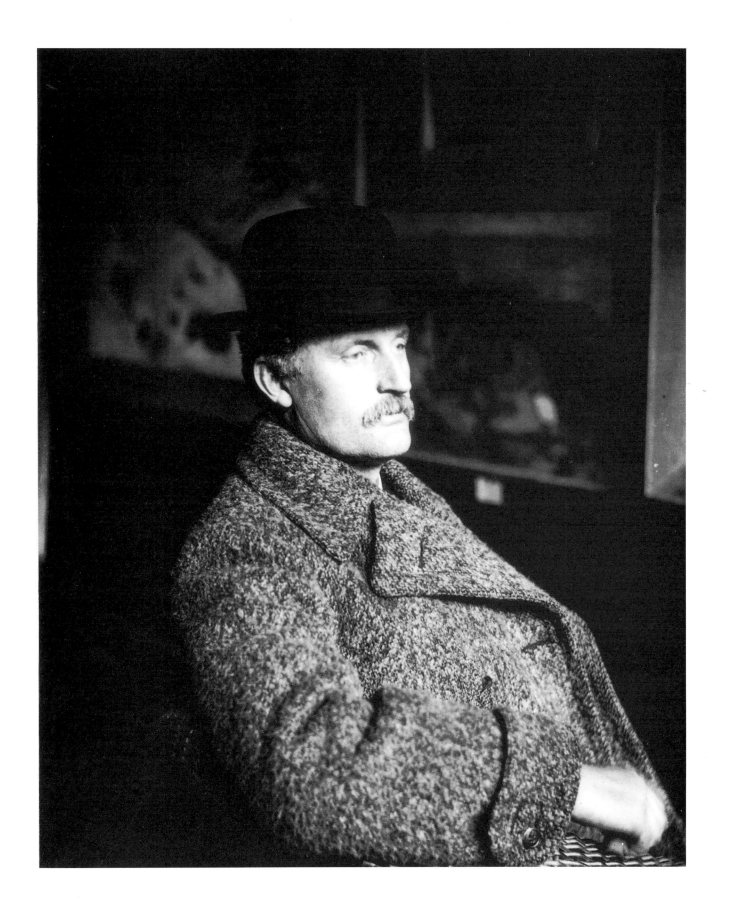

EDVARD MUNCH

The Frieze of Life

ESSAYS BY
ARNE EGGUM
REINHOLD HELLER
CARLA LATHE
GERD WOLL

Edited by Mara-Helen Wood

NATIONAL GALLERY PUBLICATIONS, LONDON
DISTRIBUTED IN NORTH AMERICA BY HARRY N. ABRAMS, INC., PUBLISHERS, NEW YORK

This book was published to accompany an exhibition at
The National Gallery, London,
12 November 1992 - 7 February 1993

© National Gallery Publications Limited 1992

Reprinted 1992

First published in Great Britain in 1992 by
National Gallery Publications Limited
5/6 Pall Mall East, London SW1Y 5BA

British Library Cataloguing-in-Publication Data. 1704483
A catalogue record for this book is available from the
British Library.

ISBN 1 85709 016 0 UK hardback
ISBN 1 85709 015 2 UK paperback

Library of Congress Catalog Card Number 92-64016

ISBN 0-8109-3630-5 US hardback

Hardback edition distributed in the United States of
America and Canada in 1993 by Harry N. Abrams, Inc.,
New York. A Times Mirror Company

Designed by Roger Davies and set in Ehrhardt
on Ventura at The Green Street Press

Translations by
Berit Scott
David Cheetham
Duncan Foster
Angela Shury-Smith

Printed and bound in Great Britain by
Butler and Tanner, Frome and London

FRONT COVER
Edvard Munch, *The Scream* (cat. 52, detail).

BACK COVER
Edvard Munch, *The Voice* (cat. 8).

TITLE PAGE
Fig. 1 Edvard Munch photographed by B. Wilse,
Kristiania 1912.
Photograph. Oslo, Munch Museum.

CONTENTS

SPONSOR'S PREFACE

Norsk Hydro is delighted to be sponsoring this major exhibition of the works of Edvard Munch in the Sainsbury Wing of the National Gallery.

Munch is recognised as one of the most important painters in the development from Impressionism to Expressionism, but while *The Scream* is one of the most familiar images of the twentieth century, his works are not widely known in the United Kingdom. The main reason of course is that there is only one of his paintings in a British public collection, and therefore he remains largely unknown outside the ranks of art lovers.

Norsk Hydro is Norway's largest industrial company, but it too is not well known in the United Kingdom. It was founded in 1905 to develop the first successful invention involving the production of man-made mineral fertilizers. It remains the largest producer of such fertilizers in the Western World, and has also become a major force in the fields of oil and gas, aluminium and magnesium, and petrochemicals. Over the last ten years Hydro has expanded greatly in the United Kingdom in these same business areas and now employs some 2000 people. It has also taken the lead during the last two years in its approach to environmental issues. Following an assessment of the environmental impact of its operations, it was the first company to adopt full public disclosure of its findings and of its efforts to improve performance.

It is fitting that a Norwegian company should be sponsoring this exhibition of the works of this greatest of Nordic artists. Hydro has been a supporter of living Norwegian artists for many years and has built up one of the finest collections of modern Norwegian paintings. It is also the sponsor of the Oslo Philharmonic Orchestra, which under the guidance of Mariss Jansons has become one of the leading orchestras in Europe. It is a happy coincidence that this orchestra should be visiting London to inaugurate the Scandinavian Festival at the Barbican Centre at the same time as the Munch exhibition opens at the National Gallery.

Finally I would like to acknowledge the particular help and support of Mara-Helen Wood, Director of the University of Northumbria Art Gallery, who almost single-handedly has promoted the works of Munch by organising a number of travelling exhibitions in Britain during the last ten years. This wonderful exhibition in the splendour of the Sainsbury Wing is a testament to her enthusiasm for a great painter.

JOHN G. SPEIRS
MANAGING DIRECTOR, NORSK HYDRO (UK) LIMITED

FOREWORD

This exhibition contains some of the most familiar and disquieting images in European art. For three months the London public will have the opportunity – the fullest ever made available outside Norway – to see the works from Munch's Frieze of Life, to study many of its themes in several versions, and to examine how his memorable effects were achieved and modified. It is a rare and uncomfortable chance to watch a powerful imagination tackling the representation of suffering, death and transforming love.

These are topics hardly addressed on the walls of the National Gallery's late nineteenth-century rooms. This is in part because British critics and collectors have habitually been shy of emotion so indecorous or expression so strong. But it has perhaps much more to do with the traditional British focus on French art, viewing Cézanne as the high point of a formal tradition that linked the great classical achievements of Raphael and Poussin with the abstraction of the early twentieth century.

Yet there is in European painting another, no less powerful continuity: the intense examination of suffering and redemption from Grünewald and Dürer to Beckmann and Bacon. And in this other story, Munch has a privileged place.

If we can now show his greatest achievements to the British public, it is entirely due to the generosity of our friends in Norway. Every Christmas, Trafalgar Square is reminded of the close links between our two countries: this year, Norway is sending not only the customary tree, but great paintings from Oslo and Bergen, and in particular from the National Gallery, the Munch Museum and the Rasmus Meyer Collection. To them and to the other lenders, we are much indebted.

The organising of the exhibition and the compiling of the catalogue have absorbed the energies of many colleagues both inside and outside the National Gallery, without whom this exhibition would not have been possible. We have a particular debt of gratitude to Mara-Helen Wood, the doyenne of Munch studies in this country; Arne Eggum, who has contributed greatly to the catalogue; and Alistair Smith, formerly Head of Exhibitions at the National Gallery, who many years ago conceived and laid the groundwork for so ambitious an exhibition of Munch's art.

The costs of the exhibition have been borne by our sponsor, Norsk Hydro, who have supported the venture throughout with unwavering enthusiasm and with unstinting generosity. On behalf of all who work at the National Gallery and of all who will visit and enjoy this exhibition, I should like to say thank you.

NEIL MACGREGOR
DIRECTOR, THE NATIONAL GALLERY, LONDON

INTRODUCTION

Edvard Munch's Frieze of Life grew out of his personal experiences, sketches and notes from the 1880s, and assumed its final form in a series of motifs painted in the course of the Symbolist decade of the 1890s. It deals with the grand themes of love, anxiety and death – major and harrowing forces in the course of man's life.

The Frieze of Life has a commanding place in Munch's oeuvre. Although the number of paintings belonging to it was never clearly defined, the Frieze encompasses the artist's principal works up until the turn of the century. Like huge trees above the skyline these paintings stand out from the impressive body of his work. Many of the central themes were repeated in replicas which Munch treated as experimental variations.

The London National Gallery exhibition draws heavily upon three major Norwegian collections. That of the National Gallery in Oslo, where key works were acquired during the 1890s (some of them directly from the artist), includes an important group donated by the eminent Norwegian collector Olaf Schou, and works bought by the Gallery's young and enterprising director Jens Thiis at Munch's great exhibition in Christiania in 1909. The Rasmus Meyer Collection in Bergen was formed by a private collector and bequeathed to the city by his heirs in 1916. The collection contains thirty-two paintings by Munch, acquired after the exhibition of his work at the Bergen Society of Art in 1909. Finally, the Munch Museum in Oslo contains the wealth of treasures bequeathed by the artist on his death in 1944 to the city where he had spent his youth, his years of maturity after 1916, and his old age. A number of 'authorised' versions of major themes are displayed at the National Gallery in Oslo and at the Rasmus Meyer Collection in Bergen, while the Munch Museum provides an extensive and varied view of the artist's work through its collection of what might be called first thoughts and afterthoughts – sketches, preliminary versions, and later experimental variations. Valuable contributions to the London exhibition have also been received from the Gothenburg Art Museum, which has put at our disposal the important second version of *The Sick Child* (cat. 70), commissioned by Olaf Schou, and the 1893 painting of *Vampire* (cat. 20).

The presentation of the Frieze of Life in the Sainsbury Wing of the National Gallery in London is then a unique event, in that three leading Norwegian public collections have joined forces to give as complete a representation as possible of the major Frieze of Life motifs.

The birth of the Frieze owes much to contemporary European attitudes, and Munch's contacts with literary and art circles in France and Germany were seminal for his development as an artist. With Great Britain his direct contacts were few, although he was a close friend of the composer Frederick Delius. He seems to have visited London on one occasion, but apart from two black and white lithographs this visit is not documented. However, a closer study of Munch's links with British Decadent artists might prove rewarding. Only one major work by Munch exists in a British public collection: the Tate Gallery owns a

version of *The Sick Child*, painted in 1907, which is included in this exhibition (cat. 71). His work, however, was shown in London during the 1930s, and is known through a series of exhibitions arranged by the Munch Museum after World War II – the most comprehensive one being that at the Hayward Gallery in 1974.

We, at the Norwegian end, are grateful for the access which has now been given to Munch's art at the National Gallery – and I feel certain that Munch himself would have been vastly pleased had he known that the presentation of his Frieze of Life was to follow shortly after a major Rembrandt show at one of the world's most prestigious galleries. I want to thank the National Gallery through its director, Neil MacGregor, for the invitation extended to us, and for the enlightened collaboration which has led to a presentation that I believe the British public will appreciate. My thanks go also to the Head of Exhibitions at the National Gallery, Michael Wilson, and to the exhibition's guest curator, Mara-Helen Wood – an old friend and one instrumental on many previous occasions in bringing the works of Munch before a British public.

ALF BØE

DIRECTOR, THE CITY OF OSLO ART COLLECTIONS, THE MUNCH MUSEUM

The Frieze of Life

EDVARD MUNCH

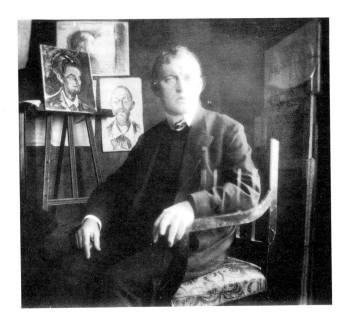

Fig. 2
Edvard Munch, Self Portrait 1908-9
Photograph
Oslo, Munch Museum.

The following essays and quotations are extracts from the catalogue Munch produced to accompany his 1918 exhibition at Blomquist's gallery in Christiania.

Oslo 1890
The Origins of The Frieze of Life

I do not paint from nature – I take from it – or help myself generously from its riches.

I do not paint what I see – but what I saw.

The camera cannot compete with the brush and palette – as long as it cannot be used in heaven or hell.

Warnemünde 1907-8
Art and Nature

Art is the opposite of nature.

A work of art comes only from inside a human being.

Art is the pictorial form created by the human nerves – the heart – the brain – the eye.

Art is the human need for crystallisation. Nature is the vast eternal kingdom from which art takes its nourishment.

Nature is not only what is visible to the eye – it is the inner reflection of the soul – in the mind's eye.

St-Cloud 1889

Spanish Dancers – 1 Fr – Entry

There was a long hall with galleries on each side – below people sat drinking at round tables. – You could stand in the middle – top hat to top hat – with a few ladies' hats in between!

At the far end, above the top hats, a small lady in a lilac leotard was dancing on a tightrope – amid the blue-grey tobacco-filled air.

I strolled in. I was looking for a pretty face – no – yes, that one didn't look too bad.

When she noticed me looking at her it was as though a mask had been pulled over her face, she turned away and stared blankly ahead of her.

I found a chair – and sank wearily into it, exhausted.

There was applause – the lilac-coloured tightrope dancer bowed with a smile and disappeared.

The Rumanian singers were performing. – It was about

love and hate, longing and reconciliation – of sweet dreams – and the soft music blended with the colours. All of these colours set against the green palm trees and the blue-green water – the vivid colours of the Rumanian costumes – in the blue-grey haze.

The music and the colours caught my attention. They were accompanied by wispy clouds and carried away by soft notes into a world of bright and happy dreams.

I should be doing something – I knew it would be easy – it would miraculously take shape under my hands.

That would show them.

A strong bare arm – a powerful brown neck – a young woman resting her head against a broad chest.

She closes her eyes, and listens with open quivering lips to the words he whispers into her long flowing hair.

I would like to create it as I saw it, right there, but in a blue haze.

The two of them at that moment when they are no longer themselves but only a link in the chain that binds a thousand generations.

People would respect the power, the sanctity of it and they would take off their hats as they do in a church.

I would produce a number of these pictures.

We should no longer paint interiors with people reading and women knitting.

We should paint real people, who breathe, feel, suffer and love.

I knew I could do it – it would be so easy. I would mould the flesh and give life to the colours.

There was a pause – the music stopped.

I felt sad.

I remember how often before I had felt like this – and when I had finished a picture – people would smile and shake their heads.

I was outside again on the blue Boulevard des Italiens - with its bright electric lamps and yellow gaslights and the ghostly faces of a thousand strangers glowing under the electric light.

During the following three years I collected sketches and pictures for a frieze – which I first exhibited in Berlin in 1893. It included *The Scream – Kiss – Vampire – Loving Woman*, etc.

It was the period of Realism and Impressionism.

Sometimes when I was either in a morbid, emotional mood or extremely happy I would find a landscape I wanted to paint. – I would set up my easel and paint the picture from nature.

It would be a good picture – but it was not what I wanted to paint. – I could not paint it as I saw it according to my mood.

This often happened. – Then I began to scrape off what I had painted – I forced myself to remember that first image – the first impression – and attempted to recapture it.

When I saw the sick child – with her pale face and vibrant red hair against the white pillow – the impression it made disappeared while I was working.

On canvas I achieved a good but different painting. – I repainted this picture several times during that year – I scraped it off – smudged the paint – and tried again and again to recapture that first impression on canvas – of the transparent pale skin – the quivering lips – the trembling hands.

I had overworked the chair with the glass – it detracted from the head. – When I looked at the painting I could just make out the glass and its surroundings – should I remove it completely? – No, it gave the picture depth and accentuated the head. – I scraped off half of the background and left the rest – now you could clearly see beyond and across the head and the glass.

I also discovered that by looking through my eyelashes I had a better impression of the picture. – I therefore hinted at them as shadows at the top of the painting. – In a way, the head became the picture. Wavy lines appeared – peripheries – around the head. – Later, I often used these wavy lines.

Finally, I stopped exhausted. – I had achieved so much of that first impression, the quivering lips – the transparent skin – the tired eyes – but the painting was not finished, the colour was wrong – it was pale grey. It looked as heavy as lead.

Between 1895 and 1906 I carried on working on this picture and eventually I achieved the vivid colour that I originally wanted. – I painted three versions. – They are all different but they each express my feelings, that first impression.

In spring – with the sick child and her mother by the open window and the sunlight streaming in, I said farewell to Impressionism and Realism.

In *The Sick Child* I broke new ground – it was a breakthrough in my art. – Most of my later works owe their existence to this picture .

No painting ever caused such offence in Norway. On the opening day, when I entered the gallery there was a crowd of people in front of the picture, – they were laughing and shouting. When I went outside again, the young Naturalist painters were standing in the street with their leader Wentzel. They were the most celebrated artists of the day – Wentzel was at his best then and there are several excellent paintings by him from that period in our museum. 'Humbug painter!' he yelled in my face.

'It is an excellent picture. Congratulations,' said Ludvig Meyer; he was one of the few people who had something good to say about it.

Aftenposten wallowed in vulgar abuse.

Nevertheless, this art-hating newspaper has its uses – but so does a night-watchman. *Aftenposten* always had and still has a Jonas Rask. He was the type who dabbled in painting at school and got a pass mark for his essays.

Jonas Rask was kicked out by Thaulow, Christian Krohg and the others. – Of course, they were the heavyweights – and Thaulow was rather powerful – the son of a wealthy pharmacist – therefore *Aftenposten* was afraid of him.

But what good did that do ... he was replaced by another Jonas Rask type – and it will continue. Now it is Haug's turn.

But why persecute him ? Perhaps it is not his fault. – The crude masses that help to fatten *Aftenposten* demand someone like that.

If he were removed, the crude masses would replace him with someone just as impossible. – The brutal masses can demand anything they like – they pay for the paper.

These people need freshly slaughtered young painters for breakfast – a sort of sandwich paste.

A little outrage may not be so bad – but woe to the offending person.

One evening I was walking along a road – with the fjord and the town below on the other side.

I was sick and tired – I stood for some time looking across the fjord – The sun was setting – the clouds were turning red – like blood.

I felt as if a scream was going through nature – I thought I heard a scream.

I painted the picture – painted the clouds like real blood. – The colours were screaming.

This was the picture *The Scream* in the Frieze of Life.

One sunny spring day, as the band marched along Karl Johan Street, I was in a festive mood – spring – the light – the music – it was a vibrant joyful mixture – the music, the colours.

I painted the picture, with the colours vibrating in the rhythm of the music. – I painted the colours I saw then.

I painted picture after picture based on these visual impressions according to my emotional state at the time – I painted lines and colours that were fixed in my mind's eye – stuck to my retina.

And I painted what I remembered without adding anything – without the details I could no longer see. Hence the simplicity of the pictures – the apparent emptiness.

I painted pictures from my childhood – the diffuse colours from way back.

Like a phonograph, I wanted to reproduce my moods by painting the colours, lines and shapes that I had seen in a particular state of mind.

This is how I created the Frieze of Life pictures.

In the autumn of 1895 I exhibited at Blomquist's. – The pictures became the subject of considerable controversy. They wanted to boycott the premises – call the police.

I met Ibsen there one day. He came over to me. 'I do find this very interesting,' he said. 'Believe me, it will be the same for you as it was for me – the more enemies you have the more friends.'

We looked at every picture. A large part of the Frieze of Life was exhibited there.

The melancholy young man on the beach – *Madonna* – *The Scream* – *Anxiety* – *Jealousy* – *Woman in Three Stages*.

He was particularly interested in the painting with the dreaming woman – the full-blooded woman – woman as a nun – the pale one standing behind the trees.

He was amused by my portraits – where I had accentuated the features – to the point bordering on caricature.

Years later, Ibsen wrote *When We Dead Awaken*. – About a sculptor's work which disappeared abroad even though it was not exported. – I recognised several motifs that resembled the Frieze of Life pictures – the man sitting on the rocks, his head bent in melancholy.

Jealousy – the Pole lying with a gunshot wound in his head.

The three women – Irene, the woman in white, looking dreamily out at life.

Maja, the full-blooded woman – the naked one.

The woman of sadness – the pale, staring face between the tree trunks – Irene's fate, a sick nurse.

These three women reappear in Ibsen's drama just as they do in my picture.

On a light summer night the darkly dressed woman is seen going into the garden with Irene, who is naked or wearing some sort of bathing costume.

The seductive white body against the black of mourning – in the mystic light of a northern summer night.

The light summer night where life and death, day and night walk hand in hand.

In Ibsen's drama, the sculptor's portrait commissions are also mentioned – they were caricatures – animals' heads.

In Ibsen's play the sculptor's work about the resurrection remained divided and incomplete – which also happened to my work.

Some of the pictures went to Rasmus Meyer's collection in Bergen – others to the National Gallery in Oslo. I was denied any financial support to complete this project while I was working on it. It was crushed by controversy and adversity.

Now, I have reassembled what remains so that it resembles how it looked twenty years ago. – All that is left is a torso.

For a fuller explanation of the publication of this material see page 36, note 7.

Edvard Munch
A Biographical
Background

ARNE EGGUM

As a young man Edvard Munch formulated a kind of manifesto, a banner for himself and his young fellow painters in Christiania to rally around.

We want more than a mere photograph of nature. We do not want to paint pretty pictures to be hung on drawing-room walls. We want to create, or at least lay the foundations of, an art that gives something to humanity. An art that arrests and engages. An art created of one's innermost heart.[1]

Munch was the only Norwegian artist of his generation to pursue this ambition. Throughout his career he remained the great individualist in Norwegian as well as European art. He saw himself as a link in the chain of artists such as Michelangelo, Rembrandt, Manet, Van Gogh and Gauguin whose profound personal and intellectual commitment emphasised the purely human aspect of their art. A frequently quoted note from his literary diary characteristically reads: 'We should no longer paint interiors with people reading and women knitting, they should be people who live, breathe, feel, suffer and love.' At the turn of the century this form of subjectivism was typical of the Romantic tradition inspired by Runge and Friedrich in Germany, Blake in England and Goya in Spain, and it became vital to Munch at various stages of his development.

Although he was not alone in striving for a personal basis to his art, no other painter developed such a distinctive 'private' symbolism, wrought by his own traumatic experiences. His dispassionate analysis of his innermost thoughts and fears demanded 'an art which is the result of a compulsive need to open one's heart'. He did not merely strive for subjectivism; he aimed to establish universal values through individual ones. According to Jung, he 'crystallised' archetypal symbols and images of man's deepest emotions – of love, death and anxiety. To Munch Expressionism was an extremely subjective, existential art that retained some of its original and primitive qualities. In 1890 one of his friends in Berlin wrote: '...he doesn't need to travel to Tahiti to see and experience the primitive in human nature. He carries his own Tahiti within him...'[2]

In November 1880 Munch wrote in his diary: 'now I have decided to become a painter.' At this time the artistic arena in Norway was primarily dominated by Naturalism, deriving from Paris, and this led to what became known as 'the golden age of Norwegian art'. Hitherto, Norwegian artists had been educated in Germany, where they tended to stay and benefit from its comparatively richer art market.

In 1880, later called the 'watershed' year, the historical predominance of the German schools of Dresden, Düsseldorf and Munich ended and, according to the Norwegian art historian Jen Thiis, the Norwegian colony of artists 'like migrant birds in autumn' left Germany and emigrated to Paris.

There they were introduced to *plein-air* painting and to French Naturalism with their imperatives of a true rendition of nature and of life. These painters believed that nature and the artist's native environment were the only subjects he was able to reproduce unadulterated; Norwegian painters, therefore, should be painting Norwegian motifs in their home country, and a number of important artists who had been painting abroad for several years returned home.

Fritz Thaulow and Christian Krohg, both from distinguished families and academic backgrounds, became the Norwegian artists' chief spokesmen during this transitional stage, and Erik Werenskiold emerged as the driving force behind the organisation of the artists' co-operative movement. The artists who returned to Norway were not only eloquent, they were also excellent painters and this generation perhaps represents the most exciting chapter in Norwegian art history.

In Christiania, as Oslo was called until 1924, the artists initially interpreted Naturalism as the study of nature itself. Working in front of the motif, whether a model or a landscape, became crucial: this was where they would find truth. Their traditional academic education was replaced by self-study, often with an older artist acting as 'midwife'. This academy-less course had certain financial advantages for the younger artists of Munch's generation, who could ill afford the expense of a formal education. Even though he was a direct descendant of one of Norway's ruling families that included high-ranking clergymen, intellectuals and artists, Munch's father, a military surgeon promoted from the rank of lieutenant to captain, had limited financial resources. His mother came from a practical seafaring family of captains, more renowned for being men of action then intellectuals. Munch's early childhood was scarred by his father's depression, his own prolonged ill health and the illness and deaths of his mother and his sister Sophie. He never entirely escaped from those unhappy memories. In 1886 when his mother died, her younger sister Karen Bjølstad assumed responsibility for the household,

and for many years, this strong, unselfish woman was the heart and mainstay of the family.

In the autumn of 1882, Munch rented a studio in Christiania with a group of artists. They were joined by Christian Krohg, who became their self-appointed tutor. They all painted the same model, often men marked by life who had been brought in from the street. The ever-willing Krohg generously shared his expert knowledge with the young painters, correcting their work in his scholarly manner.

Munch's first important work 'A Servant Girl' (1884), later renamed *Morning* (fig. 3), shows Krohg's influence in the painterly modelling of the figure; but the golden light which appears to dissolve the objects on the window-sill and fuse the model with her surroundings suggests a new and significant development. French Impressionism, which was much debated in the press and among Munch's fellow painters, may account for his concentration on, and interest in, the inherent value of light.

Later that autumn when he painted a full-length portrait of his sister Inger in a dark dress against a smouldering blue-black background, Munch appears to have reversed the shimmering light and shadowy blue hues that characterised *Morning*. Instead, Inger's face and sensitive hands are highlighted to reflect the deep emotional content of the picture.

Called *Inger in Black*, the portrait was presented in the Norwegian section of the World Exhibition in 1885, Munch's first contribution to an international exhibition. It was a relatively daring choice by the jury. When it was exhibited the following year at the annual Autumn Exhibition in Christiania the critic of the conservative daily newspaper *Aftenposten* wrote a damning review, describing the woman as 'ugly', a 'Louise Michel' – a reference to the French anarchist. 'The worst possible description of a woman', Munch is reputed to have said later. At that time it was generally believed that painting a radical picture was tantamount to being a radical and the pejorative terms 'anarchist' and 'impressionist' became inseparably linked with Munch's name during the next few years. By this time, however, he had been adopted by the Christiania-Bohème, an avant-garde group of writers and artists whose leader Hans Jaeger was a self-proclaimed anarchist.

With financial assistance from his wealthy older colleague Fritz Thaulow, Munch spent three weeks visiting the

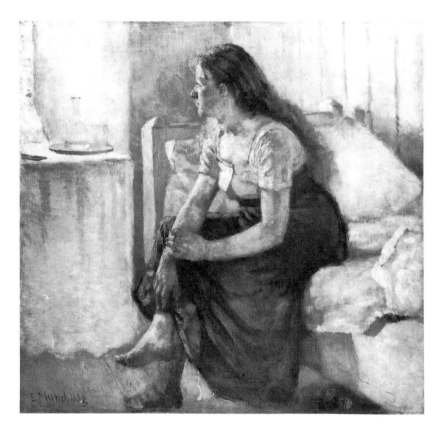

Fig. 3
Morning 1884
Oil on canvas, 96.5 x 103.5 cm
(38 x 40¾ in.)
Bergen, Rasmus Meyer Collection.

World Exhibition in Antwerp and Paris in the spring of 1885. After this trip he painted the dashing full-length portrait of a fellow-painter, Karl Jensen-Hjell (Private Collection), which he exhibited at the Autumn Exhibition that year. *Aftenposten* described the painting as 'the extremity of Impressionism, the inside-out image of art'. The newspaper *Dagen* referred to Munch as 'the painter of ugly things'.

Around this time Munch started painting what was to become one of his most important motifs, *The Sick Child*. Here he seems to have broken free from the constraints of Naturalism and found a more powerful idiom capable of expressing stronger personal emotions. According to Munch himself, he repainted the picture at least twenty times. In retrospect he believed that this exercise bore the seed for his major works and for some of the issues that later influenced developments in twentieth-century art. He later summarised it as 'a thoroughly nervous, cubist and colourless picture'. In another context, he wrote:

I began as an Impressionist but it was limited and I had to find another way of expressing the emotional turmoil I experienced during that bohemian period of my life. My association with

Jaeger helped – (paint your own life). *The Sick Child* was the first break from Impressionism – I was searching for its expression.[3]

When the painting was exhibited with the title 'Study' at the 1886 Autumn Exhibition there was a storm of protests. No other painting in the history of Norwegian art had provoked such outrage and indignation. On the opening day people crowded in front of the picture, laughing. Gustav Wentzel, a prominent young Naturalist painter who practised a style of photographic realism, shouted 'humbug painter' as Munch left the exhibition.

In April 1889, Munch arranged a retrospective exhibition of 63 paintings and a large number of drawings at the Students' Association in Christiania. It was unheard of for a young, controversial artist to have a one-man show, and according to *Aftenposten*, the retrospective 'revealed a high degree of boldness and lack of self-criticism'. However, impressed by the intensity and depth of Munch's work, Christian Krohg wrote an enthusiastic review in the newspaper *Dagbladet*:

He paints – that is to say – he looks at things in a different way from other artists. He sees only the essence and, consequently, paints only that. That is why Munch's pictures as a rule are 'unfinished', as people have taken such delight in saying. Oh yes!

They are finished. Finished from his hand. Art is finished when the artist has said all that he really has to say, and this is the advantage Munch has over generations of painters, he has the unique ability to show us how he felt and what gripped him, making everything else seem unimportant.[4]

Munch's reputation as an artist of unusual, if peculiar, talent was gaining momentum. Through his column in *Dagbladet*, the prominent art historian and critic Andreas Aubert recommended Munch for the Norwegian government's state grant, as well as a travel grant, on condition that he look for a first-rate life drawing tutor. Munch applied for and was awarded the state grant that year and for each of the subsequent three years. Later that autumn he left for Paris and dutifully enrolled as a pupil of the successful portrait painter Léon Bonnat.

Probably even before his departure to Paris, Munch started a hand-written, quasi-autobiographical, illustrated diary, which contains the motifs that he later developed as part of his Frieze of Life. The diary also includes a lengthy description and several sketches for the picture *Evening on Karl Johan* which he in fact painted much later, in 1892. The material for this 'literary diary' was partly an edited version of notes dating from as early as 1886. Munch attributed his naturalistic style directly to Hans Jaeger's literary oeuvre, which in turn had been influenced by Zola's naturalist programme, but treated in a subjective

manner. Jaeger's ideology was powerfully summed up in one of the '10 commandments' of the Christiania-Bohème, published in 1888: 'Thou shalt write thy own life.' However, his attempts at writing a number of self-compromising novels such as *From the Kristiania-Bohème* (1885) cost him dear. The book was banned and condemned as blasphemous and immoral, and Jaeger was sent to jail.

Munch's diary contains tragic childhood memories, tender love scenes, impressions of Christiania café society, as well as reflections on art. In the last section his comments on the theory of art reflect some of the ideas found in Krohg's review of Munch's one-man show, but with a slightly more radical 'expressionistic' emphasis.

At different times one sees things with different eyes. The way in which one sees also depends on one's frame of mind... On emerging from a dark bedroom into the morning room, for example, one would see things in a bluish tinge. Even the deepest shadow will have a sheen of pale light. After a while, one becomes accustomed to the light and the shadows deepen and everything becomes more distinct. If one attempted to paint this atmosphere...one couldn't just sit there staring at everything and expect to paint it 'just as one sees it'. It should be painted the way it looked from that first impression...[5]

In the autumn of 1889, shortly before leaving for Paris, Munch exhibited *Evening*, later renamed *Inger on the Beach* (fig. 4), at the Autumn Exhibition in Christiania. The public and the press were as enraged by this painting as

Fig. 4
Evening (Inger on the Beach) 1889
Oil on canvas, 126.4 x 161.7 cm
(49¾ x 63½ in.)
Bergen, Rasmus Meyer Collection.

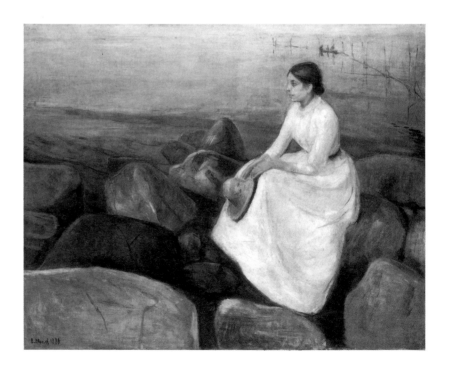

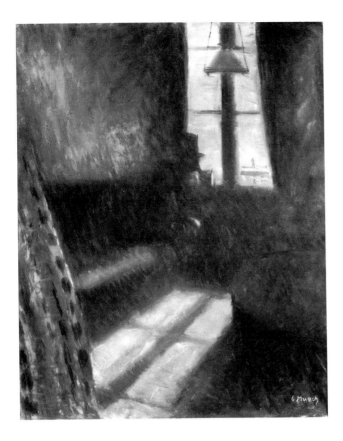

Fig. 5
Night 1890
Oil on canvas, 64.5 x 54 cm (25½ x 21¼ in.)
Oslo, The National Gallery.

they were by *The Sick Child*. The almost stereotypical image of a sad and lonely figure in light-coloured clothes sitting on the bare multicoloured stones in front of a calm motionless sea evokes a mood of melancholy. The pale, crisp glowing hues of the painting and its still, yet lyrical, expressiveness, suggest that Munch, like so many others of that period, was influenced by Puvis de Chavannes.

Munch studied life-drawing at Bonnat's studio in Paris for several months and then moved to lodgings in St-Cloud on the outskirts of Paris. Standing at the window of his room overlooking the Seine, he painted a series of motifs in the Neo-Impressionist idiom of Seurat, and with the same deft execution, reminiscent of Monet's series depicting a single motif in differing light conditions.[6] However, Munch's major work during the winter and spring at St-Cloud was *Night* (fig. 5), in which a shadowy, melancholy figure wearing a top hat sits with his head on his hand at the far end of the gloomy pictorial space. The

outline of the cross-shaped window frame is reflected in the pool of moonlight on the floor. This expressive use of space has associations with Van Gogh's art, and the monochromatic colouring recalls Whistler's nocturnes, which were fashionable in Paris at that time.

In St-Cloud, Munch wrote what later became known as his St-Cloud Manifesto (see page 11). He explained that when he received the news of his father's death in Norway he had a vision, in a Paris nightclub, of painting a series of 'powerful, sacred' moments, and 'people would respect the power, the sanctity of it – they would take off their hats as they do in a church'; this vision was later developed into the Frieze of Life.

Munch's other literary texts indicate that the famous love scene described in the St-Cloud Manifesto, which he would depict as he 'saw it then in a blue haze', alludes to his great love affair with 'Mrs Heiberg', which began at Åsgårdstrand in the summer of 1885, shortly after his return from Paris. In a recently discovered draft, a longer, more explicit description of the love scene suggests other memories of 'Mrs Heiberg' and reveals how they acted as a catalyst for his more existentialist Frieze of Life motifs of the 1890s.[7]

On holiday in Norway at the coastal resort of Åsgårdstrand in 1891, Munch painted what later became the first motif for this series, 'Evening', which is better known today as *Melancholy* (see cat. 44). This painting has formal associations with Gauguin's Synthetist style of defining large surfaces of colour with clear outlines. The undulating coastline wending its way through the pictorial space is indicative of the powerful influence of Japanese woodcuts, which Munch probably studied and had no doubt encountered in French art.

There is every reason to suppose that before leaving Paris, and his lodgings at Rue Lafayette, Munch visited Gauguin's exhibition at the nearby Théâtre de Vaudeville, which opened on 21 May 1891. The exhibition was shown to coincide with Maurice Maeterlinck's poignant Symbolist drama *L'Intruse*,[8] which almost certainly influenced the subsequent emphasis of Symbolism and Synthetism in Munch's art.

When 'Evening' was exhibited at the Autumn Exhibition in Christiania, it was initially ignored by the press. However, Christian Krohg, perhaps the most influential painter at that time in Norway, wrote a lengthy article on the

painting in the newspaper *Verdens Gang*. In his view it had a 'serious and strict, almost religious quality...related to symbolism – the current movement in French art...Munch should be congratulated for making the boat yellow – otherwise, he wouldn't have painted the picture'.[9]

The slumped figure in the foreground was modelled on the 21-year-old Jappe Nilssen, an aspiring author – and a friend and relative of Munch's – who, during the summer at Åsgårdstrand, had a passionate affair with the artist Oda Krohg, ten years his senior and the wife of Christian Krohg.

Munch's literary notes from this period mix observations on his friend's tragic affair with his own rekindled memories of his association, six years earlier, with 'Mrs Heiberg' when he was the same age. These almost frenetic notes recalling his own erotic experiences and crisis, as well as later literary drafts, reflect the majority of the Love motifs of the Frieze of Life.

On the Riviera in Nice, Munch developed *The Kiss* (cat. 17), another Frieze of Life motif. In all three known versions of this motif, painted in the winter of 1891-2, he concentrates on the contrast between the busy life outside and the stillness inside. Instead of the harsh Nordic light, these pictures reproduce the soft, blue-grey colours of the south, like the Impressionists' studies of light. However, the underlying mood of the pictures contains disturbing elements that distinguish Munch's 'Kiss' from other more traditional renderings of this subject.

In March 1892, Munch joined the Norwegian painter Christian Skredsvig and his wife Maggie at the house they had rented at St Jean-Cap-Ferrat. Skredsvig wrote about Munch's visit:

For some time he has wanted to paint the memories of a sunset. Red as blood. No, it really *was* coagulated blood. But no one would see it the same way. Anyone else would think of clouds. Talking about it made him feel sad and uneasy. Sad because the humble means available to art were never enough. 'He is striving for the impossible and his own despair is his faith,' I thought; but I advised him to paint it. – And he painted this curious 'scream'. [10]

This painting which is today known as *Despair* (fig. 29) and hangs in the Thielska Gallery in Stockholm was referred to by Munch as 'the first scream'. The close-up of the foreground figure in profile, wearing a soft hat and looking over the railing, has the character of a self portrait. A drawing from the same year illustrates how Munch devised the composition, by extending the blood-coloured clouds into the sketched frame and giving the foreground figure a prominent spatial position, to convey its powerful message. The text added to the drawing confirms that this is the same experience depicted in the motifs Despair and the Scream:

I was walking along the road with two friends – watching the sunset – the sky suddenly turned red as blood – I stopped, leant against the fence, deadly tired – above the blue-black fjord and the town lay blood and tongues of fire – my friends walked on and I was left, trembling with fear – and I could feel an infinite scream passing through the landscape

Although the remaining Frieze of Life pictures were painted in Berlin over the next few years, Munch always maintained that the pictures were rooted in his bohemian years in Christiania and Paris. In February 1929 he wrote to Ragnar Hoppe: 'The Frieze of Life was planned in Paris in 1889 – It was being prepared during the Bohemian movement.' In an interview with Erik Lie who was reviewing his exhibition at the Diorama Hall in Christiania in 1897, Munch was asked, 'Have you ever thought of writing instead of painting?' 'I have. And perhaps that's what I should have done. Almost everything you see started as a manuscript. Much of it was written almost ten years ago...'[11]

In 1892 Munch was invited to exhibit at the Verein Berliner Künstler, where his pictures caused such a scandal that the exhibition closed within a few days. Munch became *the* subject of conversation and Berlin society welcomed him socially. However, he gradually gravitated towards the more radical, literary circle centred around August Strindberg which met regularly at the Black Piglet café in Berlin. Although predominantly Scandinavian, the group also included the Polish writer Stanislaw Przybyszewski, the German art historian Julius Meier-Graefe and the young German author Richard Dehmel. The group's interest focused on French-Belgian Symbolism and on Nietzsche's philosophy and its obsession with psychology, eroticism and fantasies of death, which may have given new force to Munch's motifs, particularly his images of Love, Anxiety and Death: *The Voice* (cats. 7 and 8), *Madonna* (cat. 26), *Vampire* (cats. 20 and 21), *Jealousy* (cat. 32), *Ashes* (fig. 27), *The Scream* (cat. 52), *Death in the Sickroom* (cat. 67) and *By the Deathbed* (cat. 62).[12] Working from his many sketches he transposed the experiences from his childhood and youth into a condensed 'expressionist' idiom in which

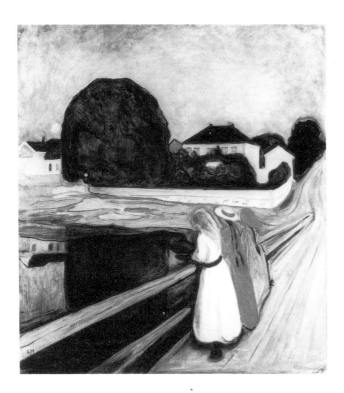

Fig. 6
Girls on the Bridge 1901
Oil on canvas, 136 x 125 cm (53½ x 49¼ in.)
Oslo, The National Gallery.

the use of colour is symbolic and suggestive rather than descriptive. He also applied a repertoire of pictorial formulae, as well as a set of signs and symbols, which he kept repeating and varying; for example, the moon's phallic reflection on the sea, the almost stereotyped young man – the artist's *alter ego* – and the contrasting female figures, dressed in light and dark colours.

During the period 1896-8, Munch returned to live in Paris and mixed with a circle of artists and musicians. He was invited to illustrate Baudelaire's *Les Fleurs du Mal* – but the project was cancelled when the publisher died; he made posters for Ibsen's *Peer Gynt* and *John Gabriel Borkman* at the Théâtre de l'Oeuvre, and his work was singled out when it was exhibited at the Salon des Indépendants and at Bing's Art Nouveau Gallery. This time, Munch had arrived in Paris as a mature artist, bringing with him his principal works, but the extent of his influence on the international art world during this period is debatable.

Nevertheless, the stimulating effect of Paris is reflected in the masterpieces he produced just after the turn of the century, such as the lyrical and harmonious *Girls on the Bridge* (fig. 6), a motif of puberty charged with the eroticism of a Nordic summer night. It is probably the most outstanding example of Munch's 'new artistic use of colour' which appears to have influenced the French Fauvists, particulary Dufy's *Three Parasols* (1906, Houston, Museum of Fine Arts),[13] in which the colour and composition can be compared to Munch's painting. In this context Christian Krohg's comments in an article of 1909 are interesting: 'In conclusion, if I were to give an impression of Matisse as a painter, I would say that he resembles Edvard Munch...I think Munch is the father of Matissism, though he may perhaps disown his child.'

In the summer of 1899, Munch visited northern Italy and Rome where he studied, among other things, the monumental art of the Renaissance. On his way back he called on his old friend Julius Meier-Graefe in Paris and expressed his enthusiasm for the inspirational *stanze* of Raphael and his intention to return home and create works suitable for large wall surfaces. This is perhaps most obvious in his many winter landscapes with their rhythmic changes of colour and line which were produced during this period. Similarly, the more colourful paintings of the Frieze of Life such as *Metabolism* (cat. 47), *The Dance of Life* (cat. 31) and *Red Virginia Creeper* (cat. 57) also suggest a temporary change of direction.

In 1902, Munch exhibited the Frieze of Life at the Berlin Secession. Hitherto the content of the Frieze had been fairly flexible, but for this exhibition he presented the first formal selection and grouped together the Love, Anxiety and Death motifs. His influence on young northern European artists and his more comprehensive success in Germany both stem from this period. Munch continued to live and work in Germany until his nervous breakdown in 1908, and produced a number of monumental, full-length portrait commissions, including those of his friends Herman Schlittgen (*The German*) and Marcel Archinard (*The Frenchman*), of Walther Rathenau and Ernest Thiel, and of Dr Linde's four sons. The art historian Carl Heise described the latter as the most important group portrait of the twentieth century.

Munch was also commissioned to produce decorative panels for Max Linde in Lübeck (1903-4) and for Max Reinhardt's theatre in Berlin (1906-8). He based both of these on the Frieze of Life. But Dr Linde considered the

strongly coloured, almost aggressive spontaneity of Munch's interpretation of youth and the implied awakening of sexuality too erotic and, therefore, inappropriate for his children's room.[14] In contrast to the Linde frieze, the panels for the entrance hall of Max Reinhardt's theatre describe mature love between man and woman, with the familiar winding Åsgårdstand coastline in the background. Using diluted paint on unprimed canvas, Munch achieved a soft, glazed effect which gave the frieze a lyrical, elegiac mood.[15]

In almost direct contrast to his deteriorating health, Munch's monumental images from this period show a more extrovert attitude to life. His *Bathing Men* (fig. 7), planned as a pentaptych, but produced as a triptych, depicts the cycle of man's life from childhood to old age. At the same time he produced the Green Room series, a new and bitter interpretation of the Frieze of Life which more accurately reflects his bouts of acute depression.

After years of restless travelling, mental illness and alcoholism, Munch suffered a complete nervous break-

Fig. 7 Bathing Men 1907
Oil on canvas, 206 x 227 cm (81 x 89½ in.). Helsinki, Atheneum.

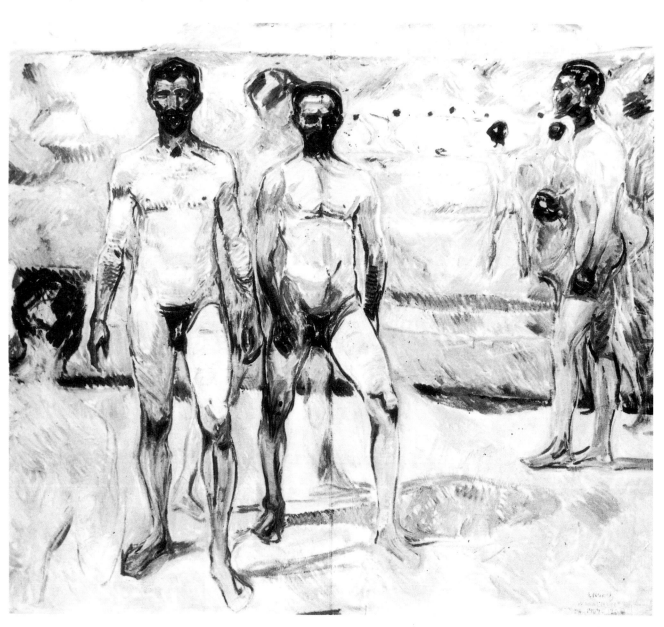

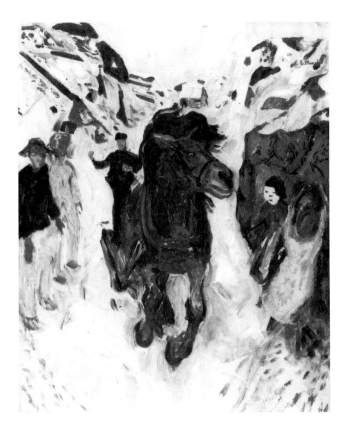

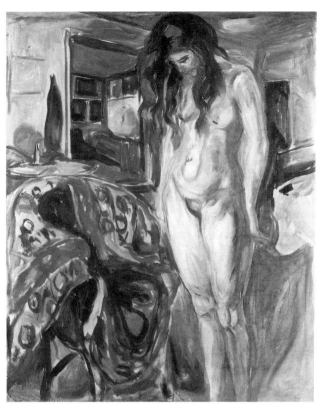

Fig. 8
Galloping Horse 1910-12
Oil on canvas, 148 x 119.5 cm (58¼ x 47 in.)
Oslo, Munch Museum.

Fig. 9
Model by a Wicker Chair 1919-21
Oil on canvas, 122.5 x 100 cm (48¼ x 39½ in.)
Oslo, Munch Museum.

down in 1908 and committed himself to Dr Jacobson's clinic for nervous disorders in Copenhagen. On his return to Norway, he settled down at the small coastal town of Kragerø, where he began a new chapter in his life and art.

He immediately started work on his entry for the Oslo University competition. Despite fierce opposition, he finally won the competition and his magnificent, monumental paintings, the most outstanding in Norwegian art, were unveiled in the Great Hall (Aula) in 1916. The classical simplicity of the main panels, *History*, *The Sun* and *Alma Mater*, demonstrates his renewed interest in the Norwegian landscape and a fresh, spontaneous handling of paint similar to his other monumental paintings of this period.

This dynamic and vigorous brushwork can also be seen in *Galloping Horse* (fig. 8). The horse hurtles towards the viewer, sweeping aside any obstacles in its path. The exaggerated foreshortening of the animal with its head thrown back creates a powerful illusion of movement.

In 1912, Munch was given a separate room at the famous Sonderbund exhibition in Cologne, where he was acknowledged as the greatest single influence on the development of contemporary modern art in Germany. The following year in Berlin, he and Picasso were the only invited foreign artists to be given their own rooms at the Autumn Exhibition in recognition of their importance to emerging young German artists. However, whereas the most avant-garde tendencies in modern art developed towards Futurism and Cubism, or, in the case of Kandinsky, towards abstraction, the external world remained a principal element in Munch's art.

The 1920s and 1930s were a productive period for Munch, but he led a reclusive life at his home in Ekely, on the outskirts of Oslo, seeing only his closest friends. In 1922 he completed a frieze for the employees' dining room at the Freia Chocolate Factory, a joyous and harmonious depiction of life that is not unlike the Linde frieze. Munch

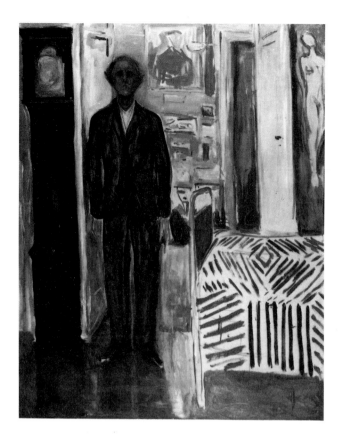

Fig. 10 **Between Clock and Bed** 1940-2
Oil on canvas, 149.5 x 120.2 cm (58¾ x 47¼ in.)
Oslo, Munch Museum.

Between 1932 and 1935 Munch made vibrant 'radical copies' of his earlier Frieze of Life motifs. He may have been influenced by the Brücke artists, particularly the violently exaggerated colouring of Karl Schmidt-Rotluff, whose work was included in a comprehensive exhibition of German art at the Kunstnernes Hus in Oslo in 1932.

During the last decades of his life, Munch produced a series of self portraits in which he traced, year by year, his mental and physical progress towards his approaching death. In his self portrait *Between Clock and Bed* (fig. 10) he positions himself standing at midday between two symbols of death, the clock and the bed; a lonely figure in a brightly coloured room with his life's work behind him.

NOTES

1. MS. The Munch Museum, Oslo, N39. Probably written winter 1888-9.
2. Franz Servaes in *Das Work des Edvard Munch*, Berlin 1894.
3. MS. The Munch Museum, Oslo, N122.
4. *Dagbladet*, 27 November 1891.
5. MS. The Munch Museum, Oslo, T2770.
6. See Rapetti 1991, pp. 73-84.
7. For a systematic explanation of the analogy in Munch's literary texts and the motifs of the Frieze of Life, see Eggum 1990. The recently discovered draft of the St-Cloud Manifesto is published in Rapetti 1991, p. 342.
8. The performance was given to raise money for the Symbolist poet Paul Verlaine (1844-96), by this time a broken man both psychologically and physically.
9. *Verdens Gang*, 27 November 1891. In his comprehensive discussion of Melancholy in 'Despair', *Edvard Munch. Symbols and Images*, Washington 1978, the Norwegian art historian Trygve Nergaard claims that it was a highly schematic and apparently unfinished version of the motif, signed and dated 1891 (now at the Munch Museum, Oslo) that was being shown at the 1891 Autumn Exhibition. Christian Krohg's long and detailed description of the picture in *Dagbladet* cannot, in my judgement, refer to this picture. The description does, however – in every single detail with regard to the colour shades – agree with cat. 44. This painting is dated 1894 but in my opinion there is reason to believe that this is a case of incorrect post-dating by Munch, of which we find several examples in his other works. When post-signing his pictures, Munch was often very casual about precise dates. I would not, however, disregard the possibility that both versions may have been exhibited. Indeed, after the second hanging at the Autumn Exhibition, Munch's aunt wrote to Munch, who was by now in Copenhagen, that the picture 'is now looking quite different', causing the critics to 'eat their words'.
10. Skredsvig 1908.
11. *Morgenposten*, 16 September 1897.
12. Reinhold Heller was the first researcher to treat the theme of the Frieze of Life in a scientific manner. See Heller 1969.
13. Reproduced in Rapetti 1991, p. 290.
14. See Eggum 1982.
15. See Kreger 1978.
16. See Eggum, 'Munch's Late Frieze of Life', *Edvard Munch 1869-1944*, Stockholm 1977.

continued to work in his outdoor studio making monumental studies for a new series of Love motifs intended for the planned new City Hall of Oslo. The series consists of a number of nude bathing scenes and illustrates the love between man and woman. Munch concentrated on this project for several years but it was never realised.[16]

Another group of motifs from these later years depicts the artist and his model, in which Munch analyses the relationship between an older man and a young woman. Compared to his earlier stark, box-like rooms, these interiors appear crammed with objects and doors leading to a succession of other rooms. However, the artist is not depicted in the principal work of this group, *Model by a Wicker Chair* (fig. 9), a powerful, richly coloured painting. Returning once more to the landscape, he painted a series of harmonious blue winter night scenes showing views from his home at Ekely. *The Bohemian Wedding* and *Death of a Bohemian* (depicting Hans Jaeger on his deathbed) are among a third series of thematic pictures he produced later in life.

Form and Formation of Edvard Munch's Frieze of Life

REINHOLD HELLER

'Death is the birth of life.'
Edvard Munch[1]

On the occasion of his 75th birthday on 12 December 1938, Edvard Munch posed in his winter studio at Ekely, his home just outside Oslo, for the Norwegian photographer Ragnvald Vaering (fig. 11). The photograph shows Munch, neatly dressed in suit and tie, seated on an old sofa in this largely unfurnished utilitarian space, surrounded by stacks of prints and rolled-up canvases, his small sculpture *Workers* (1910), and numerous paintings leaning against and hung on the walls. It is a portrayal of the artist and his work, similar to other photographs for which Munch posed or which he took of himself. As such it fits an informal iconography of artists' photographed portraits that equates, by means of visual proximity and association, the creator with his products. In this equation, the artist is surrounded by recent works, those contemporary with the photograph and thus indicative of current concerns, and may be seen actually (or seemingly) at work on a painting. For the museum-going public, who see these photographs reproduced in exhibition catalogues or on the pages of newspapers and magazines, they provide apparent access to the private person of the artist, as well as to the privileged scene of artistic creativity in process. The photographs document the present but also provide indications of the future, of continuity with the work depicted and the works that preceded it.

In this context, Munch's 75th birthday photograph is surprising, because what surrounds him in his studio are not new works at all, but paintings from or related to his series the Frieze of Life, most of them conceived during the 1890s. They hang in two tiers, while others are temporarily stacked against the walls. It is as if Munch, at the age of 75, were making an inventory of his past. Surrounded by the imagery of his youth, he has constructed an environment that effectively rejects the present. While such retrospection may be common and understandable for someone late in life, here it seems to deny Munch's continuing proud activity as an artist, his paintings and prints of the 1930s, and the value he placed in them as he exhibited and sold them. The photograph appears to proclaim that Munch wished to be identified with the Frieze he had conceived nearly forty years earlier.

The birthday photograph is not unique in this respect. It forms part of an informal series of photographs Munch had made of his summer and winter studios during the 1920s and, again, in the late 1930s (fig. 12). All focused on

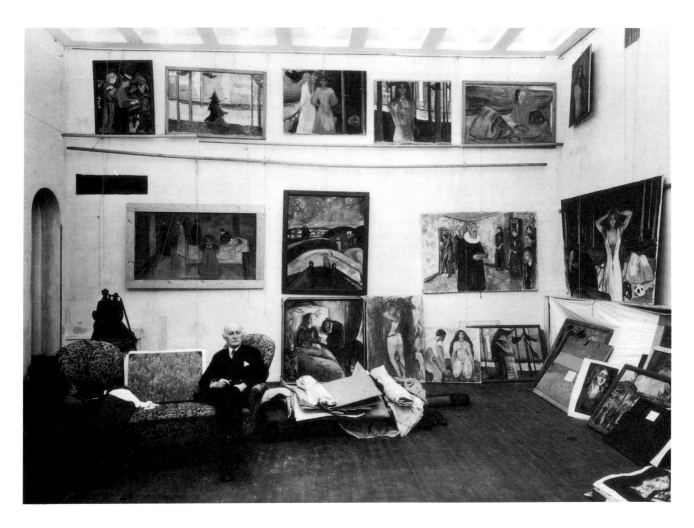

Fig. 11
Edvard Munch in his Winter Studio, Ekely 1938
Photograph. Oslo, Munch Museum.

the Frieze's themes and motifs, to the virtual exclusion of his later works. In the photograph of 1925, however, the floor is littered with tools, canvases, turpentine and paint. The instruments for continued work are juxtaposed in their anarchic jumble with the emergent order of the Frieze paintings to form an effective allegory of artistic creation, the imposition of order onto chaos. In the 1938 photograph, however, the Frieze appears as an isolated and completed achievement. The artist, although present, is not engaged with his work, nor are there signs of further involvement with it. The Frieze of Life, elevated into an icon of Munch's life itself, becomes the paradigm of his entire career. He last showed Frieze paintings grouped serially in 1927 at the vast retrospective exhibitions that

took place in the National Galleries of Berlin and Oslo. Early commemorations of his 65th birthday, these exhibitions proclaimed his unique and fundamental historical significance for the course of modern culture in both Germany and Norway. The Sonderbund Exhibition in Cologne in 1912 had first recognised Munch as one of the inaugurators of Expressionism, but this double-sited exhibition confirmed his status as a pioneer of modern art, a hero of artistic revolution.[2] In Berlin, 244 paintings documented the nearly fifty years of Munch's career; Oslo's catalogue listed 289. Both concluded with works from 1926 and a recent self portrait that provided incontrovertible testimony of Munch's continued existence and – as he is seen in bright sunshine, palette and brush in hand

– vital artistic activity.[3] Subsumed among other catalogue entries, only one of hundreds of achievements, was the listing for the Frieze of Life, accompanied in Oslo by a brief explanatory note:

No. 73-90. 'Frieze of Life'.
A series of frequently treated synthetic depictions of life and love, suffering and death. 'On this frieze, I have worked for about 30 years, with long interruptions,' the artist wrote in a little brochure from 1925. The first loose sketches date from the years 1888-9; 'Kiss', 'Jealousy', 'Street' (?)[sic], 'Man and Woman at the Seashore' [Two People] as well as 'Anxiety' were painted during 1890-1 and exhibited for the first time together in Tostrup Gardens in 1892 and later in the same year at Munch's first exhibition in Berlin. The next year the series was augmented by new works, among them 'Vampire', 'The Scream', 'Madonna' and 'Ashes' and exhibited as a self-contained frieze under the title 'Eighteen Motifs from the Modern Life of the Soul' at his second exhibition [in Berlin] on Unter den Linden. The series was not fully completed until 1902, when it was further augmented with paintings such as 'Death Room' ['The Sick Room'], 'The Dead Mother', 'Golgotha' and 'The Dance of Life' to give a total of 22 exhibited at the Secession in Berlin. As early as 1897 the frieze was exhibited at the Indépendants in Paris and in 1902 and 1904 in Oslo at Blomquist's[.] 192.. [sic] partly with new versions.[4]

The catalogue failed to identify the author of this brief, incomplete and rough text.[5] However, it reads much like similar texts by Munch himself, notably those published on the occasion of another exhibition of the Frieze in 1918 at Blomquist's gallery, mistakenly recalled as being from the 1920s.

Fig. 12
Munch's Studio, Ekely 1925
Photograph. Oslo, Munch Museum Archives.

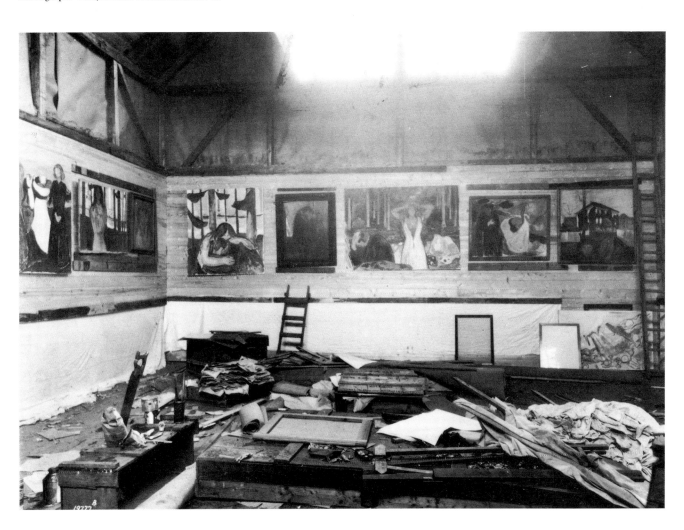

The paragraph summarising the exhibition and the development of the Frieze of Life repeats the beginning of the pamphlet *Livsfrisen*, a collection of his own commentaries and critical responses written at the time of the 1918 exhibition.[6] There are no records of how these Frieze paintings were displayed in 1918 or 1927, and in his pamphlet Munch gave only general indications of his wishes, suggesting alternatives and indicating continued activity:

It was my opinion that the frieze should be placed into a room which could serve architecturally as a suitable frame around it, in such a way that each individual panel might achieve its full effect without endangering the sense of the totality. But unfortunately so far no one has appeared who has thought of realising this plan.

It cannot be considered complete. There were constant lengthy interruptions as I worked on it. Because I have worked on it so long, naturally no single technique is continued throughout. I consider many of the pictures to be no more than studies, and of course my intention is to unify it all only when there is a proper space for it.[7]

In part, Munch was responding to critics who complained of a lack of stylistic cohesion among the paintings exhibited in 1918, many of them newly painted reprises of his earlier Frieze paintings. He suggested that the disharmony could be overcome by separating the paintings into different rooms, one for the death motifs, for example. Alternatively, in a properly expansive space, he could paint larger versions of the themes, and consciously seek cohesion in size and repeated elements. Whichever solution might be taken, the continuing nature of the projects mattered. The Frieze was not a closed concept but a perpetual concern, spoken about in the present tense and temporarily housed at the studio in Ekely, nicknamed by him for this purpose his 'castle in the air':

I consider the painting series to be one of my most important works, if not the most important.... [One] critic predicts that a patron will surely be found to provide a space for the frieze, to buy some ground and build a home for it. This time he predicted correctly. I have built a home for it myself. And if he can lose his sour disposition long enough, he is welcome to come and see it.[8]

The 'home' for the Frieze permitted constant interaction as Munch continued to paint new versions of paintings for it well into the 1930s. In 1938, however, the potential for change was absent in the photographs as Munch celebrated his birthday, proudly seated, clothed formally, a figure of nobly posed inactivity.[9] Work begun in the 1880s had come to an end.

'The first, loose sketches', Munch wrote in his pamphlet *Livsfrisen*, which was quoted in the 1927 catalogue but seems never to have been distributed, 'date from the years 1888-9.' In a handwritten note he added to the printed text: 'The Frieze of Life was begun in conversations and the moods from the time of the [Christiania-]Bohème – at the tables of the Grand [Café] – and during wanderings in the light nights [of summer].'[10]

During the late 1880s, Munch started writing his recollections in notebooks, accompanied by drawings, of scenes related to his childhood and to recent romances, especially his affair with a cousin-by-marriage, Millie Thaulow, to whom he gave the pseudonym 'Mrs Heiberg'.[11] It was she, he recalled, who initiated him into the joys and terrors of sexuality and love:

What a deep mark she left on my mind, so deep that no other image can ever totally drive it away.... Was it because she took my first kiss, that she took the sweetness of life from me? Was it because she lied, deceived, that one day she took the scales from my eyes so that I saw Medusa's head, saw life as a great horror? And everything that I had previously seen in a rose-coloured mist now seemed empty and grey to me.[12]

His illicit love for 'Mrs Heiberg' seemed justified to Munch during the 1880s as he sought to put into practice the teachings of Hans Jaeger, unofficial leader of the group of Norwegian artists and writers informally known as the Christiania-Bohème. Jaeger offered his young followers a heady mixture of ideas, an adaptation of Hegelian dialectic and determinism, derived from Emile Zola, from messianic socialism, and from the futuristic visions of the German Romantic philosopher Johann Gottlieb Fichte. The liberating principle of his utopian vision was free love:

An open, free life together for open, free men and women knowing no laws for the organisation of society other than freedom and love and happiness on earth; a society in which each single life is able to develop in all its individuality like a fruitful tree planted in fertile soil.... Oh, what people they would be! Godlike people! in contrast to the miserable creatures that now creep around on the earth's surface, hiding themselves, each separate and alone, in the dark cellular holes of decrepit freedom-suffocating institutions and traditions, frightened of the strong, stimulating daylight of an open, free society.[13]

The pillars of the old society, with their hypocritical principles that called for monogamous marriage while they maintained legalised prostitution, would be destroyed in a society where women and men could love freely, no longer having lifelong fidelity imposed on them, able to separate guiltlessly once love ceased, free to love again and to spread the good news of love to others. The process of sexual love – attraction, consummation and separation – was also made the subject of study; Jaeger encouraged a number of experimental love affairs among the members of his Christiania-Bohème, including a love triangle formed by the painter Christian Krohg, the ex-wife of a wholesale grocer, Oda Lasson, and Jaeger himself. The scientific control of these would be the individual records of memories and impressions kept by the several women and men involved in the relationships. Jaeger's experiment ultimately failed, however, as unwelcome emotions of jealousy and yearnings for exclusivity disrupted the triangular harmony; Krohg and Oda Lasson married, and Jaeger alone published his semi-fictionalised account of the relationship as *Syk kjaerlihet* (Perverse Love):

There was, after all, no more than one true woman on all the earth – oh, how I trembled! How you coursed through me like a perverse anxiety within my blood! And I saw you leave ... and fear ran ever more insanely through my blood; and my entire body shook when suddenly you turned your head and looked at me with your grave, large-eyed, fate-like face ... – Oh God, my God, how sick I was![14]

Munch's autobiographical notations and drawings resulted from his similar contribution to the bohemian complex of amorous experimentation. Consciously initiated – 'So he thought he too could find a woman. There could be some significance to that, outside the bonds of marriage'[15] – Munch's love affair with 'Mrs Heiberg' evolved during walks in the forests and on the seashore of the Oslo Fjord, and ended in the city of Christiania in fits of overpowering jealousy and despair. Notes and letters from 'Mrs Heiberg' were treasured, taken to Paris when he moved there to study in 1889, and became fetishes of memory that replaced her reality: 'I stared at each single letter, turned the bit of paper over again and again, looked at each fold in order to find marks left by her fingers.... How deep a mark she must have dug into my heart so that no other image can ever totally erase hers.'[16]

He worked on his own diary-like texts, copied, revised and rewrote them repeatedly, especially during 1890 and 1891, as he brooded alone in Paris after hearing that at home his father had died suddenly and without him.[17] To the semi-fictionalised memories of 'Mrs Heiberg' he added similarly impressionistic recollections of his family's dead, of his father, his mother, and his sister Sophie, whose death had served as the subject of his ambitious paintings *The Sick Child* (1885-6) and *Spring* (1889):

It was evening. Maja lay flushed and feverish in her bed; her eyes blinked and she looked restlessly around the room. She was hallucinating. My dear sweet Karleman, take this away from me; it hurts so. Please, won't you: She looked pleadingly at him. Yes, you will. Do you see the head over there? It is Death.

It was night. The Captain stood at the side of the boys' bed. You have to get up now, my children. They understood, quietly dressed, did not ask why.

My darling Maja – I have to tell you this – the Lord will take you for Himself soon. A sudden jerk passed through her body, then death – Then she gathered her energies and smiled weakly. – Would you like to live? Yes, she whispered, I would like that so much. – Why, little Maja? – Because it is so nice here. – Sing a hymn, Maja. – She whispered almost soundlessly. Now we were supposed to come together around her. Would she really die then? During the past half hour she had felt almost better, after all, than before; the pain was gone. She tried to raise herself, pointed to the armchair at the side of the bed. I would like to sit up, she whispered. How strange she felt. The room looked different, as if seen through a veil. Her arms and legs felt as if they were filled with lead. How tired![18]

During the following years, Munch expanded on these themes, revised the texts repeatedly and worked the drawings into independent images that he exhibited in Berlin as a self-contained series, 'A Human Life', in December 1893.[19]

Numerous other works by Munch from the late 1880s and early 1890s could also be serially grouped, even if they were not initially intended to be so. Repetitions of themes, such as the dying child, suggested interconnections, as did a consistency of narrative and symbolic concerns that continued from one image to the next – his repeated depiction of figures in landscapes at dusk, for example. Munch's close association during 1889-92 with the Danish poet Emanuel Goldstein and the Norwegian neo-Romantic writers Sigbjørn Obstfelder and Wilhelm Krag likewise fostered a predilection for serial imagery as he worked on illustrations for collections of their poetry. Scandinavian

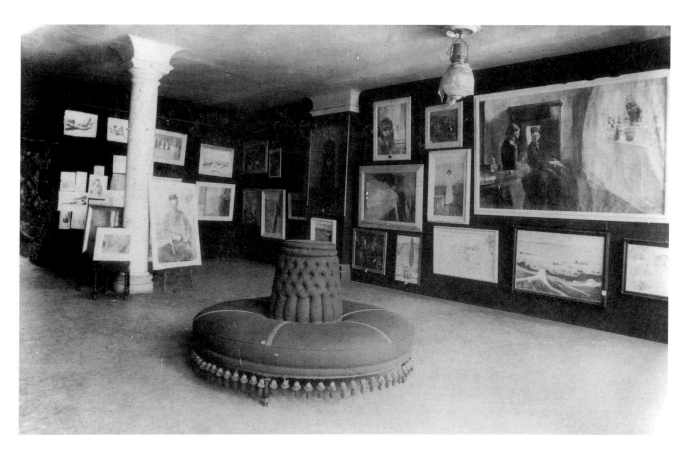

Fig. 13 Edvard Munch Exhibition, Equitable Palace, Friedrichstrasse, Berlin 1892-3
Photograph. Oslo, Munch Museum.

manifestations of Decadence and Symbolism, the poems addressed a world of moods and obsessive reflections on aspects of love and sexuality, illness and death, art and immortality that closely approximated Munch's own writings and their illustrations.[20] Work on these, and the experience of seeing large collections of his paintings in exhibitions in Norway, Denmark and Germany in 1892, gave him a sense of their ability to comment mutually one upon the other:

I placed them [the paintings] together and found that various paintings related to each other in terms of content. When they were hung together, suddenly a single musical note passed through them all. They became completely different from what they had been previously. A symphony resulted.[21]

In March of 1893, Munch explained to the Danish painter Johan Rohde that he was consciously attempting to expand his 'symphony':

I am currently occupied with making a series of paintings. Many of my paintings already belong to it Up to now, people have found these quite incomprehensible. When they are seen together, however, I believe they will be more easily understood. Love and death is the subject matter.[22]

Munch continued with the autobiographical drawings and texts, but the first paintings that resulted from his new project largely broke with preceding compositions and their specific motifs; he also avoided their dependence on anecdote and incidental narrative. After working with extraordinary intensity during the summer and autumn months of 1893 in Norway, totally isolated from other concerns, Munch exhibited his new paintings in Berlin, in a first-floor gallery rented at 19 Unter den Linden. The core of the exhibition consisted of six new oils and pastels, organised under the title Study for a Series: Love, but the exhibition's leitmotif was the newly completed painting *A Death* (now known as *Death in the Sick Room*), dramatically

displayed at the top of the entrance stairway as an introduction to Munch's new work. A view of the various members of Munch's own family, reacting in isolation and bewilderment to the hidden process of dying (the dying person, seated on a chair next to the bed, is not seen by the viewer), proclaimed an awareness of dying, death and decay as the fundamental reality hidden within the portraits, landscapes and other scenes that followed. Death in the painting is the experience of the living, of the survivors, more than of those who die. The experience in *A Death* was Munch's, not his sister's.

Munch's focus on personal experience and subjective responses to existential situations also characterised the paintings and pastels of the Love series. The exhibition listing identified the six images sequentially, to trace the emergence, climax and dissolution of a love relationship: *Dream of a Summer Night, Kiss, Love and Pain, The Face of a Madonna, Jealousy* and *Despair*.[23] Embodied in these images, set against a background of shifting blues or in the landscape of the Oslo Fjord with its meandering shoreline, its softly illuminated summer nights and its dramatically striated sunsets, is a universalised narrative of love that moves from initial flirtations, to the ecstasies of physical consummation, then to the anxieties of jealousy and rejection. The filter for seeing this experience of love was provided by the amorous experiments of Hans Jaeger and the Christiania-Bohème, of Munch and his 'Mrs Heiberg', and by the awareness of death so powerfully portrayed in *A Death*.

The German neo-Romantic poet Richard Dehmel, whom Munch knew in Berlin in 1893, responded to the Love series with a verbal translation of its mood, its overpoweringly suggestive combination of eroticism and fatalism:

Already it is getting dark; come, come home,
come! The leafy mass of the chestnut trees reaches out
toward us like sharpened claws.
It is too lonely here, too hot and damp for us.

Then see: the lines of your hand,
look, they are too much like mine.
You seem, suddenly, so very close to me,
as if known earlier,
perhaps in some other world.

Once I had a sister: she is dead.
Be not so silent, as if you could not speak!
The clouds of evening stream so red
through the young trees,
as if blood-soaked incest threatened us.

Listen! Yes, just as wild and helpless
as the nightingale just sounded,
your heart trembles in my hand.
We know it; for us, that is enough.[24]

Freely adapting Munch's imagery, Dehmel approximated the scenes of the Love series with his references to their suggestive atmosphere, set among dark tree trunks, where the intimate, mysterious encounter of woman and man take place, and by a central pivotal focus on the dramatically blood-soaked sky of *The Scream*. He dedicated the poem to Dagny Juel, a Norwegian music student and disciple of Hans Jaeger. Munch had introduced her to Dehmel and others in his Berlin milieu in March 1893 at about the same time as he wrote to Rohde about his plans for a new series of paintings devoted to exploring motifs of love and death.

Munch had been in Berlin since October 1892, when he arrived to install his works at the Association of Berlin Artists, who invited him to exhibit on the recommendation of one of its Norwegian members. Once actually seen by the Association's members, however, Munch's paintings with their adhesion to Impressionist, Neo-Impressionist and Symbolist aesthetic and stylistic principles offended their generally reactionary artistic mores, and they forced the early closing of the exhibition. Munch's brusque dismissal, considered an offence of etiquette against an invited guest, caused a major scandal in Germany's art world and aggravated existing antagonisms and divisions in the Association. It also provided Munch with unprecedented amounts of publicity, which he exploited by sending his exhibition to several German cities and then reopening it in Berlin late in December (fig. 13).[25] He then became one of the core members of a group of progressive Scandinavian, Polish and German writers, artists, physicians and students who met at Türke's Wine Cellar on the Neue Wilhelmstrasse.[26]

Transformed into a centre for bohemian and artistic debate, the wine bar was renamed Zum schwarzen Ferkel (At the Black Piglet) by the group's most renowned member, the Swedish dramatist August Strindberg, who

derived the name from the old, soot-blackened wine sack hung over the entrance. Other members were Ola Hansson, the Swedish novelist and essayist then most noted for his novella *Sensitiva Amorosa*, which attempted a dissection of various forms of sexual love; Richard Dehmel, whose poem 'My Creed' announced: 'I was conceived during a wild night/ and in the greatest ecstasy of passion!/ And now I yearn to live only for passion,/ just as passion conceived me';[27] and the Polish medical student, socialist newspaper editor and aspiring novelist, Stanislaw Przybyszewski. During the winter months of 1892-3, their discussions of their anti-naturalist literary and artistic efforts attracted a diverse group of writers and painters. From Norway came Christian Krohg and his wife Oda, the young art critic Jens Thiis, the poet Sigbjørn Obstfelder, and the playwright Gunnar Heiberg; from Denmark, the poet Holger Drachman; from Finland, the essayist Adolf Paul; and from Sweden, the botany student Bengt Lidforss. In addition to Dehmel, the Black Piglet's German contributors included the novice poet Max Dauthendey; the literary and art critic Franz Servaes; Hermann Schlittgen, a cartoonist and impressionist painter; Julius Meier-Graefe, an engineering student and would-be novelist who later became one of Germany's pre-eminent art critics; and Dr Karl L. Schleich, the discoverer of local anaesthesia. It was a remarkably gifted group, an unstable amalgam of sensitive male egos little inhibited by intellectual or artistic modesty, highly innovative and extraordinarily jealous of each other's achievements. According to Strindberg's melodramatic characterisation they were: 'A collection of damned souls, because among them there was not a single one who did not drag along the burden of an adverse fate.'[28] Their competition often emerged in a chameleonesque exchange of their professions as painters, writers, musicians and scientists: Przybyszewski performed Chopin piano sonatas, Strindberg practised at being a painter and chemist, and Munch resumed writing his subjective autobiography, his love-inspired recollections of 'Mrs Heiberg' and his death-dominated memories of childhood.

As he turned to his writings he also announced his intention to produce a series of paintings devoted to love and death, and he drew on experiences originating in the milieu of the Christiania-Bohème. These concerns now matched those of the Black Piglet fraternity, who saw women such as Dehmel's or Hansson's wives in their midst only with displeasure, but concentrated their artistic imagery all the more on their subjective and personal experience of sex as a means to analyse the nature of universal woman. Ola Hansson presented their argument most concisely:

For men such as myself, there always comes sooner or later, a time when all real attachments to women become tiresome. There is in all such attachments, no matter what else there may be, so much that is banal and painful. I have had more than enough of that, and now I use women at arm's length, in the study of them and of myself, and from that point of view I can reject all the trivial aspects of sexual relationships while using the pure essence, without all the distasteful accretions.[29]

It was not the material fact of a relationship between a man and a woman that concerned them, but what they saw as the mystery of sexuality and gender – '... the primal substance of life, the content of evolution, the innermost essence of individuality,... the eternally creative, transformatory and destructive,' according to Przybyszewski.[30] Conclusions concerning this eternal feminine substance, moreover, derived from introspection, from the analysis of the men's own egos. The nature of woman, according to Black Piglet logic, could be discovered only in images contained in a man's soul.

Into such abstracted ruminations on sexuality, the powers of woman, and the effects of reproduction – physical, psychological, and artistic – Munch introduced Dagny Juel, a woman, real and palpable. Dehmel dedicated his poetic disquisition on the nature of love to her. Strindberg, Schleich, Meier-Graefe, Servaes and Lidforss were also attracted to her, as was Munch. She appears cat-like, crouching in perpetual readiness for attack, in the memoirs of Adolf Paul:

One day she stepped into the Black Piglet at Munch's side – blonde, thin, elegant, and dressed with a sense of refinement that understood how to hint at the body's sensuous movement but simultaneously avoided giving too precise a definition to its component contours. Thus she tempted a man's robust strength without destroying the fashionable decadent nervous glorification of the head with too much 'unmotivated' fleshiness! A classic, pure profile, her face overshadowed by a profusion of curls! ... A laugh that inspired a longing for kisses and simultaneously revealed two rows of pearl-like white teeth that lurked behind her thin lips, waiting for an opportunity to attach themselves! And, in addition, a primeval, affected sleepiness in her move-

ments, that never excluded the possibility of a lightning-quick attack![31]

Judging from this and other colourful accounts of Dagny's explosive brief reign in the Black Piglet, she encouraged each of her admirers, accepted and rejected their advances repeatedly, and motivated their art. 'She moved freely and proudly among us,' Munch recalled, 'encouraging us, constantly comforting us, as only a woman can, and her presence alone was enough to inspire us. It was as if the simple fact that she was nearby gave us new inspiration, new ideas, so that the desire to create flamed up fresh and new in us.'[32]

The theoretical discussions about sexuality, life and the nature of women quickly gave way to the realities of jealousy, much as had occurred in the Christiania-Bohème. It was a jealousy felt with the intensity only possible among a group of male artists, each convinced of his own superior genius and of his attractiveness to women. In the hysteria of his response, Strindberg surpassed all others, but his feelings of persecution, betrayal, misogyny, and offended innocence were unusual only in their loudness and accusatory consistence. Disgusted and disappointed, Adolf Paul wrote home to Finland:

Strindberg is now the enemy of one of his former friends, and since private slandering seems to be the order of the day among artists in such a situation, so they now reveal each other's small failings to their mutual friends, and since they are failings told with such fantasy, you can imagine how they blow up small bagatelles into formidable major crimes.... I am totally fed up with the humbug and the dirt into which the entire former coterie of friends has dissolved.[33]

The free love and jealousy Munch had witnessed in the Christiania-Bohème seemed to have returned as Dagny took on the role of 'Mrs Heiberg' and expanded on it. Once again he found himself rejected by the woman, although Dagny retrieved him from time to time in her expertly danced round of free love among the surplus of geniuses in the Black Piglet.

The circle broke under the strain. Within two months of her charged entrance to the fraternity's midst, the varied members were fleeing separately and desperately on trains heading north, south, east and west: Strindberg to marry Frida Uhl in Austria, Bengt Lidforss to his waiting parents in Lund, Dehmel and Hansson and Schleich to their understanding wives, and Munch to his paintings. He followed them to exhibitions in Breslau, Dresden and Munich, then retreated to the isolation and safety of Norway. Przybyszewski alone remained in Berlin. There he continued his courtship of Dagny Juel, deterred only when he was arrested on charges of harbouring a fugitive Russian anarchist in his home. The development of a progressive, anti-naturalist art in Berlin seemed to have foundered in the storms of love and jealousy that surrounded Dagny Juel.

But when Munch returned to Berlin, nearly half a year later, he brought with him his painting *A Death*, the six studies inaugurating the Love series, thirteen other new paintings, and over thirty significant watercolours and drawings for his exhibition at 19 Unter den Linden. They were the direct product of the Black Piglet's remarkably fertile explosion.

Munch's series continued to grow during 1893 and 1894. In March 1895, two years after Dagny Juel entered the Black Piglet, Munch exhibited fourteen paintings from the Love series, with an additional closing vignette, at Ugo Barroccio's gallery in Berlin (currently accepted titles, where different, and dates are in parentheses):

1. Mysticism (Starry Night, 1893)
2. Two People (Eye in Eye, c.1894)
3. Two Eyes (The Voice, 1893)
4. Kiss (c.1893)
5. Vampire (c.1893-4)
6. The Loving Woman (Death and the Maiden, c.1894)
7. Madonna (1894)
8. Sphinx (Woman in Three Stages, 1893-5)
9. Separation (c.1894)
10. Hands (c.1893-4)
11. Jealousy (Jealousy-Melancholy, 1891-3)
12. Evening (Evening on Karl Johan, 1894)
13. Insane Mood (Anxiety, c.1893-4)
14. The Scream (1893)
15. Vignette (Metabolism, 1894-5 and 1918)[34]

Munch wrote a brief explanation of his serial concept:

The paintings are moods, impressions of the life of the soul, and together they represent one aspect of the battle, between man and woman, that is called love –

From its beginnings, where it is almost rejected (3 items) – then paintings No. () Kiss, Love, and Pain, where the battle has then begun – Painting No. () The woman who gives herself and

takes on a madonna's painful beauty – the mystique of an entire evolution brought together: Woman in her many-sidedness is a mystery to man – Woman at one and the same time is a saint, a whore, and an unhappy person abandoned.

Jealousy – a long, empty shoreline.

The woman's hair has entwined and entangled itself around his heart.

The man is very disturbed by this battle – (No. 4) insane mood - nature to him appears as a great scream in which blood-red clouds [are] like dripping blood (No. 6 and 7).

No. () (Girl with Hands) Lust. [35]

The series fell into distinct, but interrelated sections: the stirring of erotic love, the initial encounters and sexual embraces, the woman as madonna and mystery, and finally jealousy with its aftermath of despair. In its narration, Love proffered the conclusions derived from events in both the Christiania-Bohème and the Black Piglet. But the series, feverishly produced by Munch during the summers of 1893 and 1894, was also his response to despair. Art was his salvation.

This was Munch's final formulation of the Love series. He exhibited it again in Christiania in 1895 and in Paris in 1897, apparently without change. He painted little during this time and instead devoted himself largely to translating his painted imagery into woodcuts and lithographs, many derived from Love and intended for his never-realised print portfolio, *The Mirror*, also entitled 'Love'.[36] In it, he re-incorporated the death theme that had served to introduce the painting series in 1893, and just as then he allowed it to function as the prelude to love and life. *The Mirror* began with depictions of death, then focused on motifs of metamorphosis – the earth, containing rotting corpses, giving birth to life – before turning to love and, in conclusion, to melancholy and despair. From these final moods of isolation the artwork recounting the process – a man's response to a woman's physical creation of life, her mediation between life and death in the form of a child – emerged.

Munch briefly abandoned the series after 1897 and its Paris exhibition, then returned to it in both prints and paintings in 1899, seeking transitions between the two still separate components of love and death. He exhibited the result, again in March, again in Berlin, in 1902, as Frieze: Cycle of Moments from Life, a total of twenty-two paintings divided into four sections:

Left Wall: Seeds of Love
Evening Star (The Voice, 1893)
Red and White (1894)
Eye in Eye (c.1894)
Dance (Dance on the Shore, c.1900)
Kiss (c.1893)
Love (Madonna, 1894)
Front Wall: Flowering and Passing of Love
After the Fall (Ashes, 1894)
Vampire (1893)
Saint Hans Night (Dance of Life, 1899-1900)
Jealousy (1895)
Sphinx (Woman in Three Stages, 1893-5)
Melancholy (1895)
Right Wall: Life Anxiety
Red Clouds (Anxiety, 1894)
Street (Evening on Karl Johan, 1894)
Autumn (Red Virginia Creeper, 1898)
Last Hour (Golgotha, 1900 [?])
Scream of Anxiety (The Scream, 1893)
Rear Wall: Death
Death Battle (Fever, 1893)
Death Room (Death in the Sick Room, 1893)
Death (Hearse on the Potsdamer Platz, 1902)
Life and Death (Metabolism, 1894-5 and 1918)
The Girl and Death (Dead Mother and Child, c.1893)

With the exception of *The Dance of Life, Golgotha, Red Virginia Creeper, Dance on the Shore*, and *Hearse on the Potsdamer Platz*, the paintings were all conceived by 1895. New additions provided transition, but the major transformation was in Munch's ordering, which now presented death as the final scene, a fatalistic and pessimistic conclusion rather than an ironic but optimistic beginning, as it had been in 1893. The Frieze maintained its final composition in additional exhibitions in Leipzig, where Munch had it photographed (figs. 14, 15, 16), then, with modest changes to fit space limitations, in Christiania (1904) and Prague (1905). Unable to sell the Frieze as a totality, he began to sell its components. It appeared to be a finished project, but it failed to remain an intact statement on the interactions of life, sexuality and death. Instead of working further on the Frieze, Munch obtained commissions from Dr Max Linde and from Max Reinhardt, for serial images that offered variations on the Frieze motifs and, in 1910, he began an alternative project with his paintings for the University Aula in Christiania.

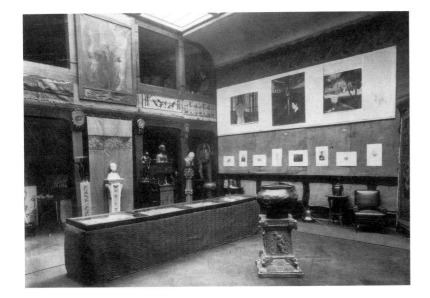

Figs. 14-16 Edvard Munch Exhibition,
P. H. Beyer & Son, Leipzig 1903
Photograph. Oslo, Munch Museum.

Entrance and left wall.

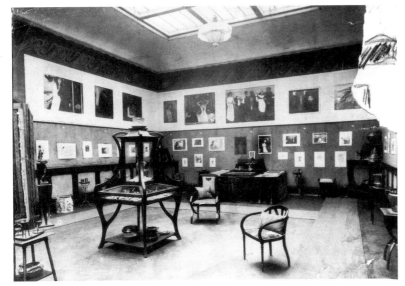

Left wall and wall opposite entrance.

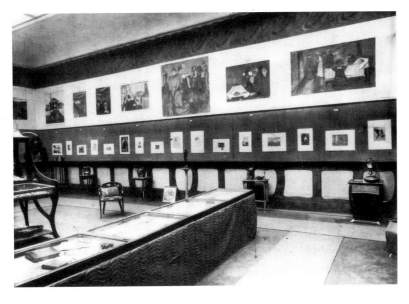

Right wall.

The Frieze project came back to life, however, after the Aula was completed. Having sold many of its components, Munch painted new versions of the series' images, which he exhibited at Blomquist's gallery in Christiania in 1918 as the Frieze of Life. Portions of the friezes he had made for Dr Linde and Max Reinhardt were inserted as alternative means of transition between his motifs of the 1890s. The Frieze took on new configurations. In Ekely, the order of images was shifted around, new versions of older works were painted, and a new central image was added, a reprise of his 1885-6 painting *The Sick Child*. 'I already have four versions of *The Sick Child* in various galleries,' he observed, 'and that is too many And if despite this I have now painted a fifth version for myself, it has to be allowed me, and I have a right to keep it and own it myself. It belongs to the "Frieze of Life" and I can and will never be separated from it.'[37]

Photographed for his 75th birthday, Munch placed his version of *The Sick Child* against the wall behind him. Informally, it thus formed a central base and supporting prop for other Frieze imagery – scenes of love's beginnings above scenes of death, the two themes now running in simultaneous superimposed friezes. The concept of the 1890s was retrieved as life and love rose up from death and dying, but the two also coexisted continuously, rooted in Munch himself and the memories of his childhood. As Munch sat proudly, surrounded by the projections of his youth and their lifelong revisions and resurrections, the Frieze of Life took on its final form.

NOTES

Unless otherwise indicated, all translations into English are my own.

1. Edvard Munch, *The Tree of the Knowledge of Good and Evil.* MS T 2547, Munch Museum Archives.

2. For the significance of the Cologne Sonderbund exhibition in establishing an historical and critical persona for Munch, see Heller 1984, pp. 210-12. A dissertation exploring Munch's career and critical reception during 1914-33 is currently being written at the University of Chicago by Bessie R. Yarborough.

3. *Self Portrait with Palette,* 1926 (Private Collection, Norway; formerly Kunsthalle Mannheim [deaccessioned 1937]); cf. Catalogue No. 109, *Edvard Munch,* Museum Folkwang Essen, 1987, and Kunsthaus Zurich, 1988.

4. *Edvard Munch: Utstilling i Nasjonalgalleriet 1927,* exhibition catalogue, National Gallery, Oslo 1927, p. 27. The catalogue lists the following paintings with their dates; location is the current one:

 73. Anxiety, 1893 (Munch Museum, Oslo)
 74. The Scream, 1893 (National Gallery, Oslo)
 75. Vampire, 1893 (Gothenburg, Art Museum)
 76. Vampire, 1894 (formerly Munch Museum, Oslo)
 77. The Kiss, 1894 (Munch Museum, Oslo)
 78. Madonna, 1894 (National Gallery, Oslo)
 79. Madonna, *c.*1894-5 (Private Collection)
 80. Melancholy, 1895 (Mustad Donation, National Gallery, Oslo)
 81. Jealousy, 1895 (Rasmus Meyer Collection, Bergen)
 82. Ashes, 1894 (National Gallery, Oslo)
 83. Forest Interior, 1893-4 (Private Collection)
 84. The Death Room, 1894 (Munch Museum, Oslo)
 85. The Death Room, 1895 (Munch Museum, Oslo)
 86. Death in the Sickroom, 1894-5 (National Gallery, Oslo)
 87. At the Deathbed, 1895 (Rasmus Meyer Collection, Bergen)
 88. Dead Mother, 1899 (Munch Museum, Oslo)
 89. Dance of Life, 1899-1900 (National Gallery, Oslo)

The Berlin catalogue of the exhibition included the following more concise text for the paintings Nos. 49-59: 'A series of representations, frequently reworked, of human life, suffering and death. Conceived as a frieze for a large room. Twenty-two paintings were shown in 1902 in the Berlin Secession, here there are eleven.'

The eleven paintings, with the dates and titles attributed to them in the catalogue and their current locations, were:

 49. Anxiety, 1893 (Munch Museum, Oslo)
 50. Death Room, 1894 (Munch Museum, Oslo)
 51. Jealousy, 1894 (Mustad Donation, National Gallery, Oslo)
 52. Melancholy, 1894-5 (Rasmus Meyer Collection, Bergen)
 53. Jealousy, 1895 (Rasmus Meyer Collection, Bergen)
 54. The Scream, 1895 (pastel, Private Collection)
 55. Death Room *c.*1893 (Munch Museum, Oslo)
 56. At the Deathbed, 1895 (Rasmus Meyer Collection, Bergen)
 57. Death of the Mother, 1899 (Munch Museum, Oslo)
 58. Dance, 1899-1900 (National Gallery, Oslo)
 59. Hearse on the Leipziger Platz, 1902 (Munch Museum, Oslo)

5. There was little opportunity for editing and correcting the Norwegian catalogue text. The exhibition in Oslo was not planned until after the Berlin exhibition had opened in March and proved successful (over 30,000 visitors

were recorded, a phenomenal number by the standards of the 1920s). The Berlin exhibition closed on 15 May, and Oslo's opened on 8 June. There could not have been more than 4-6 weeks during which the catalogue could be written and printed.

6. The earlier pamphlet incorrectly listed the Blomquist exhibitions as being in 1903 and 1904. There was a Munch exhibition in 1903 at Blomquist's, but the 36 paintings included were not serially arranged into a frieze.

7. Edvard Munch, 'Livsfrisen', 4, in *Livsfrisen* (Kristiania: Private Printing [Centraltrykkeriet], *c.*1918-19 [1922-3?]). The date of this pamphlet is not certain. The pamphlet binds together three previously separate brochures, 'Livsfrisen', 'I anledning kritikken', and a selection of critical essays. Usually it is dated 1918, in accordance with the interior evidence of its text, parts of which appeared in the newspaper *Tidens Tegn*, where reference is made to the 'thirty years' since Munch first thought of Frieze motifs, i.e. 1888-9, and to coincide with the exhibition of Frieze paintings at Blomquist's in 1918. However, the 1927 catalogue notes 1925 as the date of publication. Since the name of Norways's capital was changed from Kristiania (it had changed from Christiania in 1897) to Oslo at the end of 1924, this date is unlikely, given the pamphlet's imprint. It seems probable that the individual brochures date from *c.*1918, but that Munch had them bound together later, placing the image *Omega and the Flowers* on its cover, an image he also used for the poster of his important exhibition in Zurich in 1922.

8. 'I anledning kritikken' (see note 7), pp. 6-7.

9. Also compare the photograph, taken at the same time, showing Munch standing in front of his sofa and before Frieze images. Frontispiece, exhibition catalogue, Essen/Zurich 1987-8 (see note 3).

10. Undated notation in *Livsfrisen*. Munch Museum Archives. As cited by Heller 1969, pp. 70 and 81.

11. The identity of 'Mrs Heiberg' was first established by Trygve Nergaard in his thesis, 'Refleksjon og visjon – Naturalismens dilemma i Edvard Munchs kunst, 1889-1894', University of Oslo, 1968, p. 77 and n. 173.

12. MS T 2770 (EM II), Munch Museum Archives. The entry is undated, but follows immediately upon one dated 4 February 1890.

13. Hans Jaeger, as cited by Carl Naerup, *Illustreret norsk Literaturhistorie*, Kristiania 1905, p. 233.

14. Hans Jaeger, *Syk kjaerlihet*, reprint, Oslo 1969, p. 49,

15. MS T 2759 (EM III), Munch Museum Archives.

16. MS T 2771, Munch Museum Archives.

17. For an account of Munch's response to his father's death and its relevance for his work, see Heller 1978.

18. Munch 1949, pp. 89-90. The memoir is dated 1890 by Inger Munch, but was probably written somewhat later, *c.*1891-3. In the text, Munch has fictionalised his own name into Karleman, his father into the Captain, and his sister Sophie into Maja.

19. Nos. 22-50. Series 'Ein Menschenleben'. *Eduard Munch Gemäldeausstellung*, exhibition catalogue, Berlin, Unter den Linden 19 [1893]. Several drawings apparently belonging to this series were also included in Munch's 1892-3 exhibition at Berlin's Equitable Palace and can be seen in Munch's publicity photograph of the exhibition (Heller 1984, p. 100).

20. Heller 1984, pp. 87-90.

21. Draft of a letter to Jens Thiis, *c.*1933. Munch Museum Archives. Cited in Heller 1984, p. 103.

22. Letter to Johan Rohde, undated (*c.* Feb.-March 1893). As cited by Heller 1984, p. 103.

23. *Gemäldeausstellung* (see note 19), No. 4 a-f. The present-day titles are: *The Voice, Kiss, Vampire, Madonna, Melancholy-Jealousy (The Yellow Boat)*, and *The Scream*. Of all these motifs, several versions exist from the 1892-3 period, so that it is not possible to state with absolute certainty which works were exhibited. Moreover, critics' discussions of the exhibition suggest that several of the series paintings were not finished, but rather presented in the form of pastel studies.

24. Richard Dehmel, 'Unsere Stunde', in *Lebensblätter*, Berlin 1895, p. 57.

25. For more extended discussions of the 'Munch Affair', see Heller 1969, pp. 175-91, and Peter Paret, *The Berlin Secession: Modernism and its Enemies in Imperial Germany*, Cambridge, Mass., and London 1981, pp. 49-54.

26. For the most extensive consideration of the Berlin bohemian group, see Carla Hvistendal Lathe, 'The Group *Zum schwarzen Ferkel*: A study in Early Modernism', unpublished Ph.D. dissertation for the University of East Anglia, Norwich 1972 , and Lathe 1979. See also George Klim, 'Die Gestalt Stanislaw Przybyszewskis im Rahmen der deutschen Literatur der Jahre 1892-8, mit besonderer Berücksichtigung seiner Weltanschauung', unpublished Ph.D. dissertation, Australian National University, Canberra 1970. Unless otherwise indicated, I base my review of the Black Piglet on these two scholars' fundamental studies.

27. Richard Dehmel, 'Bekenntnis', in *Erlösung*, Berlin 1891, as reproduced in *Gesammelte Werke in drei Bänden*, Berlin 1913, I., p. 11.

28. As cited by Göran Söderström, *Strindberg och bildkunsten*, Stockholm 1972, p. 21.

29. Ola Hansson, *Sensitiva Amorosa*, Uppsala 1957, pp. 3-4.

30. Przybyszewski 1893, p. 6.

31. Adolf Paul, *Strindberg-minnen och brev*, Stockholm 1915, pp. 90-1.

32. Edvard Munch, 'Dagny Przybyszewska', *Kristiania Dagsavis*, 25 June 1901.

33. Adolf Paul, Letter to Axeli Gallèn-Kallela, *c.*24 June 1893, as cited by Söderström, p. 400 (see note 28).

34. *Sonder-Ausstellung des Edv. Munch (Christiania)*, Berlin, Ugo Barroccio, 3-24 March 1895. The series was previously exhibited in Stockholm, Konstföreningens Lokal, October 1894.

35. MS N 30, Munch Museum Archives. The numbering in this manuscript does not correspond to that of any known exhibition; however, the text appears to have been written for the Berlin exhibition of 1895. Up to the title *Sphinx*, there are eight paintings listed in the same order as in the Berlin exhibition brochure. Moreover, if the exhibition listing is divided into two sections, the first ending with *Sphinx*, and if the painting *Hands* is excluded (justifiable insofar as it is an addition, not an integral part of the handwritten text), the numbers again correspond, with *Insane Mood* as No. 4.

36. Bente Torjusen, 'The Mirror', in *Edvard Munch: Symbols & Images*, exhibition catalogue, Washington, D.C., National Gallery of Art, 1978-9, pp. 213ff. See also Eggum 1990.

37. Edvard Munch as quoted by Ingeborg Motzfeld Løchen, 'Mine samtaler med Edvard Munch', in *Edvard Munch som vi kjenter ham: Vennene forteller*, Oslo [1946], pp. 66-7.

Munch and Modernism in Berlin 1892-1903

CARLA LATHE

Telegram from Berlin, 9 November: Art is endangered! All true believers raise a great lament! Call forth the rescue squads! Even Anton von Werner, like George the Dragon Slayer, has ridden out to battle against that Nordic dauber and poisoner of art Edvard Munch, and from overworked critics' columns drips the wisdom and comes the horror that fills our papers. And what are the grounds for this lamentation? An Impressionist, and a mad one at that, has broken into our herd of fine, solidly bourgeois, artists. An absolutely demented character.

With these words, the *Frankfurter Zeitung* sardonically announced in November 1892 the debut of the 29-year-old Norwegian artist Edvard Munch, who had been invited to hold an exhibition under the auspices of the Verein Berliner Künstler (Association of Berlin Artists), the most influential organisation of artists in imperial Berlin. He had been recommended by a Norwegian member of the committee, Adelsten Normann, who had seen Munch's successful and well-reviewed exhibition in Norway the previous summer.

In Norway, Munch was considered the most radical of the younger generation of painters (fig. 17) and was known to be a friend of the anarchist writer Hans Jaeger, whose publications recommended a philosophy of free love and self-analysis. Jaeger's portrait was among the 55 pictures Munch exhibited in Berlin, which included street scenes of Paris and Oslo, landscapes, images of death, portraits and figure studies. In a discussion about Munch's work, the Swedish critic Ola Hansson declared:

...he does not paint the image of nature itself but the image in his memory, not scenery directly and at first hand, as it stands there in the outer world, but its subjective likeness, which for longer or shorter periods of time is etched and burnt into his retina and into his soul and constantly springs out of the darkness in garish colours under his eyelids as soon as he shuts his eyes.[1]

Hansson was among the many critics who remarked that Munch's procedure was more characteristic of literature than of painting, and he compared him with modern poets such as Max Dauthendey, who wanted to reveal the unconscious through memories. Munch's soul-searching, however, achieved a synthesis of psychology and art that was new and experimental.

Munch's exhibition at the Verein Berliner Künstler provided the most extreme contrast to its traditional, staid portraiture, typified by that of its director, Anton von Werner, whose paintings according to one critic consisted of 'generally twelve to sixty endlessly dry and stiff gentlemen posing in uniform, remarkable for their lack of

Fig. 17

Christiania-Bohème I 1895

Etching and drypoint, 34.2 x 47.5 cm (13½ x 18¾ in.)
Oslo, Munch Museum.

expression. They could be an advertisement for a regimental tailor or an illustration for regulation army dress.'[2]

The more radical members of the Association probably hoped to provoke a confrontation, anticipating the contempt with which Munch's work would be received by their more conservative colleagues. Inevitably, Munch's exhibition brought into the open the conflict between opposing groups of artists in Berlin. It was recognised as a test case and its aftermath created new opportunities for other modernist exhibitions in Berlin.

When Munch's exhibition opened on 5 November 1892, von Werner's supporters were horrified not so much by the subject matter as by Munch's technique. At an extraordinary meeting of the Association on 11 November, it

was decided by a slim majority of fifteen votes to close Munch's exhibition, only six days after it had opened. The meeting developed into an angry riot and about 80 members of the Association who voted against the closure fought their way out of the building, led by one of the Academy's Professors.[3] The incident was reported by the press: 'When the voting about the Munch case had ended, the famous engraver Professor Köpping came forward and exclaimed in disgust "now no respectable person can continue to belong to the Art Association".'

After the failure of their attempt to negotiate change within the Association, the members who had demonstrated against the closure of Munch's exhibition – including engravers, sculptors and architects as well as painters

– formed a separate group, the Freie Vereinigung Berliner Künstler (Free Association of Berlin Artists). In January 1893, three of the Academy's professors, August von Heyden, Hugo Vogel and Franz Skarbina, labelled as Secessionists by the press,[4] were forced to resign their teaching posts as a result of von Werner's hostility and pressure from other academicians. In June of that year the Free Association held their own exhibition, which included works by Munch, Strindberg and Käthe Kollwitz that had previously been rejected by the Academy's jury. This jury-free exhibition, and others held annually from 1892 to 1897 by the group Die Elf (The Eleven), openly challenged the authority of the Verein Berliner Künstler and the Berlin art establishment.

The need to establish an alternative to the Academy's annual exhibition and to break away from the constraints it imposed led to the founding of the Berlin Secession in 1898. Walter Leistikow, a former member of the Verein Berliner Künstler who had befriended Munch, became the driving force. Max Liebermann was nominated as president and in the spring of 1899 the Berlin Secession, established in its own building, launched an exhibition which included works by Corinth, Liebermann, Slevogt, Trübner, Hodler and others. In 1901 they exhibited the French Impressionists and in 1902 Munch was invited to exhibit the paintings which later formed the Frieze of Life.

The intimate and subjective art that Munch introduced to Germany during the first decade of the twentieth century soon found a sympathetic audience and German Expressionism became a realistic alternative to the nationalist art favoured by the Prussian authorities. The latter suspected the Secessionists of being anarchists and traitors to their country. Nevertheless, avant-garde groups such as Die Brücke and Der Sturm were able to exhibit in Berlin, which became an international centre for modernism.

When Munch first arrived in Berlin it was already an important literary centre, with excellent theatres and publishers. Scandinavian literature, particularly work by Ibsen, was extremely popular among the more progressive Germans and the Berlin drama society Die freie Bühne, under Otto Brahm, opened its doors on 29 September 1889 with Ibsen's banned production of *Ghosts*. In 1890 it staged Strindberg's *The Father* and in 1892 *Miss Julie*. According to Max Halbe, Berlin society was divided between supporters of Ibsen and Strindberg (fig. 18).[5] In 1890 Brahm

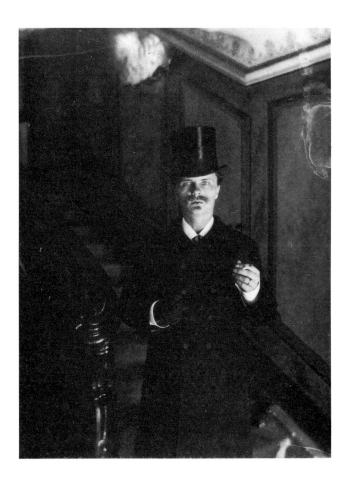

Fig. 18 August Strindberg 1886
Carte de visite photograph
Stockholm, Strindberg Museum.

published the society's first magazine, also called *Die freie Bühne*, which included translations of Scandinavian literature by Kielland, Hansson, Garborg and an abridged version of Hamsun's *Hunger*. Through *Die freie Bühne* and in association with *Die Zukunft*, Ola Hansson was able to raise financial support for Strindberg to come and live in Berlin from September 1892. Two months later, following the scandal of his exhibition, Munch was adopted by Berlin's literary avant-garde.

Writers tried to foster modern art by channelling reviews and articles through the existing literary magazines and in December 1892 Walter Leistikow's article about the 'Munch Affair' was published in *Die freie Bühne*:

He who can tell, paint, sing such things, has a poet's disposition and looks at the world, which he loves, with a poet's eyes. But great poets and painters are seldom understood at first, seldom

Fig. 19
Stanislaw Przybyszewski *c.*1893
Oil and pastel on board
62 x 55 cm (24¾ x 21¾ in.)
Oslo, Munch Museum.

honoured. They can be glad if they are not shown the door and politely thrown out, like Mr Munch ...

Stanislaw Przybyszewski (fig. 19) published an article on Munch in the same journal, now entitled *Die neue Rundschau*, in 1894, and Ola Hansson's mildly sympathetic review of the exhibition appeared in *Die Zukunft*. Like Julius Elias, editor of an annual publication on German literature, the editors of these magazines were liberal, cosmopolitan and interested in fin-de-siècle Scandinavian modernism.

The Swedish literary critic and author Ola Hansson probably had the most profound influence on Munch's development in Berlin. An authority on Nietzsche, Hansson had also written numerous articles on modern French, Russian and Scandinavian writers, as well as essays on Max Klinger, Arnold Böcklin and the French Symbolists.[6] His wife Laura Marholm translated his articles into German and the essays introduced many German writers to foreign literature and promoted Nietzsche abroad. Under Hansson's influence, Dauthendey and Przybyszewski pursued their interest in psycho-physiological revelations, which

they applied to Munch's art when they published their modernist aesthetic theories.

Several other writers, including Franz Servaes, considered themselves better equipped than art critics or historians to interpret the new modernist developments. Servaes believed that scholarly research was less important than empathy with the artist's temperament and he maintained that the creative writer could literally interpret 'the painter's psyche from within the poet's psyche'.[7]

The value of this subjective criticism of Munch's work by modernist writers is debatable. They established his reputation on literary values, making few objective assessments, analysing only the emotional content of his imagery, which they liberally translated into their own idiom. The more Munch was rejected by the official press, the more stridently he was defended by the literary world. Writers who challenged the establishment's values found Munch's radical approach to his art comparable to the approach of Nietzsche, Ola Hansson, Dehmel and the French Decadents, whom they themselves admired; Munch's art, therefore, became identified with literary preoccupations.

Many of these writers met at Strindberg's favourite wine bar Zum schwarzen Ferkel (The Black Piglet), on the corner of Neue Wilhelmstrasse and Unter den Linden. Gunnar Heiberg, who had known Munch in Norway in the 1880s, introduced him to its noisy drunken coterie: the literary avant-garde which included the Pole Przybyszewski; the Germans Richard Dehmel, Julius Meier-Graefe, Paul Scheerbart and Peter Hille; the Swede Adolf Paul; and the Dane Holger Drachmann.[8] Apart from Strindberg, Meier-Graefe and Przybyszewski were Munch's closest associates. At that time Przybyszewski was a medical student interested in neurology but he was also fascinated by the occult and by Satanism. His book of collected essays on Nietzsche, Chopin and Ola Hansson (*Concerning the Psychology of the Individual*) was published in 1892. Julius Meier-Graefe studied engineering in Berlin from 1890 and started writing in 1893 with the intention of establishing a literary position in Berlin.[9] Servaes described him as a young man of means with some writing ability, but he had two faults: he treated literature and art like sport, and he deliberately made compromises for business reasons.[10]

During the winter of 1888-9 Strindberg had corresponded with Nietzsche, who sent him copies of *Zur Genealogie der Moral* and *Götzendämmerung*. Strindberg's admiration for Nietzsche was shared by other modernist writers in Berlin who rated psychology and personal intuition higher than aesthetics or morality. Their curiosity about unconscious layers of perception and the illusion that individuals were an arena for conflicting powers brought some of the writers and artists perilously close to losing their sense of reason and of the value of life. Brooding mainly on feelings of pain, loss and injustice, they used their private experience to create a polemic art. During the 1890s Strindberg, Munch and Przybyszewski expressed notions of the dramatic struggle between good and evil, darkness and light which recall the ancient Manichaean heresy. Despite their religious upbringing, their vanity and fondness for intellectual athletics made them callous, which led Przybyszewski to declare: 'For that which is normal is stupidity, and "degeneration" is genius.'[11]

Nietzsche's dictum that frenzy, *Rausch*,[12] was the physiological precondition of art was exaggerated by Przybyszewski, who demanded that art should also produce frenzy.[13] His Polish friend Wysocki recalled that when Przybyszewski played Chopin on the piano at the Black Piglet he whispered, prayed and recited poetry to himself.[14] With a face contorted in an expression of agony, his fingers hit the keys with indescribable fury. According to Servaes: 'everyone looked as if they had been electrified. Some screamed, others cast themselves onto their knees, some ran around the room as if seized by a higher spirit (or folly).'[15] Munch later wrote about the performance with uncharacteristic effusion.[16] However, their preoccupation with this state of chaos encouraged a creative licence to destroy art, and people, which demonstrated no less contempt for others than did the ruling authorities in Berlin.

Strindberg, meanwhile, believed in a renaissance of music in which harmony would be rejected. In the mid-1890s he asked a friend to untune his piano, then play a well-known melody on it and so produce a new art based on chance.[17] He reciprocated Przybyszewski's piano-playing by singing dissipated student songs which he accompanied on his untuned guitar. This discordant duo echoed the bizarre and emotional tendencies of the group and inevitably Munch's work of this period reflected a similar dissonance. Interest in the psyche and nervous diseases was very topical and it became quite fashionable to suffer from 'bad nerves'. Whereas the French writer Zola had defined a work of art as 'a corner of nature seen through a temperament', Przybyszewski wrote that it should be 'a corner of nature as "felt" through someone's suffering soul'.[18]

Munch had encountered similar attitudes in Norway when he associated with Hans Jaeger and the Christiania-Bohème. His semi-autobiographical diaries reflect the paintings he produced in the 1890s, and he was encouraged by his associates in Berlin to record his innermost thoughts and feelings, which he later transposed in the series of paintings known as the Frieze of Life. In March 1893 Munch wrote from Berlin to the Danish artist Johan Rohde that the series would be concerned with love and death and that several of his earlier paintings, including the man and woman on the beach, the red sky and the picture with the swan, would belong to it. He added:

As bad as art in general is here in Germany, I want to say one thing: it has the advantage of having produced some artists who so surpass all others that they are unique – for example Böcklin – whom I'm inclined to rank above all contemporary painters – Max Klinger – Thoma [sic] – Wagner among musicians –

Nietzsche among the philosophers. France has an art that ranks above the German, but no greater artists than those mentioned.[19]

In December 1893 Munch opened a new, radically different exhibition in Berlin, which included six paintings grouped together as a series on the theme of love, ending with *The Scream*. Some critics thought that Munch's work had deteriorated and the Norwegian newspaper *Morgenbladet* reported that people had asked if Munch painted with his hands or his feet. In 1893-4 his imagery became more explicitly erotic. *The Voice, Death and the Maiden, Madonna, Vampire, Separation, Puberty, Rose and Amelie, Woman in Three Stages* and *The Hands* all depict the stages and effects of love on the psyche. Ola Hansson's and Przybyszewski's fictional works, Dehmel's poetry, Strindberg's and Heiberg's plays contained parallel themes, but these writers were among the few to appreciate the change in Munch's work at the time.

Munch shared his associates' interest in psychical experience and is said to have enthusiastically read books on the occult by Aksakow and Swedenborg.[20] Some of the group even participated in a spiritualist seance at the studio of the sculptor Franciszek Flaum, hoping that a ghost would leave imprints of his feet on wet clay.[21] While Strindberg began theorising about an art founded on chance, Munch introduced new elements to his imagery in which, for example, the woman in *Madonna* is depicted surrounded by an aura, and a menacing shadow looms over the figure in *Puberty*. His figures are not projected against a static, inert background but hover in ambiguous, fluctuating spaces. Munch later explained the symbolism of his images by referring to the contemporary conviction that invisible rays and vibrations passed between people. Munch, Strindberg and Przybyszewski all believed that recent technical advances and experimentation supported the intuitive dimension of their art. Munch said of his painting *Separation*, 'I symbolised the connection between the divided pair with the help of her long wavy hair...The long hair is a sort of telephone wire.'[22]

In 1894 Przybyszewski reprinted his review of the Love series in the first book on Munch, *Das Werk des Edvard Munch*, with contributory essays by Franz Servaes, Willy Pastor and Julius Meier-Graefe which overlooked his less sensational images. Przybyszewski applied his own terms to Munch's new pictures and the painting 'Love and Pain' was retitled *Vampire*, a decision Munch later regretted; he

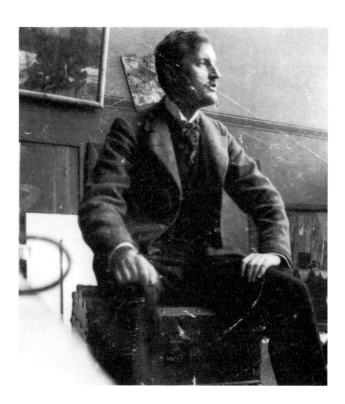

Fig. 20
Edvard Munch in Berlin 1902
Photograph
Oslo, Munch Museum.

explained: 'it was in the time of Ibsen – and if people were really bent on revelling in symbolist eeriness and called the idyll vampire, why not ?'[23]

However much Munch may later have wished to distance himself from contemporary literary aspirations, he became identified with his friends' form of modernism and developed it as part of his self-image. The writers who lionised him were influenced by Nietzsche and inspired by Dostoevsky, and they cast him in the mould of an anarchist and exponent of Nordic anxiety and introspection. Meier-Graefe and Przybyszewski praised Munch for expressing what they believed to be important areas of human awareness, and Munch appears to have approved of their articles. In the winter of 1908-9 he even said that Meier-Graefe had written about him with more understanding than anyone else, but this remark was made while he was convalescing at Dr Jacobsons's clinic in Copenhagen.[24] According to Kenworth Moffett, Meier-Graefe had written little about Munch 'and in both cases there is a highly literary approach and little concern about the works of art themselves.'[25]

The critics Andreas Aubert in Norway and Thadée Natanson[26] in Paris considered Munch's literary associations in Berlin detrimental to his artistic development, and the contemporary writer Arthur Holitscher believed that Meier-Graefe, Przybyszewski and Pastor did Munch's art a disservice: 'They seized their enthusiasm with both fists and rammed him at the public's head.'[27]

Many of the Germans who were attracted to Munch's work were interested in spiritualism and in Nietzsche, and only identified with his images of heightened emotion. His art was thus associated primarily with aggression and emotional instability, but this is not representative of his life and work as a whole. In 1892 his exhibition at the Verein Berliner Künstler included scenes of Norwegian life which showed no neurosis. He continued to create monumental images of people living and dying, but also more direct studies of landscapes, children, workers and women washing or bathing. It may have been with some relief that he regularly withdrew from the intellectual circles in the cities to spend the summers at Åsgårdstrand, where the people and landscape provided the material for some of his most lyrical and characteristic pictures. It seems significant that he admitted to Albert Kollmann in a letter in 1904 that he felt well in Åsgårdstrand, ill in Berlin.[28] However, the preference of Munch's literary friends for his more neurasthenic works is perhaps understandable when one recalls that Munch's initial plan for his 1893 Love series declared that: 'The paintings are moods, impressions of the life of the soul, and together they represent one aspect of the battle between man and woman that is called love.'

NOTES

1. Ola Hansson, 'Vom Künstlerischen Schaffen', *Die Zukunft*, 3, 1893, p. 321.

2. Quoted by Harry Count Kessler, 'Herr von Werner', *Kunst und Künstler*, 2, 1904.

3. Kruse's memories were published by Erich Büttner in his postscript 'Der leibhaftige Munch' to the German translation of Thiis 1934, p. 85.

4. *Weser Zeitung*, no. 16560, Bremen, 9 January 1893.

5. Extract from Halbe's *Jahrhundertwende* (Danzig 1935), published in *Strindberg im Zeugnis der Zeitgenossen*, ed. Willy Haas, Bremen 1963, p. 221.

6. See Stellan Ahlström, 'Ola Hansson som konstkritiker', *Konstrevy*, 5-6, 1958, pp. 234-9.

7. 'Kunstkritik und Berufskritik', *Die neue Rundschau*, 5, 1894, p. 84.

8. See J. Bab, 'Die neuromantische Bohème', *Die Berliner Boheme, Grosstadt-Dokumente*, ed. Hans Ostwald, II, Berlin and Leipzig 1904, and C. Lathe, 'The group Zum schwarzen Ferkel: a study in early modernism', unpublished PhD thesis, University of East Anglia, 1972, p. 30.

9. 'Vom jungen Meier-Graefe', *Julius Meier-Graefe, Widmungen zu seinem 60. Geburtstag*, Munich/Berlin/Vienna 1927.

10. 'Der erste Jahrgang des "Pan"', *Die Zeit*, no. 94 , Vienna, 18 July 1896, p. 43.

11. *Auf den Wegen der Seele*, Berlin, 1897, p. 47.

12. 'Zur Psychologie des Künstlers', *Streifzüge eines Unzeitgemässen, Götzendämmerung* (1889), *Nietzsches Werke* 8, ed. Fritz Koegel, 12 vols., Leipzig 1896, pp. 122-3.

13. *Zur Psychologie des Individuums*, I, Berlin 1892, p. 47.

14. Alfred Wysocki, *Sprzed Pol Wieku*, Cracow 1956.

15. 'Jung Berlin III', *Die Zeit*, 5 December 1896, p. 155.

16. 'Mein Freund Przybyszewsk', *Pologne Litteraire*, 15 December 1928, p. 2.

17. Related by Sigurd Wettenhovi-Aspa, *August Strindberg intim, Aufzeichnungen eines Zeitgenossen*, Helsinki 1936, p. 28.

18. Stanislaw Przybyszewski, preface to Danish edition of *Over Bord*, Copenhagen 1896 (copy in Munch's library).

19. Letter in the Munch Museum Archives, Olso.

20. Przybyszewski 1965, p. 222.

21. Peter Hille, 'Unter Geistern', MS.10147 in the Peter Hille archive, Stadt-und Landesbibliothek Dortmund.

22. Quoted by Hougen 1968, pp. 11-12.

23. Quoted by C. Gierløff, 'Kampår', *Edvard Munch som vi kjente ham. Vennene forteller*, Oslo 1946, p. 133.

24. See H.P. Rohde, 'Edvard Munch pa klinik i København', *Kunst og Kültur*, 46, 1963, p. 266.

25. *Meier-Graefe as Art Critic*, Munich 1973.

26. Aubert in *Morgenbladet,* 1 November 1895, and Natanson in 'Correspondence de Kristiania', *La Revue Blanche*, 59, November 1895.

27. *Die Zeit*, 17 September 1898, p.186.

28. Quoted by Krieger 1978, p. 11.

The Frieze of Life Graphic Works

GERD WOLL

In October 1894, Munch exhibited his series of Love motifs in Stockholm. Shortly afterwards he returned to Berlin, where he began converting a number of the most important paintings from the series into graphic images, probably in the hope that this would provide an income. Munch had no money of his own, and at that time selling paintings was still more of a speculative dream than a realistic prospect. However, it would have been equally important to him to distribute his prints widely and thus spread his artistic message.

Ever since the scandalous exhibition in Berlin in the late autumn of 1892, Munch's paintings were in demand by a large number of art dealers, who wanted to exhibit his controversial and much-maligned work. During the following years, therefore, he enjoyed many exhibitions in Germany and Scandinavia, making his living largely from the entrance fees. He made several more versions of his major paintings, but he soon realised that the great advantage of prints was that they could be exhibited and sold in large numbers in several places at the same time.

In many of the notes he wrote during his long life Munch stressed the importance of the artist's role as mediator and redeemer. He believed that the spirit of the artist lived on through his work, and that even after his death the artist could help others gain greater insight into their own lives and problems – provided he was able to express in his pictures his own sufferings, ideas and feelings in a way that enabled other people to understand and relive them.

Munch chose to combine some of his paintings into series or friezes so that the relationship between the pictures could be expressed more clearly. Later in life he applied this idea to his public murals to ensure that his work did not disappear 'like a scrap of paper into some private home where only a handful of people will see it.'

In June 1895, Julius Meier-Graefe, one of the founders of the German periodical *Pan*, published a portfolio of eight intaglio prints by Munch. Although the portfolio contained only a single motif from the Love series, that of *Two People*, Meier-Graefe states in the accompanying leaflet that Munch was planning to produce prints of the series, but he also drily added: 'Hopefully, he will become a professor before that; he will definitely not become one afterwards.' By this he doubtless meant that these particular pictures were too uncompromising for a broad public, which may explain his careful selection of the prints to be

included in the portfolio. Most of these were replicas of earlier paintings. Among them were *The Sick Child*, *Girl by the Window*, *Moonlight at St-Cloud*, and a few that were more daringly anchored in the bohemian café society of the time: *Tête-à-Tête*, *Christiania-Bohème I* and *The Day After*. Noticeably absent were the drypoint of *Madonna* with its border of sperm cells and foetus, which might have caused a degree of public distaste, and *Death and the Maiden*, which has similar decorative elements. Among the Love motifs based on his paintings, Munch in all probability also made etchings of *Attraction* and *The Voice* before the Meier-Graefe portfolio was published, whereas *The Kiss* and *Woman* were possibly not made until later that same year.

It is not known exactly when Munch began to take a serious interest in producing lithographs: *Puberty* was probably created as early as 1894, and he certainly made two lithographic portraits of Harry Graf Kessler in the spring of 1895. These are all carefully drawn on the stone with lithographic chalk, and it would be natural to assume that the more confident lithographs, such as *Self Portrait with Skeleton Arm*, *Madonna*, *Vampire* and *The Scream*, in which he also made more daring use of lithographic ink, were finished a little later – probably after the publication of the Meier-Graefe portfolio, and perhaps as a direct result of his plans to make print versions of the pictures in the Love series.

From February 1896 Munch lived in Paris, and during the year or so that he spent in the city he was able to concentrate on producing prints, and experiment with the new and exciting developments in modern printmaking methods taking place there – particularly in colour lithography.

In the April issue of the periodical *L'Aube*, a small notice stated: 'Our collaborator the painter Edvard Munch, who has such strange pictures at the Salon des Indépendants, is negotiating with "Le Nouveau" [Bing] to open an exhibition of his work. The well-known publisher Mollard will publish some of his latest prints in a collection of master lithographers.'

On 19 May 1896 an exhibition of Munch's paintings opened at Bing's Salon de l'Art Nouveau. According to the catalogue, of which we have only a transcript, Munch apparently designated ten of his paintings as belonging to a series named *L'Amour*, and he grouped fourteen of his etchings and lithographs into a similar series. Mollard (which was also the name of one of Munch's Parisian friends) is probably a misprint for Vollard, a young dealer who had recently established his own gallery and invested considerably in the publication of modern prints. In the portfolio called *Les Peintres-Graveurs*, published by Vollard in the spring of 1896, Munch was represented by a two-colour print of the lithograph *Anxiety*. However, the announcement in *L'Aube* could have been intended as advance publicity for a more comprehensive publication of Munch's lithographic output.

The Bing exhibition included only a small number of new prints executed in Paris, but among earlier ones we find both *Vampire* and *Madonna*, exhibited in two versions, one of which was hand-coloured. This suggests that despite the great expressive energy that Munch had achieved in his strong, black lithographs, he missed working with colour. From 1896 to 1897 many of his graphic works, including his monochrome prints, show how he experimented with colour to enhance the impact. A number of them are printed in colours other than black, and several are on coloured paper. Furthermore, a large proportion of his prints from this period are hand-coloured in watercolours or gouache, an indication perhaps that he was planning to develop them into multicolour prints. However, such a process was both time-consuming and above all expensive, and Munch could afford to execute only a limited number of lithographs as multicolour prints.

One of the most important prints he made in Paris was the coloured version of *The Sick Child*, printed by the famous printer Auguste Clot and executed in a large number of colour combinations. Munch must have drawn the motif on two different stones, which were then printed separately as independent prints, as well as used together to make multicoloured prints. One of the key stones, which is printed in either black or red, is drawn with lithographic chalk, whereas the other seems to be painted with diluted ink; it also shows the energetic use of a scraper. Prints from this particular stone have an almost physical surface texture, resembling that of the original painting, in which the paint was scraped off and reapplied many times over. In the colour prints, this stone is most often printed in a light tone of grey or blue. The stones for the other colours have been worked with chalk or ink in a more conventional manner and were used to print many different colour

combinations. For the most complicated prints, Munch must have used at least five stones.

Contrary to what later became common practice, Munch rarely numbered his prints in particular editions, and would never allow his stones or blocks to be obliterated after printing. He went to great lengths to keep them so that he could make reprints whenever he wished and could afford to do so. The lithographic stones normally belonged to the printer, who preferred them to be ground down and re-used. If the artist wanted to keep them for reprints, he would have to pay the printer rent to keep the stones in storage with their motifs intact.

Before leaving Paris in 1897, Munch signed an agreement with Clot in which he undertook either to buy all 23 stones stored there for 197 francs or to pay a monthly rent of 25 francs. In Clot's files there are letters from Munch regarding the rent for September and October, and the Munch Museum in Oslo has a receipt from Clot as late as March 1898. In early May of that year, Munch returned to Paris for a month and may have made other arrangements for the stones during that visit.

Surprisingly, the stones for *The Sick Child* were not among the ones he so carefully retained. Nearly a hundred versions of this lithograph are known today, and there is every probability that they were all printed by Clot in Paris in 1896-7. An inscription on one of the prints suggests that the stones were ground down afterwards.

It is difficult to see any reason other than a financial one why Munch did not keep the stones of *The Sick Child*. In those years he was constantly short of money and Clot's storage fees would have represented a heavy financial burden. In a draft letter to Meier-Graefe, written shortly after his return to Norway in the summer of 1897, Munch complained that all his studies and his lithographic and woodcutting equipment were being held at the railway station because of an unpaid freight bill for 200 marks. In his letter he offered Meier-Graefe fifty copies of a possible hundred prints of *The Sick Child* in return for an advance of 400 marks. In which case, the edition would be numbered and published, indicating that Munch undertook not to print more copies later.

In the autumn of 1896, Munch appears to have become preoccupied with woodcuts, a technique in which he was able to prepare the block himself right up to the moment of printing, without the assistance of a professional printer.

Fig. 21
Man's Head in Woman's Hair 1897
Lithographic poster printed in red, green, black and gold
63.5 x 47 cm (25 x 18½ in.)
Oslo, Munch Museum.

He could also print trial proofs on his own – if need be without using a proper press. This made the process much less expensive than lithography, and he must have soon realised that woodcuts offered new and exciting possibilities for multicolour prints. It was probably in 1897 that Munch developed his unique jigsaw puzzle technique of cutting the wooden blocks into pieces with a fretsaw; he then inked the pieces individually, put them together again to form the motif and printed them as a single block.

One of his first wooduts made with this technique is thought to have been *Man's Head in Woman's Hair* (cat. 37), an image he used for a poster for his Diorama Hall exhibition in Christiania in the autumn of 1897 (fig. 21). This was Munch's first exhibition poster and it was executed in a technically ingenious way: having made a

Fig. 22
Funeral March 1897
Lithograph, 55.5 x 37 cm (21¾ x 14½ in.)
Oslo, Munch Museum.

frottage of the main motif onto wood, he transferred the motif to a lithographic stone and got the printers to add the appropriate text. Thereafter, the poster was printed lithographically in three colours: red, green and gold.

A large number of graphic works were included in this exhibition. In the programme he announced his plan to publish some of them in a series of portfolios which he called *The Mirror*. In these portfolios, the death motif was added to the love motifs, which now contained all of his most important images. *By the Deathbed* and *Death in the Sickroom* were among the lithographs he made in Paris during 1896, as well as such love motifs as *Jealousy*, *Attraction* and *Separation*. In addition to the death scenes based on his own experience, he also included some symbolic fantasies on the theme of metabolism, such as *Funeral*

March (fig. 22), *The Land of Crystals*, *Metabolism* and *The Urn*. In *Lovers in the Waves* (fig. 23), which he produced both as an etching and as a lithograph, he made a new variant of the theme of a loving woman. Unlike his other Love themes, however, he never made a painted version of this motif.

In the summer of 1898, Munch received a request from the German periodical *Quickborn*, asking him to produce illustrations for an issue for which Strindberg would provide the written text. Munch appears to have been enthusiastic about the idea, but Strindberg expressed some displeasure at Munch's involvement. The two men had been close friends in Berlin since 1892 and had spent much time together in Paris in the spring and early summer of 1896 before Strindberg's mental collapse and precipitate departure for Sweden. Strindberg later expressed his experiences and delusions during this period in his play *Inferno*, in which Munch appears thinly disguised as a Danish painter.

While preparing his drawings for *Quickborn*, Munch stayed in Norway, much of the time apparently in Åsgårdstrand. The original drawings were lost when the periodical went bankrupt immediately after the Munch/Strindberg issue came out, but a few have since turned up.

Munch did not develop many entirely new motifs; he mainly built on images conceived earlier. To accompany Strindberg's poem *Samum*, Munch made a paraphrase of *Lovers in the Waves*, where a grinning skull replaces the male head – a motif he later repeated in his lithograph *The Kiss of Death*. For the same poem he also re-used the motif *Harpy*, which he had previously made as an etching; this drawing in turn inspired a lithographic version. He also used the lithograph *Self Portrait with Skeleton Arm* (cat. 76), the upper part of the lithograph *The Urn*, and a drawing of a young woman seated, holding a large bleeding heart rather similar to the one seen in the etching *The Heart* (cat. 38).

However, he produced a new picture for the front cover (fig. 24), an image of the suffering artist – which could be seen as a kind of artistic credo. The upper body of a naked male figure with Munch's own features seems to grow out of the ground. The man is holding one arm up behind his head in a classic gesture of suffering, the other hand is pressed against his heart, from which blood streams copiously. The blood runs into the ground, out of which

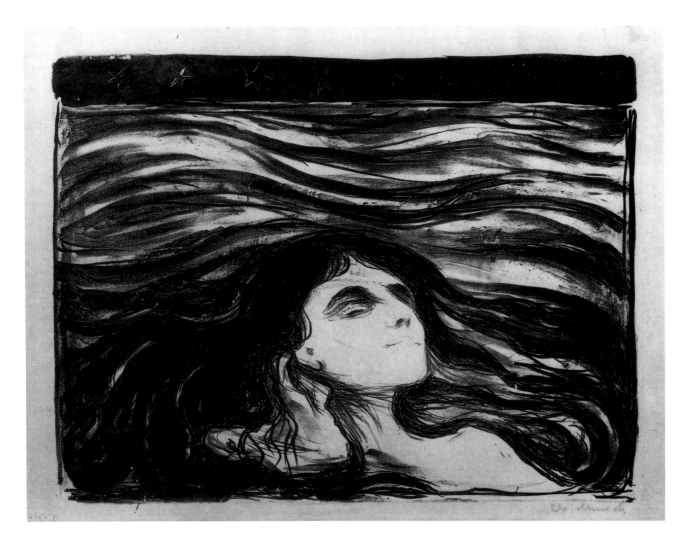

Fig. 23
Lovers in the Waves 1896
Lithograph, 47.5 x 71 cm (18½ x 28 in.)
Oslo, Munch Museum.

grows a beautiful red flower. This detail of the blood flower and the suffering man reappears in many of Munch's earlier works but is never as clearly portrayed as in this illustration. In his written work, Munch also expressed the idea that it is through his suffering and by his heart's blood that the artist creates his work. A short time afterwards, Munch made a woodcut of this motif entitled *The Flower of Pain* (fig. 25).

Munch was concerned above all with the function of art and the artist's special place in the world. As a creative artist, he compared himself to the fertile woman as she is represented in such works as *Madonna*, and to the suffering man as depicted in *The Flower of Pain*. Through her ability to perpetuate life, woman plays a direct role in the great universal cycle. Man, on the other hand, with his intellect and his heart's blood can create works of art for the use and pleasure of future generations.

Through his new motif in *The Mirror* and his illustrations in *Quickborn*, Munch discovered important ideas about the continuity of his art, which influenced his designs for a new series of paintings based on the central motifs in his oeuvre. At the Berlin Secession in 1902, he clearly extended this concept to include a 'presentation of a number of pictures of life', which also included motifs of death. The following year, at the Leipzig exhibition, his large painting *Metabolism* was hung as a kind of addition to the Frieze (fig. 28).

Fig. 24

Quickborn, The Flower of Pain 1897
Indian ink, wash, watercolour and crayon
50 x 43 cm (19¾ x 17 in.)
Oslo, Munch Museum.

graphic series *Alpha and Omega*, which he made during his stay in Copenhagen in 1908-9, may be regarded almost as a caricature of the Frieze of Life, yet Munch saw it as a very important work. Subsequent generations have perhaps had reservations about the series, but the cycle of motifs forms an integral part of what Munch had been expressing in his great imaginative works on the themes of love, life and death.

Fig. 25

The Flower of Pain 1898
Woodcut, 46.5 x 33 cm (18¼ x 13 in.)
Oslo, Munch Museum.

Munch later described this painting as being 'as necessary to the whole frieze as a buckle is to a belt'.

The Frieze of Life was never realised in its full extent as a painted frieze, nor as a graphic series or portfolio. *The Mirror* had to be given up presumably due to the lack of a publisher willing to invest the necessary capital, and perhaps because the concept was too vague. Nevertheless, Munch did not abandon the idea of publishing a graphic portfolio. Many years later he was to include prints and drawings, often accompanied by short texts, in a large journal that he called *The Tree of Knowledge*, probably hoping that it would be published one day. The litho-

The Frieze of Life

I have always worked best
with my paintings around me
I placed them together
and felt that some of the pictures
related to each other
through the subject matter
when they were placed together
a sound went through them
right away and they became
quite different
from when they were separate
they became a symphony

CONTRIBUTORS

AE/SB Arne Eggum / Sissel Biørnstad
FH Frank Høifødt
ML Marit Lande
I M-W Iris Müller-Westermann
TS/EL Tone Skedsmo / Ellen J. Lerberg
GW Gerd Woll
IY Ingebjørg Ydstie

Love

In my art I have tried to explain
to myself life and its meaning
I have also tried to help others
to clarify their lives

1 Self Portrait with Cigarette

1895

Oil on canvas
110.5 x 85.5 cm (43½ x 33¾ in.)
Oslo, The National Gallery.

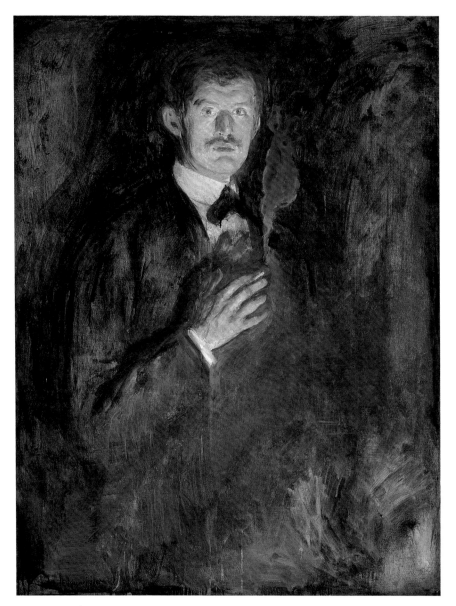

In 1895 Munch was 31 years old and had already completed the main motifs in his Frieze of Life when he painted *Self Portrait with Cigarette*. The artist emerges before the viewer from a room wreathed in smoke. Only the face, and the right hand with a cigarette, are distinguishable from an otherwise undefined blue space. The strong light from below creates an unreal, ghostly atmosphere.

The right hand is held across his chest, in the centre of the picture. The bent arm indicates that despite his motionless pose he is in a state of spiritual activity that keeps his body tense. His three-quarter-length image is barely visible; glimpsed in outline, his dark suit seems to dissolve into the blue pictorial space. The paint has been handled idiosyncratically: washed and stroked in all directions, removed in some places and thinned in others to create an expressive, active space that draws attention to the figure of the artist, who is both enveloped and isolated so that he appears lonely and confident at the same time. By filling the immediate picture plane Munch reduces the distance from the viewer, while simultaneously creating a feeling of space through the rising swathes of smoke, thus giving a sense of tension to the picture.

The smoky atmosphere is an allusion to the bohemian milieu of Christiania and Berlin. There are obvious links between this painting and the portrait of the bohemian painter Gerhard Munthe, painted by Munch's teacher Christian Krohg ten years earlier in 1885, who is depicted holding a cigarette in a smoke-filled space. However, whereas Krohg portrays the ambience of the Grand Café, Munch avoids a realistic representation to evoke an atmosphere of confidence and contemplation.

There are clear associations too with a photograph of August Strindberg, which was taken in 1886 and used as his visiting card in the early 1890s, in which he is shown dramatically lit from below, descending a staircase and holding a burning cigarette (fig. 18). As members of the Black Piglet café fraternity in Berlin, Munch and Strindberg shared lively exchanges of views. *Self Portrait with Cigarette* expresses Munch's self-assurance as an artist; he portrays himself as a thinker not as a painter.

When it was exhibited in Christiania in 1895 *Self Portrait with Cigarette* caused great controversy: Sigbjørn Obstfelder described it as *the* romantic Norwegian portrait and praised its lyrical aspects, while the young Johan Scharffenberg, who later became a psychiatrist, adduced from it evidence of Munch's alleged mental illness.

Its purchase in the same year for the National Gallery in Christiania was important to Munch, not least because he had sold nothing at all in the previous year.

I M-W

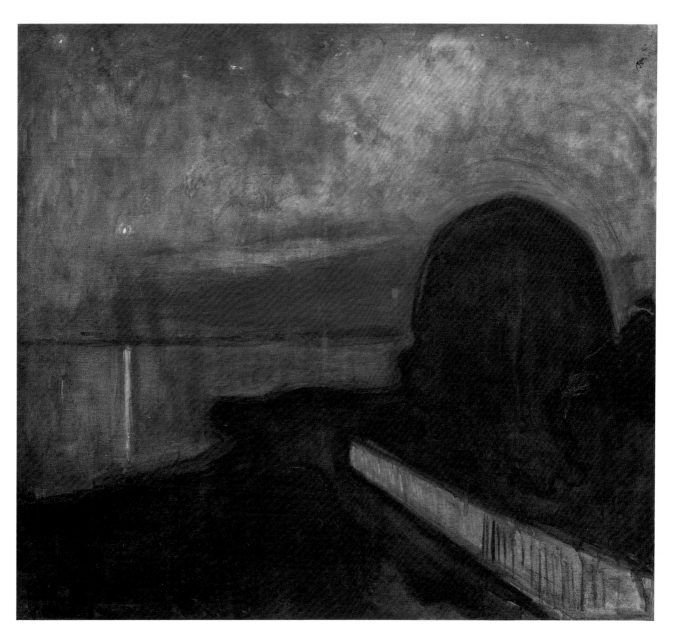

2 Starry Night

1895-7
Oil on canvas
108.5 x 120.5 cm (42¾ x 47½ in.)
Wuppertal, Von der Heydt Museum.

The countryside around the little town of Åsgårdstrand near the west bank of the Oslo Fjord held an exceptional place in Munch's art. Munch was familiar with all of its features: the gently undulating coastline, the large crowns of the linden trees, and the white fences which materialised like fluorescent bands in the summer night. After several summer holidays there, he was able to immerse himself in the essence of the place in a way which made it a reflection of his own inner landscape, while simultaneously expressing the moods and feelings of an entire generation.

In one of his many prose poems

Munch linked the origin of the painting *Starry Night* (cat. 2) to his affair with 'Mrs Heiberg', which probably started in 1885 at the Grand Hotel in Åsgårdstrand: 'They walked across the room to the open window, and leaning out looked down into the garden... it was chilly out there – The trees stood like big dark masses against the air – and up there is the moon – one is barely aware of it – it will emerge later – it is so mysterious...'

The view depicted from the Grand Hotel window is of the neighbouring garden. Its diagonal white fence seems like a deftly placed prop used to create

space and depth in the picture. Running parallel to the beach, the fence is partly hidden by the thick foliage of the linden trees, only to disappear in the garden's southernmost corner. The treetops form a powerful dome, whose outline merges into the coastline as one continuous, undulating diagonal.

The light on the horizon is the reflection of the planet Venus, which, according to its eight-year cycle, would have been in the same position in the sky in 1893, when the first version of the painting (now owned by the Getty Museum) was produced, and in 1885 when Munch met 'Mrs Heiberg'.[1] Other notes in Munch's diaries support the interpretation of this star symbol and the motif's reference to his love story: 'People's souls are like planets. Like a star that rises from the darkness – and meets another star – only to disappear again into darkness – it is the same when a man and woman meet – drift apart – light up in love – burn up – and disappear each in their own direction...'

The fluorescent sky, which is reminiscent of August Strindberg's experimental photographs, also evokes Van Gogh's *Starry Night* of 1889 (Museum of Modern Art, New York) However, in contrast to Van Gogh, Munch subdues the movement of the starlight, making it subordinate to the landscape's large, expansive forms, which are overtly influenced by Gauguin and the French Synthetist painters.

In *Attraction I* (cat. 3) two people take their position in the landscape which we recognise from the painting *Starry Night*. They are identical to the couple in the painting *Eye in Eye* (cat. 14), and the man's features are recognisably Munch's. The woman's hair appears to bind the couple together, but it is their deep-set eyes which create the most intense form of contact between them. The erotic mood of the landscape, where the soft, 'feminine' forms of the treetops contrast with the 'masculine' lines of the fence, reflect the feelings of the characters, underlining their role as pawns in the game of desire, a universal theme in contemporary literature.

Munch completed four versions of *Attraction*. An etching from 1895 has a

3 Attraction I 1896
Lithograph
42.7 x 35.5 cm (16¾ x 14 in.)
Oslo, Munch Museum.

lunette-shaped upper edge, which has been retained in this lithograph. The lunette shape has sacred associations, and is perhaps a veiled reference to Munch's St-Cloud manifesto (page 11).
ML

1. Eggum 1990.

55

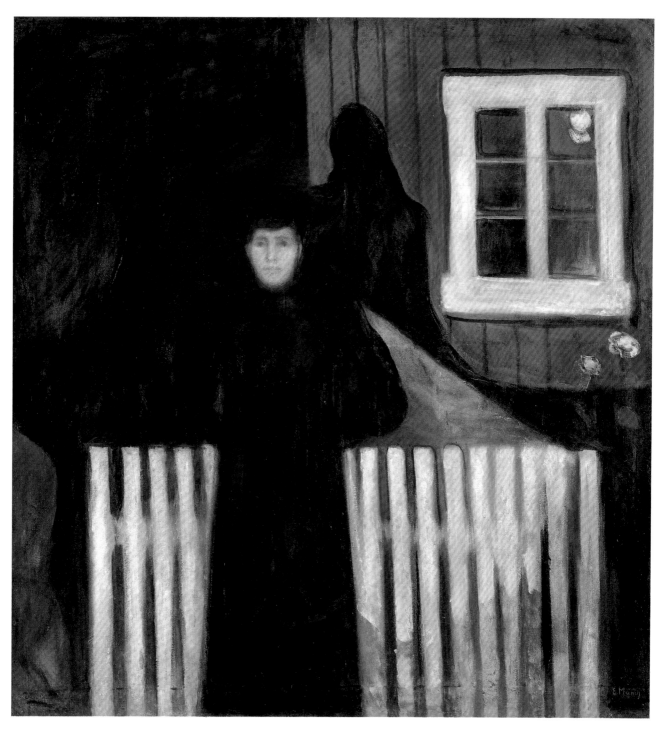

4 Moonlight

1893
Oil on canvas
140.5 x 137 cm (55¼ x 54 in.)
Oslo, The National Gallery.

During the 1890s Munch spent the summer months in Åsgårdstrand, where the Norwegian summer days and nights provided inspiration for his mood-filled landscapes.

In *Moonlight* of 1893 (cat. 4) Munch projects the mystical mood of the summer night onto a solitary woman who stands in the moonlight, in front of the white fence of a dark house. Her face in the half light has a ghostly character. A large shadow cast against the wall of the house charges the image with drama, which is enhanced by the shape suggested in the left foreground.

Apart from the white light of the moon reflected on the fence, the window frame and the window itself, all is in darkness. The shadow on the wall, and the deep green that outlines the contour of the figure, create a great curving motion in sharp contrast to the otherwise austere composition, which is dominated by horizontal and vertical lines. Munch's use of shape, line and colour to create an anxiety-ridden, mystical atmosphere is also found in several other landscape paintings produced during the summer of 1893, which have the same deep colouring as *Moonlight*. As Arne Eggum has pointed out, this is probably directly attributable to the influence of Arnold Böcklin. En route to Nice in the autumn of 1891, Munch had visited the Kunsthalle in Hamburg where, among other things, he had seen the Swiss artist's landscapes with their all-pervading moods and symbols.

From existing sketches it is possible to trace how the composition of *Moonlight* evolved over a long period, during which the female figure gradually became the dominant element. Her pose in *Moonlight* can be seen in other paintings, including *The Voice* (cats. 7 and 8), which was also painted in Åsgårdstrand in the summer of 1893.

In 1896 Munch produced a colour woodcut (cats. 5 and 6) using the motif of the painting as his starting point. However, here the female figure has been cropped below the shoulders.

TS/EL

5 Moonlight 1896
Woodcut, 41.2 x 46.7 cm (16¼ x 18¼ in.). Oslo, Munch Museum.

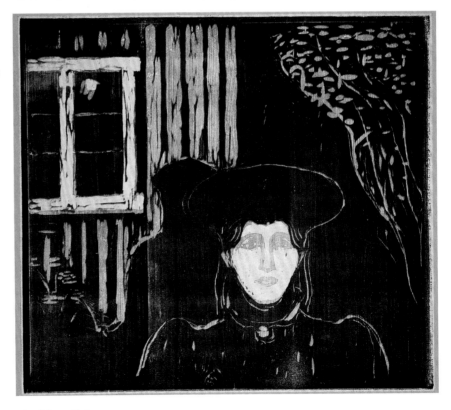

6 Moonlight 1896
Woodcut, 41.2 x 46.7 cm (16¼ x 18¼ in.). Oslo, Munch Museum.

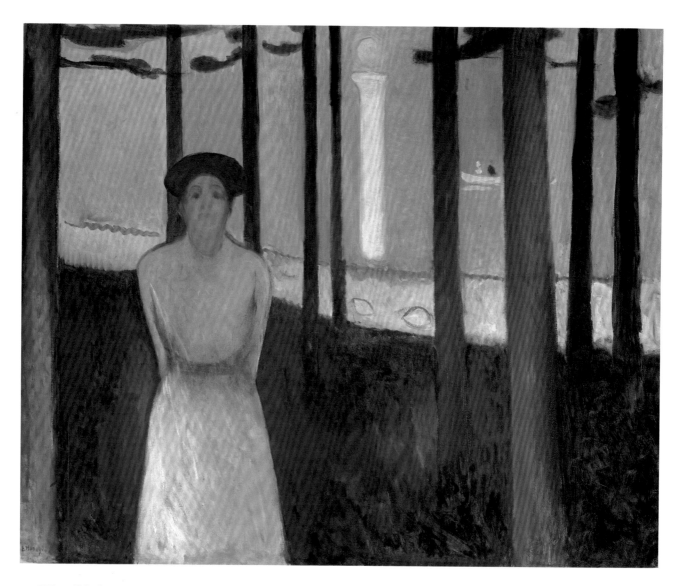

7 The Voice

1893

Oil on canvas
87.5 x 108 cm (34½ x 42½ in.)
Boston, Museum of Fine Arts.

The landscape in the background of *The Voice* is probably the beautiful Borre woods which lie to the north of Åsgård-strand on the Oslo Fjord and are famous for their Viking graves. There is a mythical air about this historic holy site, which has been a place of worship in Norway since time immemorial. The same curving shoreline links several of the Love motifs in the Frieze of Life, where – according to Munch – 'beyond is the sea, always in motion,

and beneath the crowns of the treetops a multitude of lives are lived with their joys and their sorrows.' The harmony between the dark, vertical tree trunks, which echo the shape of the woman and the column of moonlight, and the soft, shimmering shoreline engenders a melancholy and erotic atmosphere. As a sign of awakening sexuality, the moon is reflected like a phallic symbol on the water's surface.

In both painted versions of *The Voice* (cats. 7 and 8), a woman is depicted standing in the foreground as a rigidly defined shape in a light-coloured, tight-fitting dress, her hands behind her back and her head held high and slightly back. Traditionally, the Boston version (cat. 7) is considered to be slightly earlier than the Munch Museum's version

(cat. 8), in which the boats on the fjord were probably added at a later stage. The erotic tension is concentrated in the large, staring eyes of the woman, which are emphasised in the drawing *The Voice (The Eyes)* (cat. 9) by the way the bottom edge of the picture cuts across her face. It bears the inscription: 'Your eyes are as large as half the sky when you are standing near me and your hair is decked with gold-dust and your mouth I cannot see – I can only see that you are smiling ...'

In his many notes about *The Voice* Munch dwells upon the woman's eyes, which create a lyrical, almost hypnotic, atmosphere between the man and the woman:

Stand on the knoll and then I can look into your eyes – You are taller than me – I am

standing on the knoll so that I can look into your eyes. How pale you look in the moonlight and how dark your eyes are – They are so large that they cover half the sky – I can barely see your features – but I can glimpse the whiteness of your teeth when you smile ...

Standing like this – and my eyes looking into your large eyes – in the pale moonlight – do you know – then fine hands tie invisible threads – which are wound around my heart – leading from my eyes – through your large, dark eyes – into your heart – your eyes so large now – They are so close to me – They are like two huge dark skies.

Munch's literary notes reveal that the woman in *The Voice* and in several other Love motifs in the Frieze of Life, refers to the memory of his love for Millie Thaulow, whom he called 'Mrs Heiberg', a married woman two years older than himself, whom he met at Åsgårdstrand in the summer of 1885, at the age of 22. The motif was first exhibited with the title 'Summer Night'. The title *The Voice* has traditionally been interpreted to mean a woman listening to the voice of nature; however, in a retrospective note in which Munch describes his first meeting with 'Mrs Heiberg', he recalls the strangely wonderful music of her voice.

I was walking out there on the greyish-white beach – This is where I first acquired a knowledge of the new world – that of love – Young and innocent – straight out of a monastery-like home – alone among my friends not to have been introduced to this mystery – Never before felt the intoxicating power of a kiss – Here I met the youthful and two years older than myself – Christiania socialite – Everyone knew the beautiful and flirtatious Mrs T

Here I learned the power of two eyes that grow as large as globes close to me – emitting invisible threads which – would steal into my blood – my heart

Here I learned the strange and wonderful music of the voice – one moment tender – the next teasing, then provocative...

The woodcuts from 1896 (cats. 10 and 11) are very close to the Munch Museum's painting. Munch appears to have been inspired by the expressive powers of the wood block itself; the result is an almost crude and primitive expression, reminiscent of both the Greek *kore* of antiquity and the mythical figures of the light, Nordic summer nights.

AE/SB

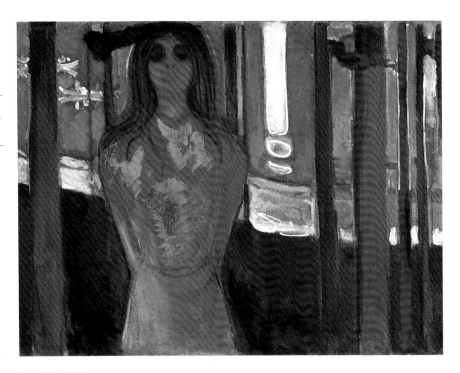

8 The Voice 1893
Oil on canvas, 90 x 118.5 cm (35½ x 46½ in.). Oslo, Munch Museum.

9 The Voice (The Eyes) 1893-6
Pencil and crayon, 41.5 x 50 cm (16¼ x 19¾ in.). Oslo, Munch Museum.

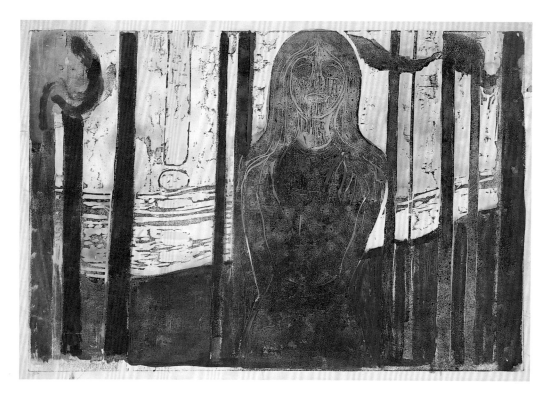

10　The Voice　1896
Woodcut, 37.8 x 56 cm (15 x 22 in.). Oslo, Munch Museum.

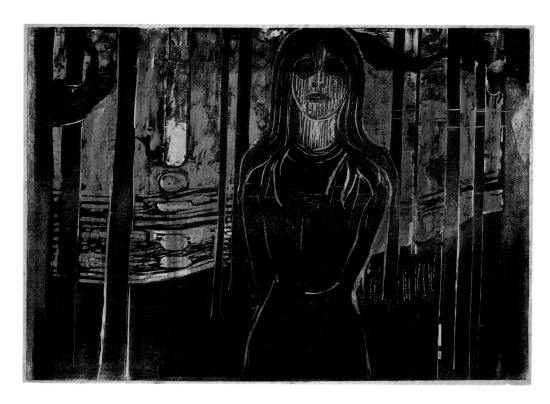

11　The Voice　1896
Woodcut, 37.8 x 56 cm (15 x 22 in.). Oslo, Munch Museum.

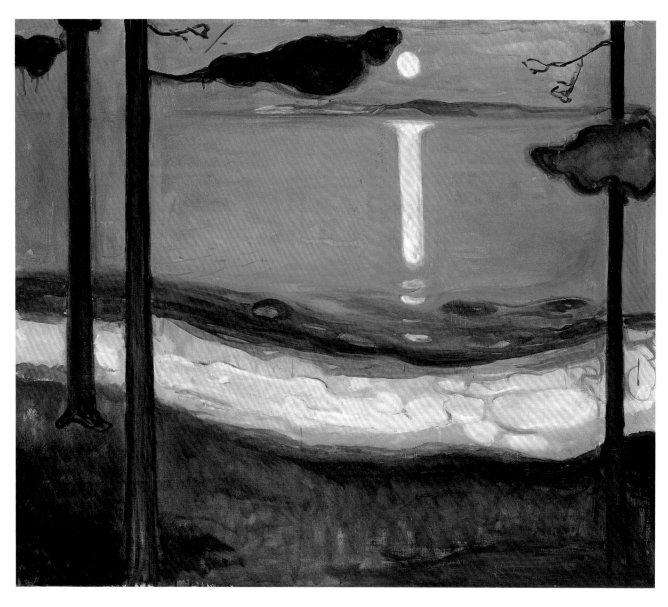

12 Moonlight

1895

Oil on canvas
93 x 110 cm (36½ x 43¼ in.)
Oslo, The National Gallery.

In the leaflet that accompanied his
Frieze of Life exhibition at Blomquist's
gallery in Christiania in 1918, Munch
wrote:

The Frieze is intended to be a series of dec-
orative pictures which should as a whole give
a picture of life. Through it winds the undu-
lating coastline, edged by the ever-moving
sea. Below the crown of the trees life is
played out in all its variety, with its joys and
sorrows.

In 1889 Munch spent his first sum-
mer at Åsgårdstrand, and as early as the
autumn of that year the coastal land-
scape appears in the painting *Inger on
the Beach* (Rasmus Meyer Collection,
Bergen). A clearer view of the coastline
appears in *Melancholy* (cat. 42), where

the man's depressed state is reinforced
by the dark, undulating shoreline.

In his paintings of the 1890s the leit-
motif of the shoreline is evident in
Dance on the Shore (fig. 26), *The Dance
of Life* (cat. 31), *Separation* (cat. 39) and
Red and White (cat. 15). The joys and
sorrows of life are enacted on this
beach, which Munch has used as a back-
drop to depict his own and others'
erotic encounters and experiences in the
light, summer nights.

During the 1880s Naturalism was
dominant among Norwegian painters.
Werenskiold, Kitty Kielland and Eilif
Peterssen spent the summer of 1886 at
Fleskum in Baerum where they too
tried to capture the white mood of the

Fig. 26
Dance on the Shore 1900-2

Oil on canvas
99 x 96 cm (39 x 37¾ in.)
Prague, Narodni Gallery.

summer nights in works in which attention to detail was replaced by atmospheric landscapes.

Moonlight of 1895 is a painting with no human figures; it is purely a mood landscape, evoking the harmony and mystery of a summer night, with its soft and beautiful colours. The composition is simple, only the three erect tree trunks and the pillar of moonlight on the water break the otherwise dominant, softly curving horizontals. The landscape resembles the background for the female figure in both versions of *The Voice* (cats. 7 and 8), where the landscape resonates powerfully with the erotic sentiment expressed in the paintings. Although the figure is absent in *Moonlight*, the landscape is no less imbued with a mood of eroticism and longing.

TS/EL

14 Eye in Eye

1894

Oil on canvas
136 x 110 cm (53½ x 43¼ in.)
Oslo, Munch Museum.

A mystical green light imbues a landscape in which a young man and woman meet. Silent and motionless they stare into each other's eyes to fathom the secret of their mutual attraction. The huge cavernous eyes reveal their inner world. The strands of the woman's red hair stretch out to the man, binding the couple together, but the tree that looms up vertically between them divides the painting, allocating the right side to the man and the left side to the woman. While the woman is at one with the colours of the landscape, with the reddish house and the red-brown tree, the man appears alien to his surroundings. His white collar perhaps suggests innocence. His white face is a premonition of sorrow for which the blood flower behind him is a symbol and a recurring motif in the Love series of Munch's Frieze of Life.

In grouping the couple to the left and right of the tree, Munch played iconographically with representations of the Fall of Man. He later used this motif more explicitly, for example in *Metabolism* of 1899 (cat. 47).

Through his almost naïve manner of painting Munch underlines archaic, eternal values. Arne Eggum has drawn attention to the later overpainting in parts of the woman's hair and the tree. Old exhibition photographs prove that the alterations were made after 1906 and that the painting was originally gloomier than it is today.

Munch also produced two engravings and two lithographs of this motif. In the lithograph *Attraction II* of 1896 (cat. 13), formerly titled 'Two Heads', Munch placed the couple in the landscape of Åsgårdstrand, whose restless coastline runs like a melody through many of the Frieze of Life motifs. The tree in *Eye in Eye* is replaced in the lithograph by a column of light cast by the full moon onto the water: a phallic symbol emphasising the erotic nature of the meeting, as well as a premonition of sorrow.

I M-W

13 Attraction II 1896

Lithograph
39.5 x 62.5 cm (15½ x 24½ in.). Oslo, Munch Museum.

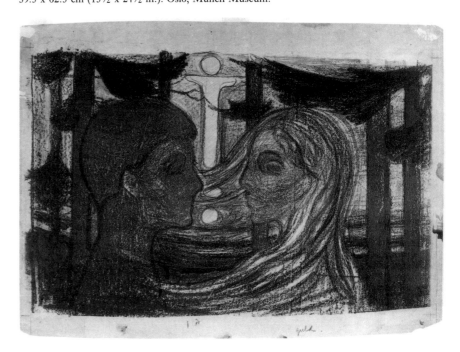

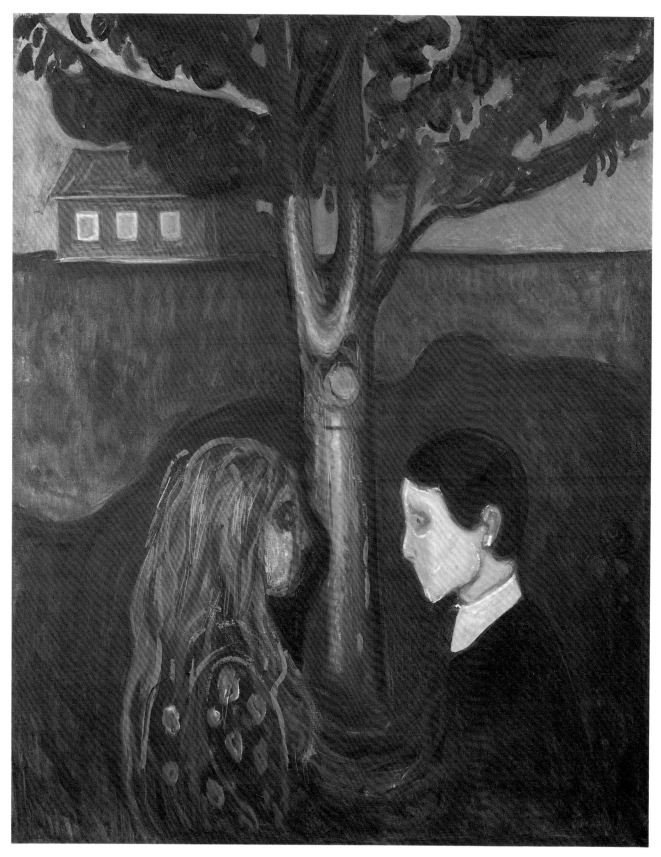

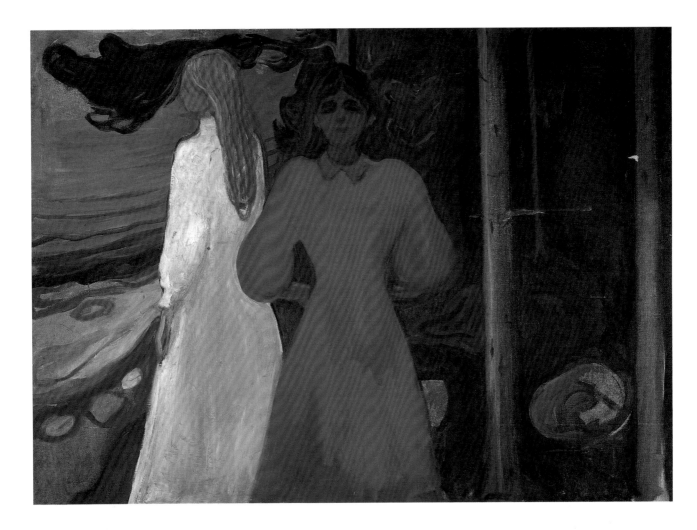

15 Red and White

1894

Oil on canvas, 93 x 125 cm (36½ x 49¼ in.)
Oslo, Munch Museum.

Two female figures, seen at close range, dominate the picture. They stand under a pine tree on a beach, which is recognisable as the landscape at Åsgårdstrand. The fair-haired woman in white faces the sea, her body as straight as a column. The dark-haired woman in red has powerfully emphasised curves; her position and expression remind us of the woman in *The Voice* (cat. 7), while the woman in white is reminiscent of the now lost painting *Two People*. Between the tree trunks, where large rocks can be seen, there are traces of a painted-out figure, darkly dressed, who appears in earlier oil sketches of the subject.

The initial composition of three women has distinct similarities with the etching of *The Woman* (cat. 16). *Red and White* could be interpreted as a metaphor for the stages in a woman's life, or the different sides of her nature. By removing the dark woman, Munch presumably intended to change the symbolism of the motif.

In his literary notes, Munch described how his feelings for 'Mrs Heiberg' alternated between attraction and repulsion. The two women with their simple colour symbolism invite us to interpret this as a picture of Munch's own – or man's – ambivalence towards women. His dreams of the ideal woman, represented by the fair-haired figure dressed in the white of innocence, seem incompatible with the mature, erotic, conscious woman's demands. The woman in red represents passion, which simultaneously implies a threat.

It has been suggested that the strong decorative style of this work shows the influence of the so-called Cloisonnist technique, as it appears in works by Sérusier and other followers of Gauguin.[1] For Munch these theories about 'the subjective deformation which is set in motion by the artist's own experiences' offered new and appropriate means of expressing his ideas.

ML

1. Rapetti 1991, p. 174.

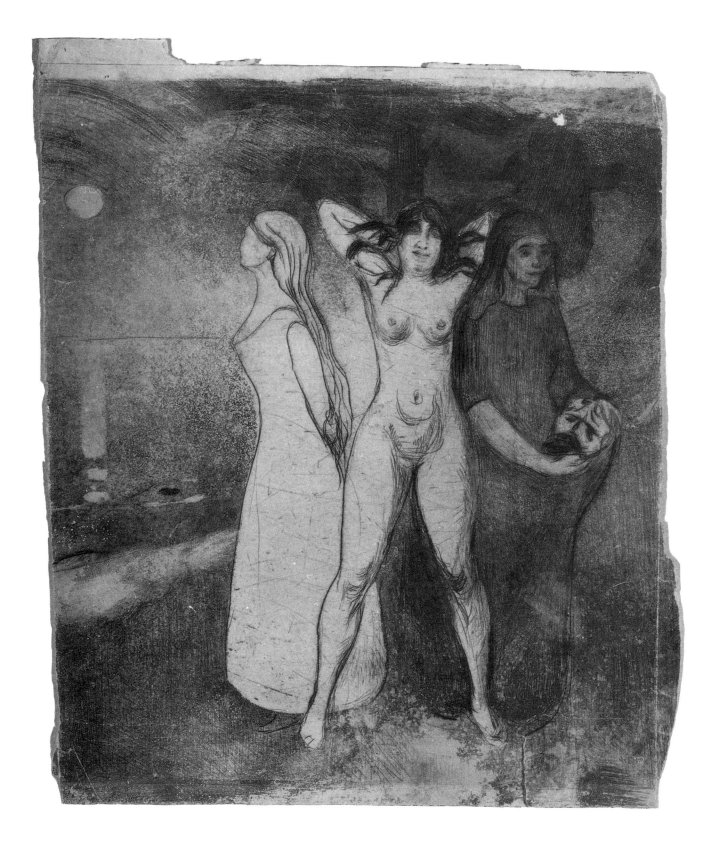

16 The Woman 1895

Drypoint, 31.5 x 26 cm (12½ x 10¼ in.). Oslo, Munch Museum.

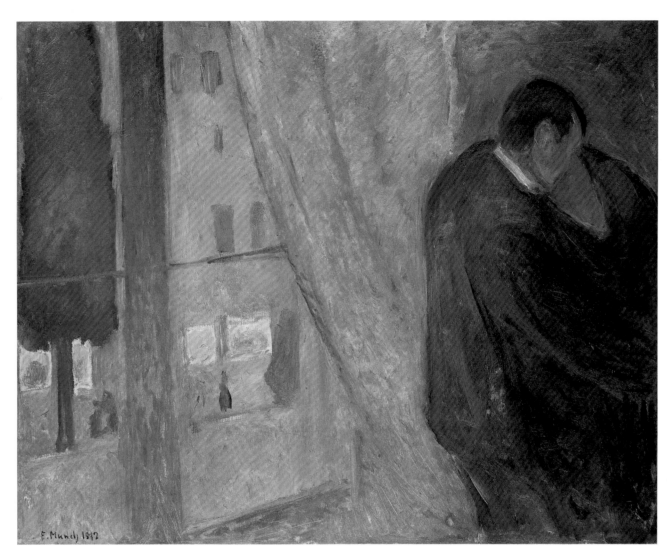

E. Munch 1892

17

17 The Kiss

1892

Oil on canvas
73 x 92 cm (28¾ x 36¼ in.)
Oslo, The National Gallery.

There are several versions of this paint-
ing: the three earliest were probably
painted during 1892, and Munch later
repeated the motif a number of times,
making various alterations. The exist-
ence of earlier drawings, however,
suggests that it has a longer history. A
scene of a couple kissing in an artist's
studio, dating from about 1889, is prob-
ably the first sketch for the subject,
which is almost certainly based on
Munch's own experience. This drawing
includes a window overlooking the
street outside. However, when Munch
later recreated the memory of this em-
brace, he varied the view from the
window in the different versions.

In the National Gallery's version of
The Kiss (cat. 17), which is usually
regarded as the first, the embracing
couple are framed in a blue haze and
placed well to the right of the window
from which the view is recognisably
that of Nice. Although the Munch Mu-
seum's later version (cat. 18) shows a
partial view of the world outside the
window, the couple have been placed
centrally and fused together to form a
sculptural, almost phallic shape.

A great number of woodcuts, varying
in format and colour, were made of *The
Kiss*. This 1897 woodcut (cat. 19)
echoes the composition of the
embracing couple and the erotic over-
tones of the painting, but omits the
window.

GW

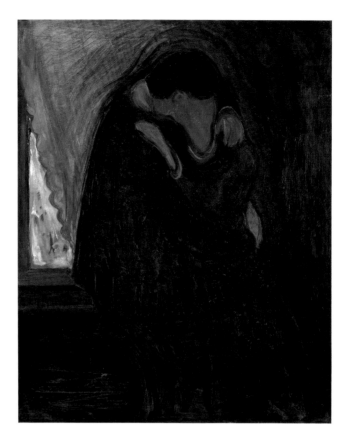

18
The Kiss
1897

Oil on canvas
99 x 81 cm
(39 x 32 in.)
Oslo, Munch
Museum.

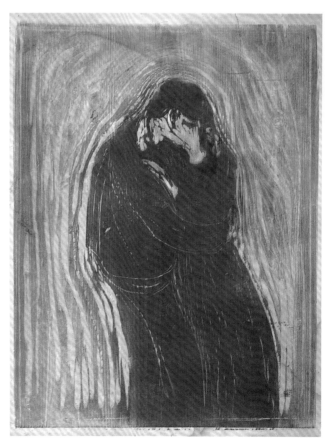

19
The Kiss
1897-8

Woodcut
59 x 45.7 cm
(23 1/4 x 18 in.)
Oslo, Munch
Museum.

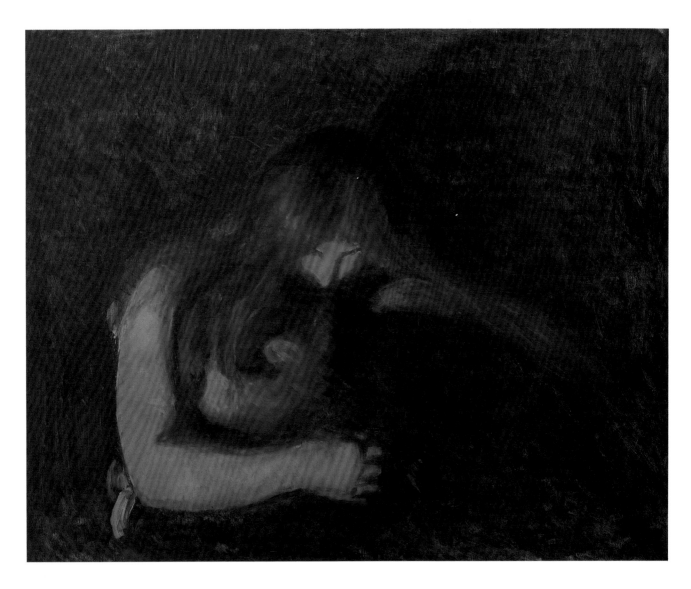

20 Vampire

1893
Oil on canvas
80.5 x 100.5 cm (31¾ x 39½ in.)
Gothenburg, Museum of Art.

Vampire was one of six paintings that made up the Love series when it was first shown in the 1893 exhibition in Berlin; it was also used as the cover illustration for the catalogue. The painting, then presented under the title 'Love and Pain', is in all probability the one owned by the Gothenburg Museum of Art (cat. 20). During 1893-4, however, Munch painted several versions of this motif (see cat. 21). The colouring and technique vary slightly in the different paintings, but the composition is virtually unchanged. This is also true of the graphic versions from 1895 (cat. 22), although the *Vampire* lithograph (cat. 23) includes a curtained window in the top right of the composition similar to that in *The Kiss* (cat. 17).

The development of the motif can be traced through several drawings from the late 1880s in the Munch Museum. It is connected with Munch's other representations of lust and desire and their related problems. In all probability it was the Polish poet and anarchist Stanislaw Przybyszewski who first named the painting *Vampire*. His article about Munch's art, based on the 1893 exhibition in Berlin, gave an explicit description and interpretation of this painting:

A broken man and on his neck a biting vampire's face... The man is rolling about in the bottomless pit, weakly, powerlessly, rejoicing in the fact that he can roll about as weakly as a stone. Yet he cannot free himself from the vampire, nor can he free himself of the pain, and the woman will always be sitting there, forever biting with a thousand vipers' tongues, with a thousand poison fangs.[1]

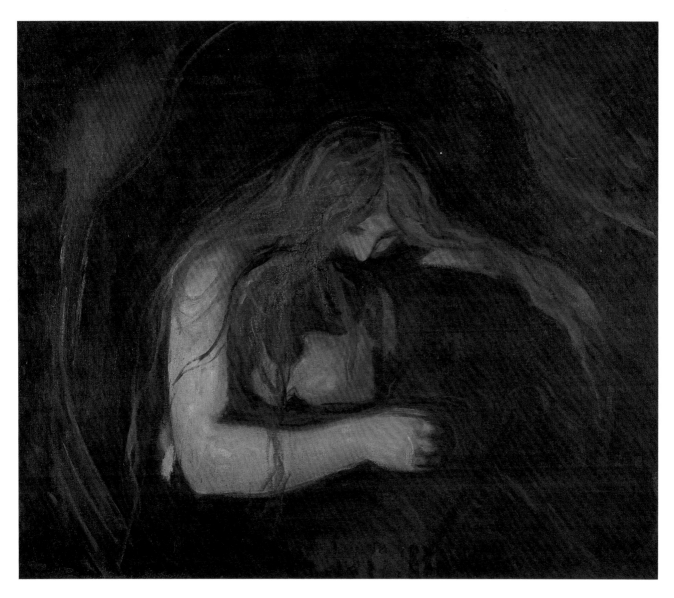

21 Vampire 1893-4

Oil on canvas
91 x 109 cm (35¾ x 43 in.)
Oslo, Munch Museum.

Misogyny of this kind was widespread in the radical circles in which Munch moved in Berlin. Munch's painting of the red-headed, sexually active woman provides an excellent illustration of this attitude, and his sympathy with it is attested by his subsequent repeated use of the title *Vampire*. It was not until an exhibition of the Frieze of Life in 1918 that he gave a new version of the subject the more prosaic title of *A Woman kissing the Back of a Man's Neck*.

Several of his earliest lithographs of *Vampire* were hand-coloured, and in 1902 Munch made a print where he used not only a new lithographic stone for the red hair but also a wooden block cut into four pieces (cat. 22), just as he did with a number of his colour wood-cuts. The wooden block was cut according to the contours and the various sections of the image in a way that also served to emphasise the composition. Munch was familiar with the different ways of combining lithography and woodcuts as early as 1896, but as far as we know he did not use this particular technique until 1902.

G W

1. Przybyszewski et al. 1894.

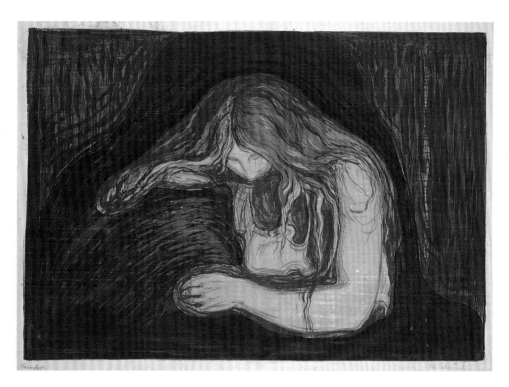

22 Vampire 1895-1902
Lithograph and woodcut, 38.7 x 55.9 cm (15¼ x 22 in.). Oslo, Munch Museum.

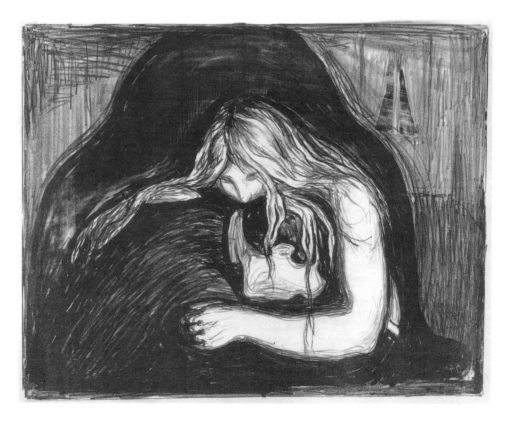

23 Vampire 1895
Lithograph, 38.2 x 54.5 cm (15 x 21½ in.). Oslo, Munch Museum.

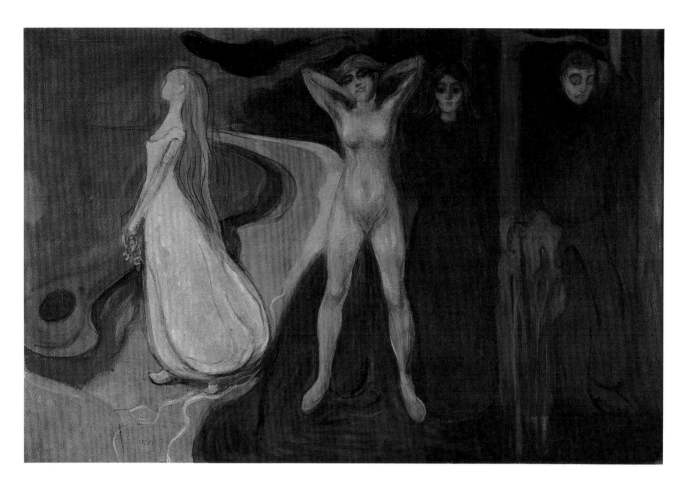

24 Sphinx

1894
Oil on canvas
164 x 250 cm (64½ x 98½ in.)
Bergen, Rasmus Meyer Collection.

Sphinx was painted in Berlin in 1894. On the left a youthful-looking woman dressed in light colours looks out towards the sea; in the centre, a naked, erotically charged woman, with her hands behind her neck, gazes provocatively at the viewer; on the right is a darkly dressed woman with a pale, expressionless face. Between the tree trunks, on the far right, stands a dejected-looking man.

The similarity between these three female figures and the figures in *Separation* (cat. 39) and *Red and White* (cat. 15) is obvious. As Arne Eggum and others have pointed out, Munch was developing the Frieze of Life cycle based on a number of archetypes. The three figures can be associated with the differing aspects of the female psyche, as well as with the cyclical passage of youth, maturity and old age.[1]

The monumental form and tight composition of this painting are not unlike Puvis de Chavanne's landscape decorations, inhabited by mythological muses. Yet Gauguin's Synthetist painting is a more obvious influence. Using Gauguin's Cloisonnist technique, Munch combined flat, painted areas and distinct contours with broad, summary brushwork, introducing an intrusive sensual presence.

When he painted *Sphinx*, Munch was evidently familiar with Jan Toorop's drawing *The Three Brides* of 1893 (Otterlo), and Max Klinger's *The Blue Hour* of 1890 (Leipzig), showing three nymphs on a beach. Yet *Sphinx* is inextricably linked to the Frieze of Life. The literary references that Munch attached to the picture are an indication of his desire to channel its interpretation into a mythical context. In Greek mythology, the Sphinx, half beast and half woman, is the guardian of the Gate of Thebes. Anyone wishing to pass through the gates had to solve its riddle. The answer given by Oedipus is analogous with Munch's theme of love, where youth is succeeded by maturity, and proceeds inexorably to old age. Towards the end of the nineteenth century, however, the term Sphinx was

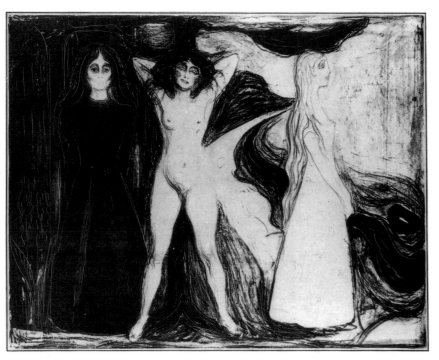

26 Madonna

1894-5

Oil on canvas
90.5 x 70.5 cm (35½ x 27¾ in.)
Oslo, The National Gallery.

The *Madonna*, or 'Loving Woman' as it was also called by the artist, was executed in several versions and plays a key role in the Frieze of Life. Although the *Madonna* theme, such as we know it through the surviving versions, was produced by Munch after his entry into the artistic society of Berlin, it probably stemmed from his period in Paris.

The *Madonna* owned by the National Gallery in Oslo (cat. 26) depicts a three-quarter-length view of a young, nude female figure with her right arm raised behind her head and her left arm fastened behind her back. Her eyes are almost closed and her features are peaceful and harmonious. Long, dark hair flows down over her shoulders, and her head, tilting backwards, is crowned by a scarlet, halo-like shape. The background is composed of an aura of waving lines and patterns.

The use of the two titles, *Madonna* and 'Loving Woman', indicates that the theme has both a religious and an erotic content. The association with the Madonna is emphasised by the scarlet 'halo'. But the figure is also characterised by her abandonment to the sublime moment of love. When Munch first exhibited *Madonna* its wide frame carried depictions of spermatozoa and embryos, and these details are present in his graphic representations of the theme. In 1895 Munch made lithographic versions using the same composition as the paintings. In these prints (cats. 27 and 28) the border around the motif suggests conception: the moment a new life is created.

In the Frieze of Life, Munch wanted to show people who breathe, feel, suffer and love. In his art he was able to translate strongly subjective experiences into pictures of universal relevance, but few of his paintings are so charged with love and emotion as *Madonna*, which treats the very miracle of existence, with woman as the starting point of life. Munch's many commentaries on the

25 Sphinx 1899

Lithograph
46.2 x 59.2 cm (18¼ x 23¼ in.)
Oslo, Munch Museum.

used synonymously for *femme fatale*, the woman that consumes man. When the painting was first exhibited at the Konstföreningen, Stockholm, in 1894, the catalogue for the exhibition included the subtitle 'All others are one – you are a thousand'. This quotation comes from the Norwegian playwright Gunnar Heiberg's play *The Balcony*, in which a woman appears as three different personalities to her three lovers. Munch is also reported to have described the motif as 'The Norns' – the three goddesses of fate in Nordic mythology; this association with these custodians of life and death underlines the fateful aspect of man's meeting with woman.

Ibsen took particular note of this picture at an exhibition in Christiania in 1895. The theme is thought to have inspired the three female figures in his play *When We Dead Awaken*, of 1899. Munch's lithographic version of *Sphinx* (cat. 25) was made in the same year.

IY

1. Eggum 1990.

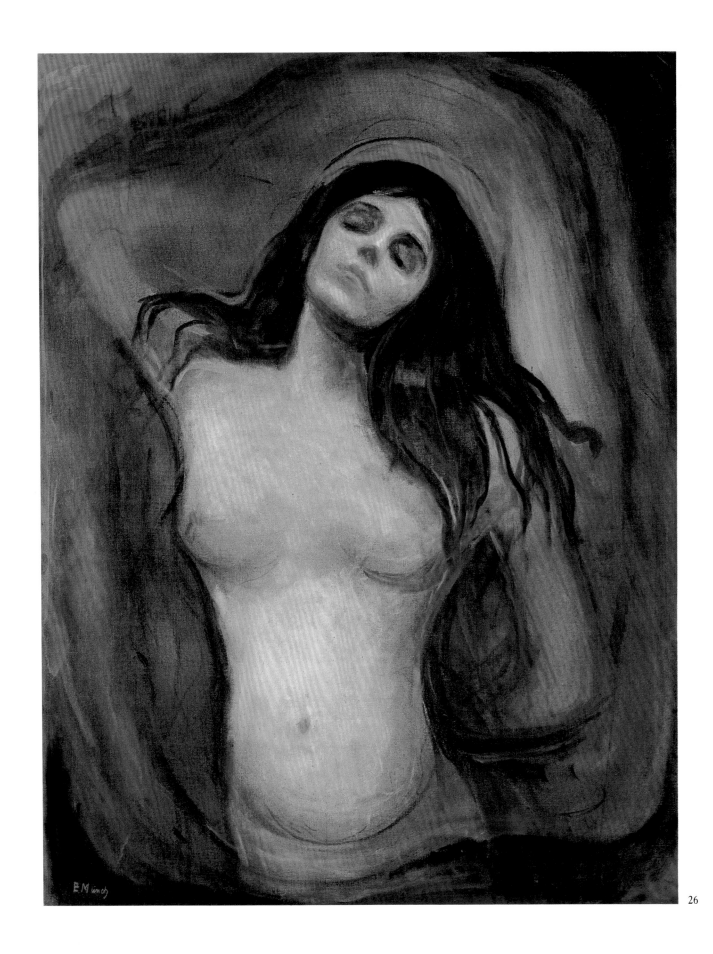

26

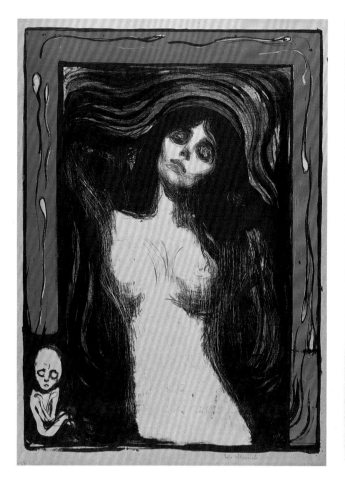 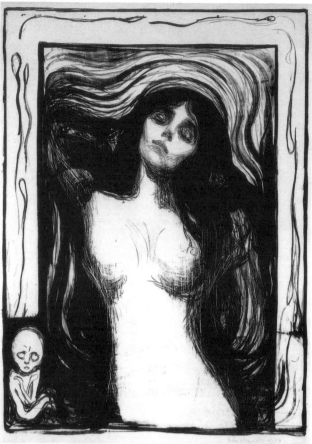

27 Madonna 1895-1902
Lithograph, 60.5 x 44.2 cm (23¾ x 17½ in.). Oslo, Munch Museum

Frieze of Life show that the idea of
death was also present. In the early
1890s he wrote:

Your face holds all the love in the world.
Moonlight steals across your face so full of
Earthly beauty and Grief. For now Death
extends her hand to Life and a bond is made
between the thousands of generations who
are dead and the thousands of generations to
come.

TS/EL

28 Madonna 1895
Lithograph, 60.5 x 44.2 cm (23¾ x 17½ in.). Oslo, Munch Museum.

29 Madonna 1893-4
Oil on canvas, 90 x 68.5 cm (35½ x 27 in.). Oslo, Munch Museum.

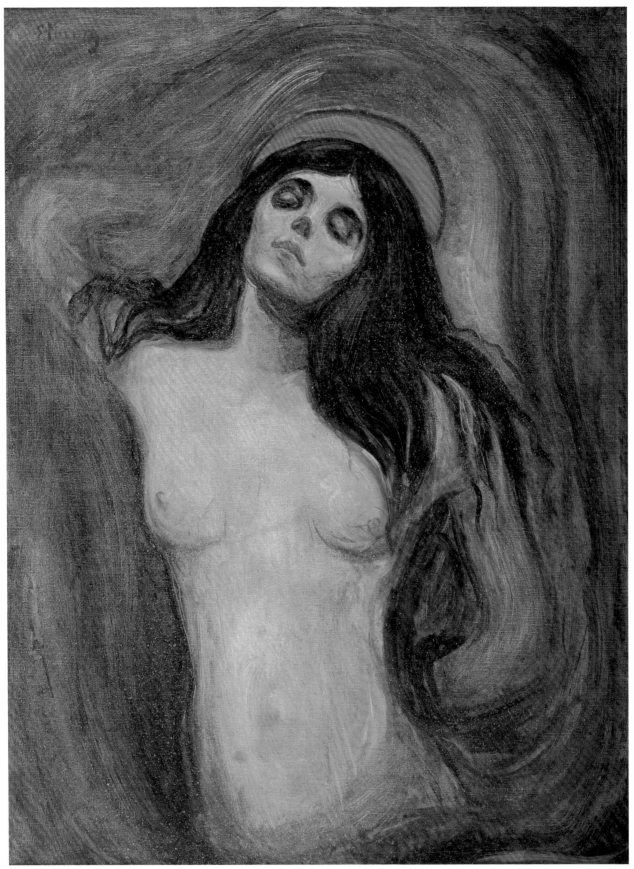

29

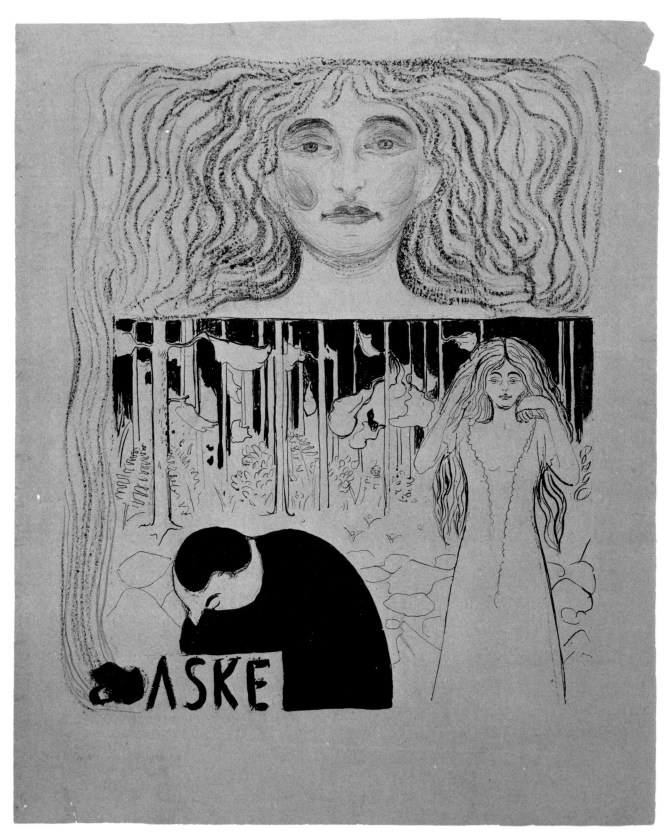

30 Ashes

1896
Lithograph
50 x 43 cm (19¾ x 17 in.)
Oslo, Munch Museum.

Fig. 27 Ashes 1894

Oil on canvas, 120.5 x 141 cm
(47 ½ x 55 ½ in.)
Oslo, The National Gallery.

In an obviously autobiographical note in his diaries, Munch wrote: 'We walked out of the stifling, flower-filled woods out into the light night – I looked at her face and I ... had committed adultery – A gorgon's head – I bent over and sat down ... I felt as if our love ... was lying there on those hard rocks.' (The paper is partly torn and some words are missing.)

In the motif known as *Ashes*, as in so many of his pictures, Munch mingles personal experience with a deeper symbolism. His own first title for the 1894 painting (in the National Gallery, Oslo) was 'After the Fall' (fig. 27), a clear indication of his use of biblical symbolism. Here the man, slumped in deep despair, has turned away from the woman, whose wide-open eyes staring straight at us, long, streaming hair and classic gesture of both hands clasping her head express her shocked state.

In the lithographic version of 1899 (cat. 30), however, the woman seems quite calm, almost smiling, as she stands arranging her hair. The smoke from the tree trunk in the foreground drifts up past the space containing the man and woman, to finish in a separate top section transformed into hair, which encircles a large female head. The face echoes the expression of the woman in the passage below, the serpentining hair making a clear allusion to the gorgon's head. GW

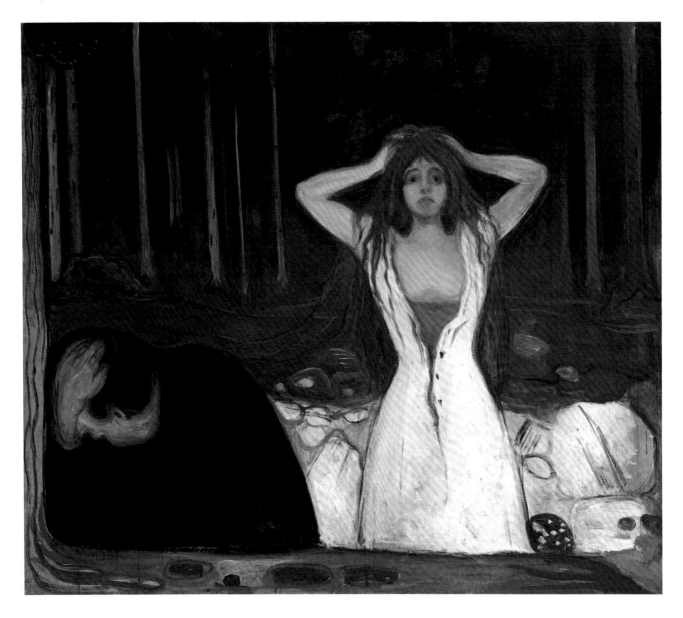

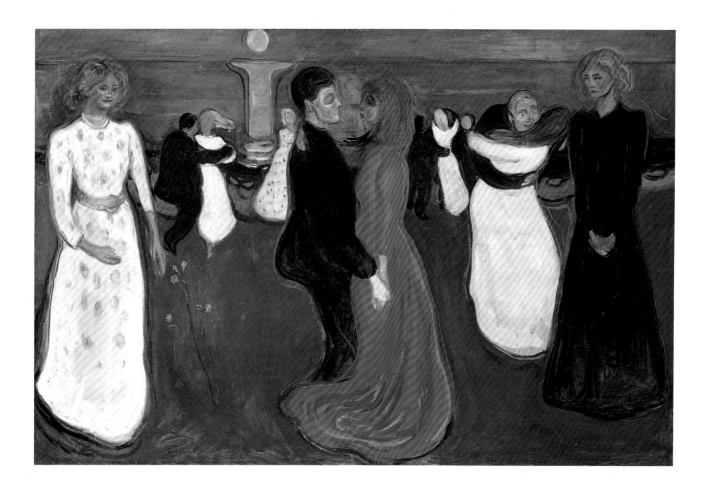

31 The Dance of Life

1900

Oil on canvas
125.5 x 190.5 cm (49¼ x 75 in.)
Oslo, The National Gallery.

Created at the turn of the century *The Dance of Life* is another key painting in the Love series of the Frieze of Life, and depicts Munch's situation in society. Its genesis is rooted in his relationship with Tulla Larsen.

In the centre Munch dances on a green meadow by the water with a red-haired woman in a long dress. She is his first love Millie Thaulow – whom he calls 'Mrs Heiberg' in his literary notes, giving himself the pseudonym Brandt. He is infatuated with her. As they dance arm in arm the hem of her long dress sweeps over his feet like a wave. A single contour line encloses the couple. But, while the other swaying, dancing couples succumb to the erotic mood of the summer night under a full moon, Munch remains stiff and numb. In contrast to Munch's restrained pose, the man on the right, who resembles the bohemian writer Gunnar Heiberg, bends lustfully over his partner. The

women standing on the left and right hand of the composition both resemble Tulla Larsen. The woman on the left stretches out her hand to the flower growing in front of her, while the woman in black turns towards the central dancing couple with her hands folded in a gesture of resigned disappointment. Munch described the painting in his diary:

I am dancing with my true love – a memory of her – A smiling, blond-haired woman enters who wishes to take the flower of love – but it won't allow itself to be taken – And on the other side one can see her dressed in black troubled by the couple dancing – rejected – as I was rejected from her dance...

'Mrs Heiberg', two years older than Munch and married, had severed their relationship in the 1880s. Munch expressed the pain and powerlessness of being deserted in several pictures including *Separation* (cat. 39). The affair he

78

later had with Tulla Larsen he found oppressive. Unable to respond to the intensity of her affection, which left him mentally and physically exhausted, he continually retreated from her to find peace and regain his strength.

Munch's earlier paintings *Eye in Eye* (cat. 14) and *The Kiss* (cat. 17) depict the development of a relationship as it progresses from erotic attraction to consummation and eventually rejection in *The Dance of Life*. Munch is aware of the erotic power of the woman but refuses to give in to her. 'I believe that I am only suited to painting pictures and so I clearly felt that I must choose between love and my work.' 'I throw myself into my work, I must if I am to bear life.'

The parallel between Munch and Tulla, who are both dressed in black and turned towards each other, is clear. Just as Munch was rejected by his first love, so Tulla in turn is rejected by Munch. To this extent they complement each other as partners in

suffering. 'I sought to make clear to you my relationship to life and to love and I sought to explain to you that I cannot join in the violent hunt to live life. I told you that I must live for my art.' '... my art – is my great love.' Art became the medium through which Munch exorcised 'the disparity of life', which in reality he could not change. *The Dance of Life* represents the crux of the Love motifs and the point at which Munch declares his retreat from life.

I M-W

32 Jealousy

1895

Oil on canvas
67 x 100 cm (26¼ x 39¼ in.)
Bergen, Rasmus Meyer Collection.

The obvious similarity between the man in the foreground and Munch's Polish friend, the writer Stanislaw Przybyszewski, has traditionally provided the main clue to this picture. The unmistakably Slavic features, with high cheekbones and intense, deep-set eyes, are almost caricatural. The figure is established in the front of the picture plane, dominating the right half completely. The pale, yellowish-brown face with auburn hair and a thick red pointed beard is distinctly isolated against the dense, deep green foliage and the dark colours of the body. In the background a man and woman stand beneath an apple tree. As the woman reaches sensually for the fruit, her dress falls open, revealing her naked body. A lock of her

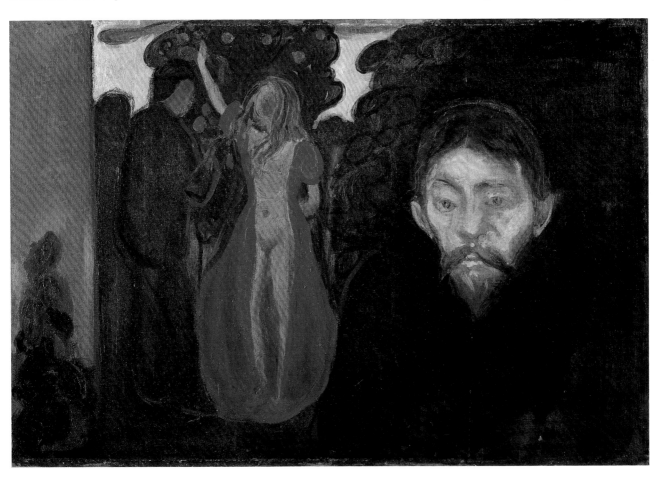

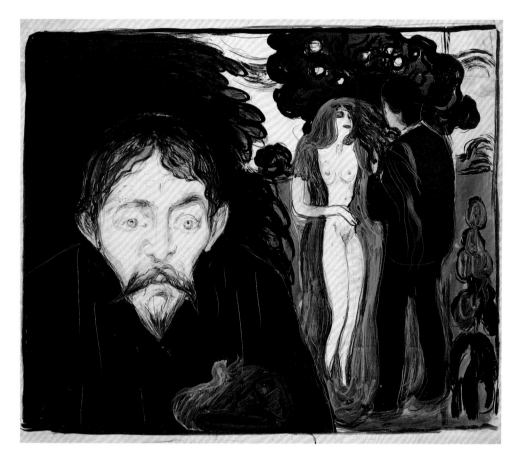

33　Jealousy I　1896
Lithograph
46.5 x 56.5 cm
(18¼ x 22¼ in.)
Oslo, Munch Museum.

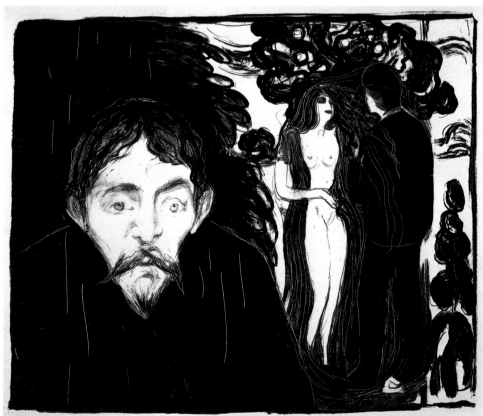

34　Jealousy I　1896
Lithograph
46.5 x 56.5 cm
(18¼ x 22¼ in.)
Oslo, Munch Museum.

hair softly brushes the dark male figure, which is outlined in red.

The scene in the background is easily recognisable as Adam and Eve in Paradise, but the demoniacal male head in the foreground evokes associations with Satan rather than the Old Testament's God of Judgement. The painting could be interpreted as a travesty of the Holy Scripture. Munch's use of his friend's portrait is often explained by Przybyszewski's expressed proclivity towards satanism. Christianity condemned this belief as a denial of life, but here it is seen as an inescapable aspect of it. At the time, however, *Jealousy* was understood to be an allusion to Munch's affair with Przybyszewski's Norwegian wife, Dagny Juel. Przybyszewski's *roman à clef*, *Overboard* (1896), tends to be accepted as the author's reply. In it, he relates how the jealous painter commits suicide after his beloved is seduced by the writer.

Even though the biographical and biblical overtones in *Jealousy* are clearly rooted in the literary milieu of Berlin, this painting must be interpreted in the context of the Frieze of Life, where jealousy is represented as an essential element of love. Munch also produced lithographic interpretations of the *Jealousy* motif. The larger versions (cats. 33 and 34) relate closely to the painting, whereas the smaller lithographs (cats. 35 and 36) focus on the facial expression of the foreground figure, inviting the viewer to share his innermost fears about the couple in the background. On closer inspection, the woman in *Jealousy* bears a striking resemblance to the naked, erotically charged central figure of *Sphinx* (cat. 24), a *femme fatale* figure, ordained by fate to seduce men.

IY

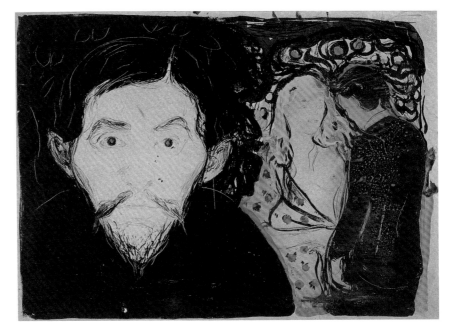

35 Jealousy II 1896
Lithograph, 32.6 x 45 cm (12¾ x 17¾ in.). Oslo, Munch Museum.

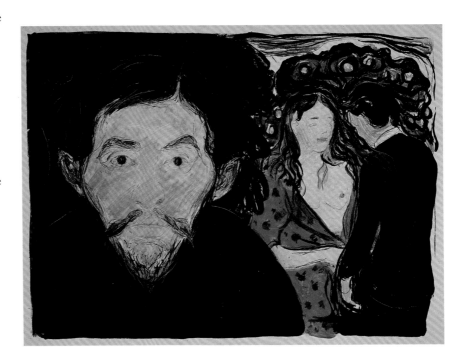

36 Jealousy II 1896
Lithograph, 32.6 x 45 cm (12¾ x 17¾ in.). Oslo, Munch Museum.

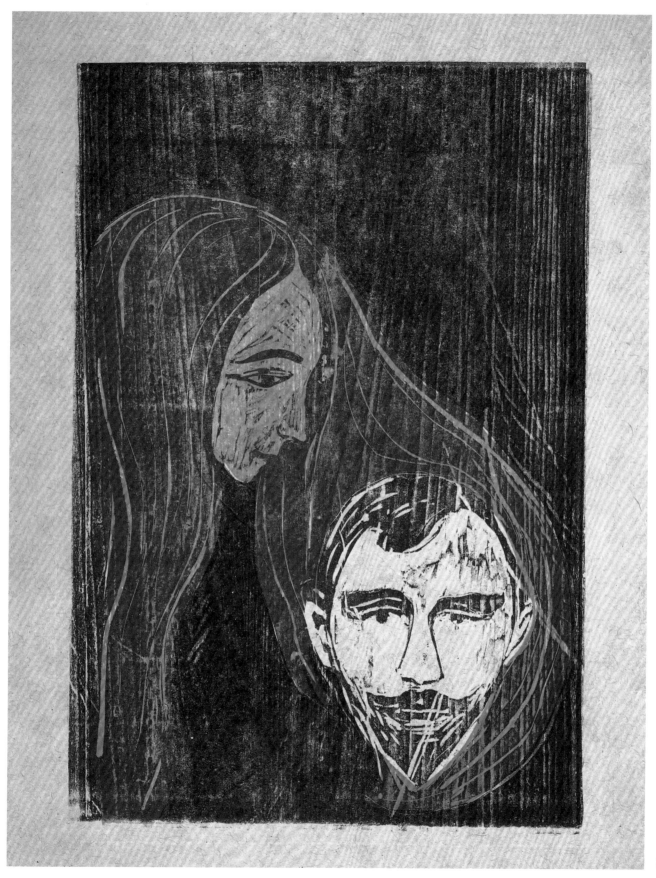

37 Man's Head in Woman's Hair

1896

Woodcut
54.6 x 38 cm (21½ x 15 in.)
Oslo, Munch Museum.

The *femme fatale* character was a popular subject for the Symbolist artists, and in Munch's art of the 1890s there are many allusions to the Salome motif. Munch's pictures of the woman with the severed male head, however, are not typical depictions of the subject, since little of the original story is preserved in them: the woman is shown playing either with the man's heart, or with his head, as a symbol of how she and her seductive sensuality have stolen both his feelings and his sense of reason.

In a small etching and in similar drawings dating from 1895, a naked woman is depicted lying on her side, holding the head of a bearded man at arm's length. In 1896 Munch made the woodcut of *Man's Head in Woman's Hair* (cat. 37), in which this image is given a highly decorative and striking effect. The woman's face is shown in profile with her long, flowing hair encircling the man's head, which is presented frontally below hers. The man bears a strong resemblance to Stanislaw Przybyszewski, who also appears in Jealousy (cat. 32), *Red Virginia Creeper* (cat. 57) and *Golgotha* (cat. 58).

In 1897, this woodcut was used as the starting point for Munch's first poster for a major exhibition at the Diorama Hall in Christiania (fig. 21). He made a frottage based on the key plate and had this transferred to a lithographic stone, thereby allowing the woodcut to be printed lithographically. A multicoloured version of this woodcut was also used as the cover for a print portfolio, which was advertised in the exhibition catalogue. The portfolio, titled *The Mirror*, was to contain graphic versions of all his major images. This gives some indication of the importance that Munch attached to the motif as a symbol representing his artistic output. One may also see it in terms of the creative artist transforming his pains and sorrows into enduring works of art.

GW

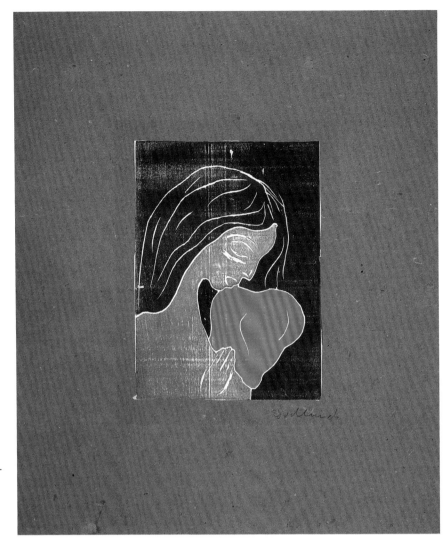

38 The Heart

1899

Woodcut, 25.2 x 18 cm (10 x 7 in.). Oslo, Munch Museum.

This woodcut was made in 1899 in a fairly small format but with a striking, decorative effect. The wood block is divided according to the various pictorial elements and inked with clear, strong colours: black for the background and the woman's hair, green for her face and body, and scarlet for the heart. The composition almost repeats the theme of *Man's Head in Woman's Hair* (cat. 37), which was made three years earlier, but the decapitated head of the man is now replaced by a bloody heart. Thematically, it is natural to consider these motifs in conjunction with each other –

there is little doubt that it is the man's heart that the woman is literally playing with, thus causing him sorrow and pain. This is the principal theme for a large part of Munch's art of the 1890s, whether the woman is represented as Salome, as a vampire or as a wood nymph.

Munch repeated the motif of the seated woman and the heart in 1898 when he made the illustrations to accompany Strindberg's texts for the German periodical *Quickborn*.

GW

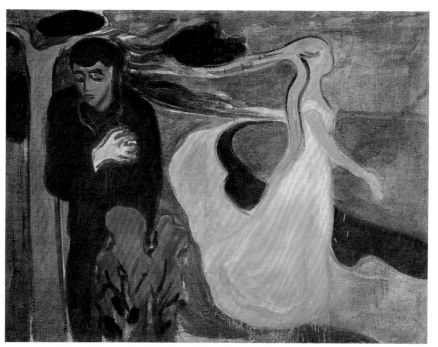

39 Separation

1896

Oil on canvas
96.5 x 127 cm (38 x 50 in.)
Oslo, Munch Museum

Separation seems a notably simple,
straightforward composition, the rapid,
spontaneous brushstrokes suggesting a
confident, inspired execution. Very thin
paint has been applied to an unprimed
canvas, which has absorbed the colour
and resulted in a matt surface, with the
nap of the canvas intact. The colours
are divided into independent areas,
delimited by soft, sinuous lines. Their
harmonies are subdued and dominated
by an elegiac shade of violet, while the
picture's overall character is one of a
rare, decorative elegance.

In Munch's pessimistic vision of love,
Separation represents the inevitable
denouement. The composition is based
on *Sphinx* (cat. 24), but is its mirror-
image and lacks the two central figures.
Towards the right of the composition,
the young, fair-haired woman walks
solemnly towards the sea. To the left,
against a tree trunk, a dark male figure
stands with his head bowed and one
hand on his chest. A blood-red plant
grows at his feet, while his hand is
drawn in the same crimson. His heart is
bleeding. 'All art, literature as well as
music, must be produced by one's life-
blood,' was Munch's maxim, and he
habitually deployed the plant as a meta-
phor for this idea.

Here, pain is manifestly caused by
the woman's abandonment of the man.
Her long, golden hair is entwined
around his head and chest. A similar
symbolic use of hair is also found in
Eye in Eye (cat. 14) and *Attraction II*
(cat. 13). In one of his pronouncements
on the theme of *Separation* Munch
declared: 'When you left me over the
sea, it was as if fine threads still united
us – it pained me like a wound.'

The grieving man forms the focus of
the painting. The woman has no facial
expression and is represented as an
ethereal fairy-tale princess. The land-
scape's idealised 'archetypal' character
intensifies the dreamlike unreality of the
scene. Munch referred to this female
type as 'the saint', 'the ideal woman'
and 'the yearning woman'. Perhaps the

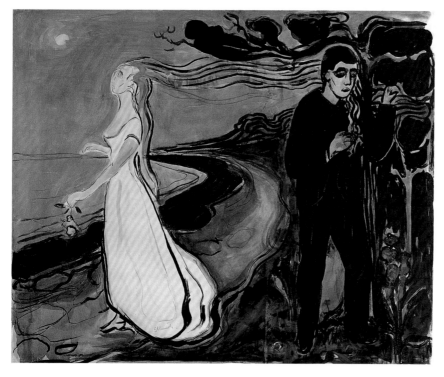

40 Separation I 1896
Lithograph and watercolour
44 x 54.5 cm (17¼ x 21½ in.)
Bergen, Rasmus Meyer Collection.

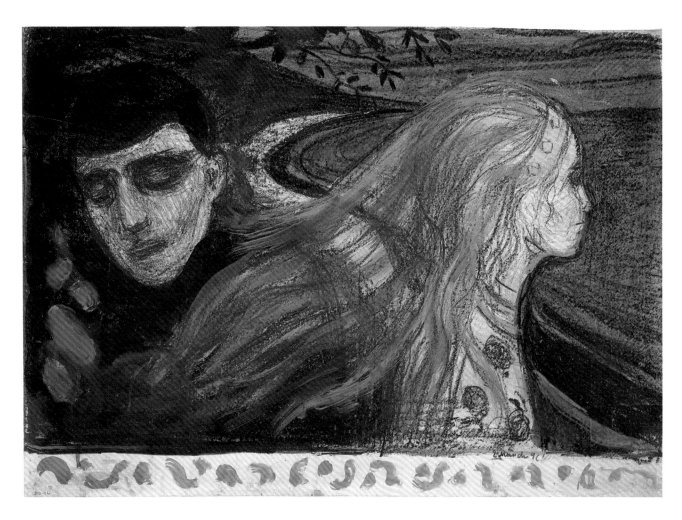

41 Separation II 1896

Lithograph
41 x 62.5 cm (16¼ x 24½ in.)
Oslo, Munch Museum.

pain is caused by the man having to abandon his illusion of the pure, perfect woman?

The lithographic version of the motif from 1896, *Separation I* (cat. 40), was completed using lithographic ink, while the finer details were scratched into the stone. Here, the man is depicted full length and the woman holding flowers, as in *Sphinx*. It has characteristics in common with contemporary art nouveau illustration. In *Separation II* (cat. 41), the couple are brought closer together and closer to the picture plane. Munch used lithographic chalk to give the drawing an exquisite richness of nuances. The woman seems frail and vulnerable and resembles the figure in the lithograph of *The Sick Child* from the same year (cat. 72), which was based on Munch's memories of his sister Sophie's death. In *Separation II*, the woman is wearing a jewelled headband and a floral dress. Her translucent hair rests like a

veil over the man's shoulder, revealing the slender nape of her neck. In this hand-coloured version the sea and the sky are dark blue, and the woman's head is highlighted. The spots of red to the left of the picture must be related to the man's 'bleeding heart', while crimson appears like a bloodstain on the woman's hair: 'its finest threads were wound around my heart.'

F H

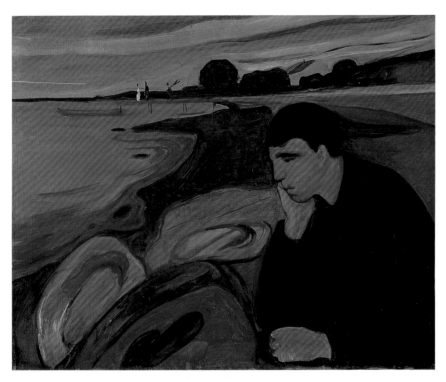

42 Melancholy

1894-5

Oil on canvas
81 x 100.5 cm (32 x 39½ in.)
Bergen, Rasmus Meyer Collection.

During his second period in France from 1889 to 1892, Munch experimented with most of the modern styles that he encountered in Paris, but it was the example of the most radical artists that was the principal inspiration for his own expressive and emotional idiom. Among the Post-Impressionists, who included Toulouse-Lautrec and Van Gogh, Munch attached particular importance to Gauguin. The conflict in Munch's art during these years corresponds closely with the struggles elsewhere in contemporary intellectual life, not least in literature. The development of his evocative powers was greatly influenced by the static, suggestively charged dramatic art of Maurice Maeterlinck. The Danish Symbolist poet Emanuel Goldstein was another influence.

In 1891 Munch painted the first version of *Melancholy, Yellow Boat* (National Gallery, Oslo). In the same year he painted another version (cat. 44), and exhibited both at the Equitable Palace in Berlin in 1892-3. From a pictorial as well as a thematic point of view, these paintings establish the keynote of the cycle of pictures he later called the Frieze of Life. Although the influence of Gauguin's Synthetist painting is evident, Munch developed a style which was unmistakably his own.

The model for the slumped figure in the foreground of *Melancholy* was the 21-year-old Jappe Nilssen. In the summer of 1891, Munch witnessed his friend's passionate infatuation with Oda Krohg, a woman ten years his senior and a prominent member of the Christiania-Bohème. The scene describes how Jappe, consumed with jealousy, is left alone on the beach while Oda and her husband, the painter Christian Krohg, prepare for a boat trip on a light, Nordic summer night. In a literary note Munch combined his impressions of Jappe's situation with his memories of his own passionate love during his youth for Millie Thaulow, alias 'Mrs Heiberg':

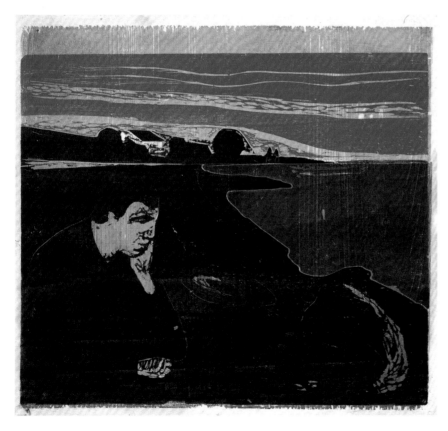

43 Melancholy 1896
Woodcut, 41 x 41.5 cm (16 x 16¼ in.). Oslo, Munch Museum.

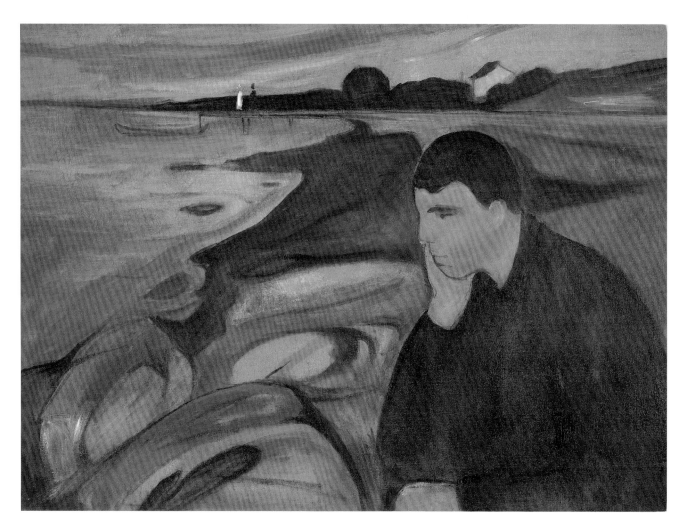

44 Melancholy 1891

Oil on canvas
72 x 98 cm (28¼ x 38½ in.)
Private Collection.

I hear the sighs and rustlings between the stones – on the horizon the grey elongated clouds – everything feels extinct – in another world – a ghostlike landscape – but someone is coming over there on the jetty – a man and a woman – they are now walking out along the long jetty – towards the yellow boat – and behind them a man carrying oars – Oh it is her – her walk – her movements as if she was standing there, her hands on her hips – oh but I know she is many miles from here.[1]

As early as 1891, Krohg described *Melancholy* as the first Symbolist or Synthetist painting in Norwegian art. The picture represents a state of mind rather than a course of action. Its shapes are drawn as large simplified surfaces. The shoreline curves in a suggestive and undulating rhythm into the depth of the pictorial space, where the sonorous blue-violet colouring is broken by the white house and the yellow boat.

Five painted versions of this subject are known, each expressing new formal and pictorial qualities; the version in Bergen (cat. 42) dates from 1894-5. Between 1896 and 1899 Munch produced woodcuts of a number of his Frieze of Life motifs, of which *Melancholy* (cat. 43) was one.

IY

1. Eggum 1990.

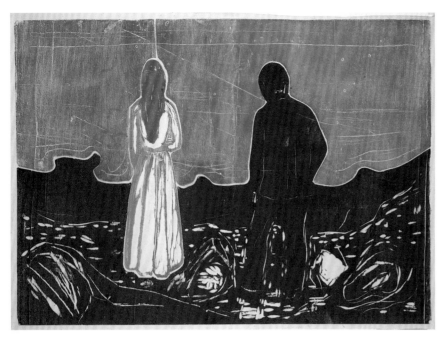

45 Two People

1899-1916
Woodcut, 39.5 x 53 cm (15½ x 21 in.). Oslo, Munch Museum.

The painting *Two People* dating from 1891-2 was lost in a shipwreck in December 1901. However, a black and white photograph of the painting taken at the 1892 exhibition in Berlin survives.

Munch repeated the motif in one of his first-ever drypoints, and although the image is reversed as a result of being drawn with a drypoint needle directly onto the copper plate, the print seems to be a faithful copy of the painting. Nevertheless, the mirror-image appears to have created an imbalance in the composition, which Munch tried to counteract in later versions by inserting a row of stakes in the water on the man's right, similar to those in the painting *Inger on the Beach* (Rasmus Meyer Collection, Bergen). The drypoint was part of a series of eight intaglio prints published by Meier-Graefe in 1895.

In 1899 Munch also produced a colour woodcut of *Two People* (cat. 45), again as a mirror-image of the painting. The woodcut, made from a single block cut into three pieces with a fretsaw, demonstrates Munch's 'jigsaw puzzle' technique at its best. In the print, the crevices between the separate pieces stand out as white contours between areas of colour, which contribute to the tautness of the composition. The woodcut exists in several states and in many colour combinations. Some of the prints have Munch's characteristic moon and column motif, created by using stencils, but in others these elements have been omitted. In 1917, he printed a number of new, richly coloured copies from this block.

GW

46 Young Girl on the Shore

1896

Aquatint with scraper and drypoint on zinc
28.2 x 21.7 cm (11 x 8½ in.)
Oslo, Munch Museum.

This beautiful colour print of a young woman dressed in light-coloured clothes standing looking out to sea is made using a technique known as scraped aquatint. The plate, which is made of zinc, was probably bought with a ready-made surface prepared with aquatint that allowed the artist to work directly onto the plate, burnishing the lighter parts of the motif. The colouring was done with a tampon immersed in ink, making each impression of the plate unique. Eleven copies of this motif are known, printed in a broad spectrum of soft colours ranging from deep blue-black to a light yellow. The print was executed and pulled in Paris in 1896-7, roughly at the same time as Munch designed a variant of the image for the programme of Ibsen's play *Peer Gynt*.

The first ideas for of this motif are in a sketchpad dating from 1891, which includes several drawings of the woman standing beside a tree trunk. One of the sketches may have been intended as a cover illustration for a collection of poems by Munch's close friend, Wilhelm Krag. Around this time Munch was also working on the painting *Two People* (see cat. 45), in which a man dressed in dark clothes is drawn towards the paler figure of the woman.

GW

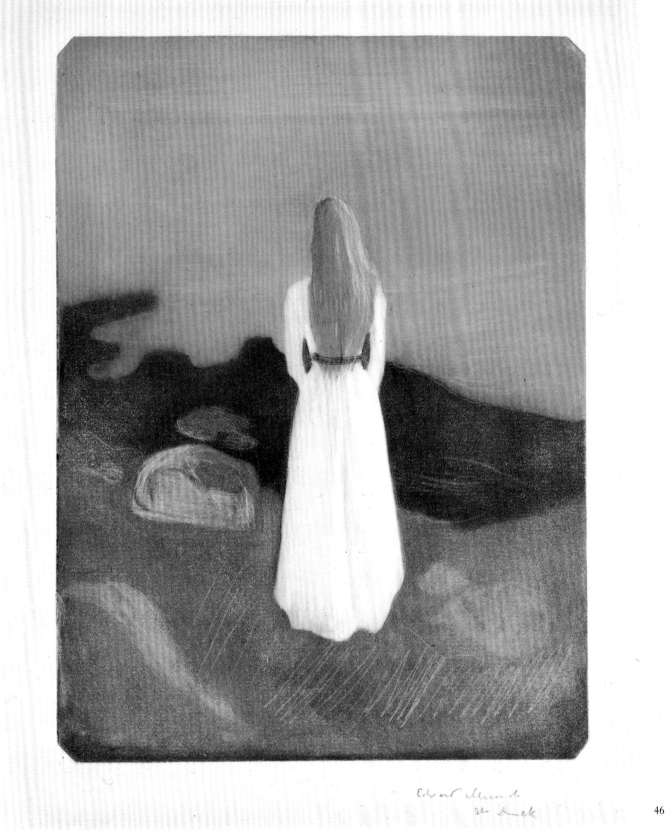

Edvard Munch
2r Druck

46

47 Metabolism

1899

Oil on canvas
172 x 143 cm (67¾ x 56¼ in.)
Oslo, Munch Museum.

In a dark wood a man and woman stand facing each other on either side of a pine tree. The composition is closely related to that of paintings such as *Eye in Eye* (cat. 14), but to a lesser degree than other Frieze of Life motifs is it 'a painting of the modern life of the soul'. Munch himself stated that *Metabolism* was 'somewhat removed from the concept but is as necessary to the frieze as a whole as a buckle is to a belt.'[1] At the same time he linked it to his mural projects of 1909-14, which deal with 'the great perpetual powers': 'The Frieze of Life and the University decorations both meet in the large painting, Man and Woman in the wood with the golden city in the background.'

At the top of the painting's carved frame is the silhouette of a town, and at the lower edge are roots and two skulls – one human, the other animal, thus linking the Christian perception of the 'kingdom of death' with the 'heavenly Jerusalem'. The picture's title indicates that a biological perspective is central, as in *Death and the Maiden* (cat. 60). In one of his notes, Munch describes the Frieze of Life as 'the way of the law', that is, the law of nature, in accordance with a pessimistic determinism anchored in biology. In another he wrote: 'Love is the law of propagation.' The preoccupation with 'propagation' was explicit in the painting's original form, which was painted over and altered some time between 1903 and 1918. As the illustration (fig. 28) shows, there was originally a luxuriant plant growing between the man and the woman, and in the middle of this plant, a human foetus appears, which is still visible in the painting.

FH

1. Munch *c.*1918.

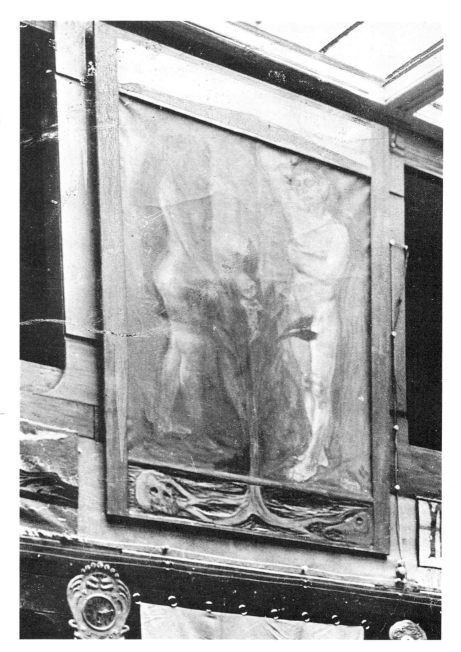

Fig. 28

Metabolism, photographed during Munch's exhibition in Leipzig in 1903.

Photograph
Oslo, Munch Museum.

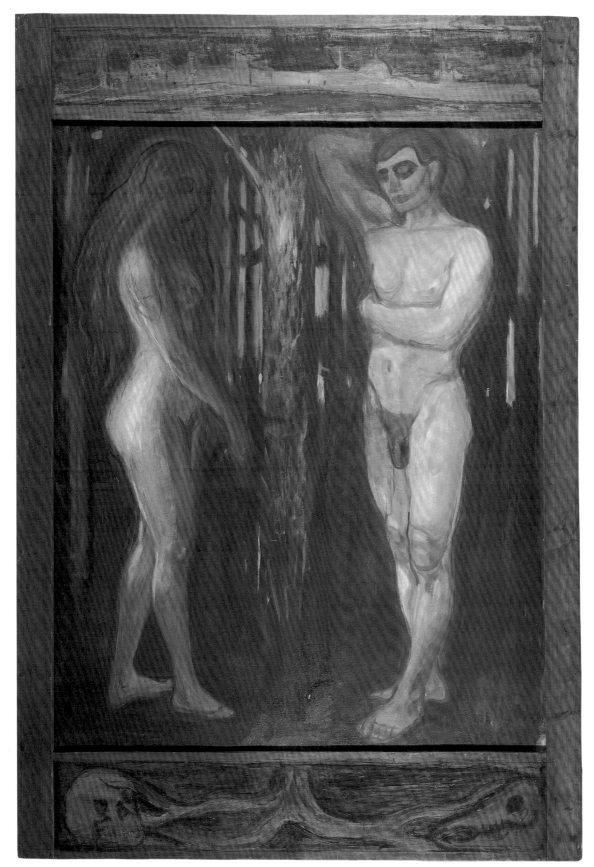

47

Anxiety

I saw all the people behind their
masks – smiling phlegmatic
composed faces
I saw through them and
there was suffering – in them all
pale corpses – who
without rest ran around
along a twisted road
at the end of which
was the grave

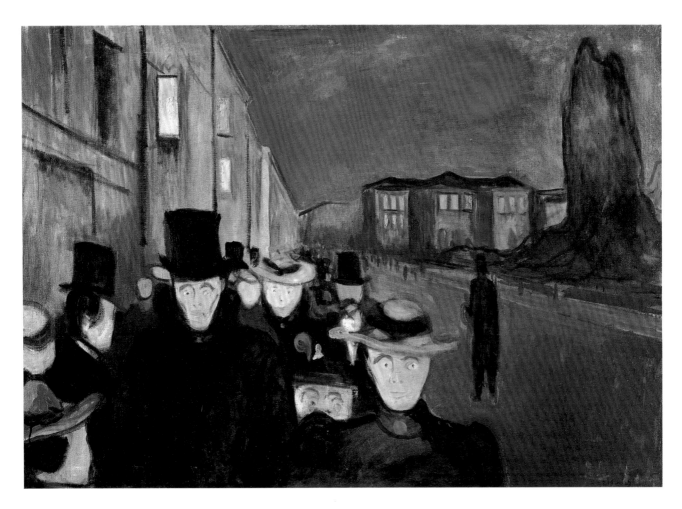

48 Evening on Karl Johan

1892

Oil on canvas
84.5 x 121 cm (33¼ x 47½ in.)
Bergen, Rasmus Meyer Collection.

In the latter part of the nineteenth century scenes of the hectic life of big cities were common in European painting. By various formal, stylistic and thematic means, the Realists, Naturalists and Impressionists had conquered the city, that primary subject for the painter of modern life. Munch's urban scenes dating from the early 1890s are rather conventional, though competently executed, experiments, using a variety of Impressionist techniques. However, his painting *Evening on Karl Johan* conjured up a human drama that his contemporaries had difficulty in imagining and even more difficulty in accepting. Christiania's main street is shown from the Royal Palace looking towards the Storting, the parliament building, in a radically foreshortened perspective. Squarely facing the advancing crowd, the viewer is forced into direct confrontation with the seemingly never-ending procession of ghost-like figures. Like crazed souls from a differ-

ent, hopeless world, their eyes stare vacantly out at us from sallow, mask-like faces. The sun is about to set, its last rays reflected in the window panes. Under a gloomy, deep-blue evening sky, the back of a lonely figure is seen hurrying down the middle of the empty street. A group of trees rises ominously on the right: a pictorial element analogous to the shadow in *Puberty* (cat. 59).

Evening on Karl Johan is the first painting in which Munch presents his figures with ghostly, mask-like countenances. The work of the Belgian Symbolist artist Ensor is generally regarded as the inspiration for these *angst*-ridden faces. But though some of Munch's drawings can be said to reflect Ensor's masterpiece, *The Entry of Christ into Brussels*, 1889 (Malibu, Getty Museum), there are few direct indications to support this argument.

Munch recorded his first sketch-like versions of this motif, together with a lengthy descriptive text, in his so-called

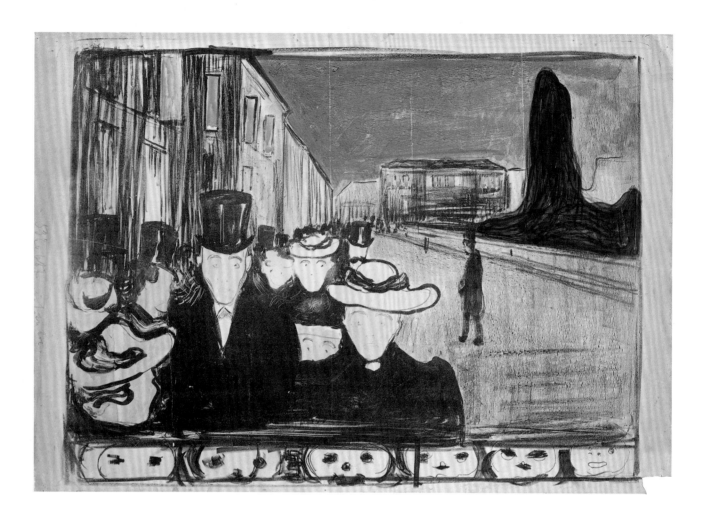

49 Evening on Karl Johan 1895

Lithograph
53.5 x 68.5 cm (21 x 27 in.)
Private Collection.

illustrated diary in 1889. The text reflects the artist's agonising infatuation with 'Mrs Heiberg' four years previously. He roams restlessly up and down the length of Karl Johan looking for her:

And there she came at last ...The people passing him looked so strange and unfamiliar and he thought they were looking at him – staring at him – all these faces – so pale in the evening light. He was trying to hold on to a thought but could not... I'm about to fall and people will stop and there will be more and more people – a frightful crowd...

then he looked at the window high above shining as bright as gold against the dark air – looked at it almost as if he wanted to hold on to it.[1]

The border of masks along the bottom edge of the lithographic version of the motif (cat. 49) may be interpreted as an expression of Munch's wish to emphasise that the picture exists between two planes of reality. There is only a single hand-coloured copy of this lithograph.

IY

1. Eggum 1990.

51 Despair

1893-4
Oil on canvas
92 x 72.5 cm (36¼ x 28½ in.)
Oslo, Munch Museum.

In November 1891 Munch travelled to France with the Norwegian painter Christian Skredsvig, who wrote in his memoirs:

For some time he has wanted to paint the memories of a sunset. Red as blood. No, it *was* coagulated blood. He talked sadly about what had consumed him with fear... He longs for the impossible and has despair as his religion, I thought, but advised him to paint it.[1]

Munch himself described an early version of *Despair* (fig. 29) as 'the first scream'.[2] A thin male figure stands leaning against a railing staring at the landscape. The sky above is flaming red. The rest of the picture is painted in subdued grey-blues, with restless brushstrokes creating an atmospheric effect. In the drawing of the same period (cat. 50) Munch limited the use of colour to the sky's blood-red fiery tongues. The drawing is accompanied by a text on the same sheet of paper, one of many accounts of the experience that is often referred to in connection with *The Scream* (cat. 52).

The Munch Museum's version of *Despair* (cat. 51) is a later one, dated by Arne Eggum to 1893-4. The colours are vibrant in comparison with the Stockholm version, the sky painted in ribbons of saturated reds and yellows. The black contours affect both the foreground figure and the landscape. The pitch of the colour, with the dominating shade of violet in the landscape, and the reflection of light from the sunset accentuating the diagonal line of the railing, are also found in the painting *Anxiety* (cat. 54).

The dark shape of the foreground figure in *Despair* is turned away from the landscape, revealing a pale, stylised face with dark, deep-set eyes. As in *Jealousy* (cat. 32) and *Red Virginia Creeper* (cat. 57), the background operates as a reflection of the mood of the person in the foreground. The figure with the bowed head and prominent eyes is an often recurring motif: it appears in *Sphinx* (cat. 24) and *Separation* (cat. 39), for example. The inspiration for the background, which

50 Despair 1892

Charcoal and gouache
37 x 42 cm (14½ x 16½ in.)
Oslo, Munch Museum.

Fig. 29 Despair 1892

Oil on canvas
92 x 67 cm (36¼ x 26½ in.)
Stockholm, Thielska Gallery.

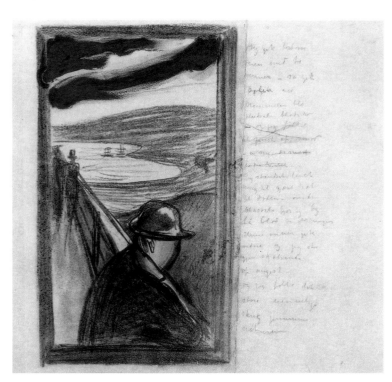

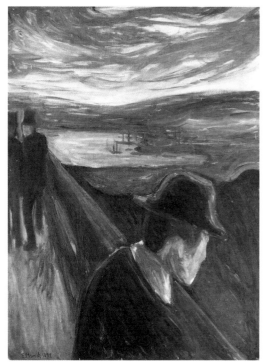

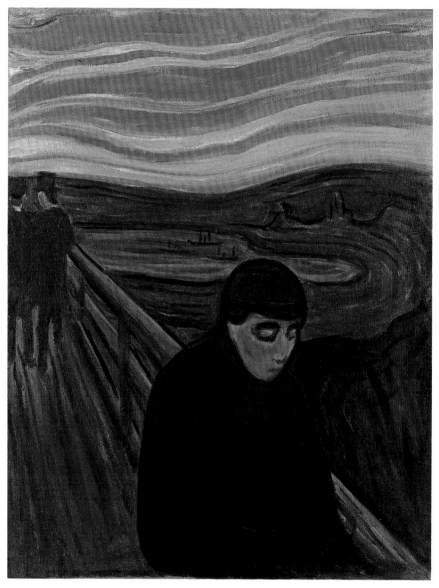

51

52 The Scream

1893

Tempera and pastel on board
91 x 73.5 cm (35¾ x 29 in.)
Oslo, The National Gallery.

The Scream is probably Munch's best-known painting. The foreground is dominated by a summarily drawn figure in a dark coat, his hands covering his ears, his eyes and mouth wide open. He appears on a path with railings that recede diagonally towards the left of the picture. In the background, two tall figures in dark clothes walk along the road. Below the road is a view of a yellow fjord, ringed by dark blue hills. Two boats sit on the fjord and the buildings of a town are suggested at its furthest point. A blood-red and yellow sky arches above. Sweeping, curved lines prevail; the figure in the foreground, the landscape, and the sky all seem caught up in one great swirling motion. The only straight lines are formed by the path and its railing, and the two figures in the background.

Like so many of the Frieze of Life paintings, the origins of this theme can be traced to events in the artist's life. In his literary diaries of the 1890s, Munch described the event:

I was walking along a path with two friends
the sun was setting
I felt a breath of melancholy
Suddenly the sky turned blood-red
I stopped and leant against the railing, deathly tired
looking out across flaming clouds that hung like – blood and a sword over the deep blue fjord and town
My friends walked on – I stood there trembling with anxiety
and I felt a great, infinite scream pass through nature.

Munch often referred to this text. The event described took place on a trip to Ekebergsåsen, and the painting shows a view of Christiania, with its fjord and hills. Munch clearly regarded the text as important in understanding the theme. In 1895, when he made lithographs of the motif, he added on several of them the following text, below the picture: 'I felt a great scream pass through nature' (cat. 53).

Munch first expressed the sensation of anxiety experienced during the walk

Munch repeated in many variations, may have been Van Gogh's undulating landscapes, where the expressive drawing can be interpreted as a projection of the artist's state of mind. The marked flatness and the contour lines clearly have their origin in Gauguin's art.

From the 1880s, melancholy was a basic theme in Munch's art. In a short article in a leaflet from 1890, Munch wrote, 'Symbolism: Nature is formed by one's mood.' This statement also represents a central artistic ambition that is strikingly expressed in the anxiety motifs of the Frieze of Life.

FH

1. Skredsvig 1908.
2. Eggum 1990.

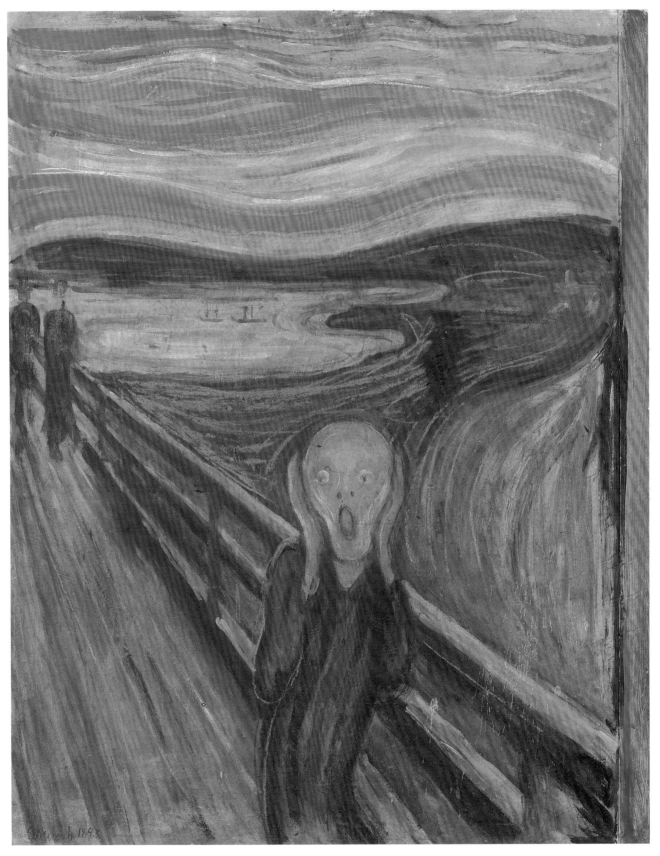

52

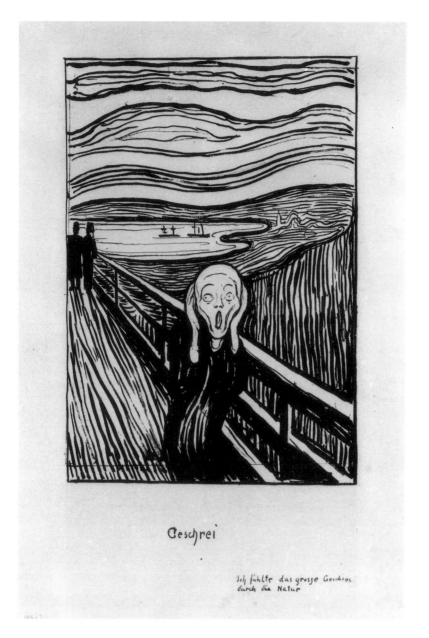

Geschrei

Ich fühlte das grosse Geschrei durch die Natur

53 The Scream 1895
Lithograph
35.5 x 25.4 cm (14 x 10 in.)
Oslo, Munch Museum.

at sunset in the painting *Despair* (cat. 51). By following his treatment of this theme from this work through to *The Scream*, it is possible to observe how the foreground figure is developed to personify the state of anxiety. The final version of this motif was produced in Berlin in 1893. Two paintings and two pastels remain. These works have become icons of man's anxiety, fear and alienation. However, the composition and colour show that man is at one with nature and with the universe. Ever since Munch first exhibited the Frieze of Life paintings as a series, *The Scream* has been one of the key paintings of the anxiety theme.
TS/EL

54 Anxiety

1894

Oil on canvas
94 x 73 cm (37 x 28¾ in.)
Oslo, Munch Museum.

In his folio of important motifs, *The Tree of Knowledge for Better or Worse*, Munch wrote about *Anxiety*: 'I saw all the people behind their masks – smiling, phlegmatic – composed faces – I saw through them and there was suffering – in them all – pale corpses – who without rest ran around – along a twisted road – at the end of which was the grave.'

 Anxiety was made in 1894 and can be roughly described as the stream of people from *Evening on Karl Johan* (cat. 48) transposed to the setting of *The Scream* (cat. 52). It is difficult to imagine that a direct personal experience lies at the heart of *Anxiety*, which seems much more typical of a symbolic composition, with its highly concentrated expression of moods and emotions, as seen in both of the earlier paintings.

 The perspective, emphasised by the diagonal lines of the rail, the steep descent towards the town and the fjord, and the violent motion of the sky with its blood-red clouds, underlines the rigidity and deathly pallor of the human faces staring straight ahead. The contrast in itself is alarming and contributes to the overall feeling of insecurity and anxiety. An underlying aura of anxiety, about death as well as life, pervades much of Munch's art. In his paintings on this theme he also expressed a more general feeling of an entire society in decay.

 Soon after his arrival in Paris in early 1896, Munch contributed to Vollard's graphic portfolio *Les Peintres-Graveurs*. He made a lithograph of *Anxiety* (cat. 56) which was printed by Clot in black and red, inked onto one single lithographic stone. The effect of this print is if anything stronger than the painting. In the foreground there are now three female faces instead of just one, and the man with the pointed beard has been eliminated. The composition is a mirror-image of the painting without the dominating line of perspective created by the railing. The strong black lines are executed with broad ink-strokes

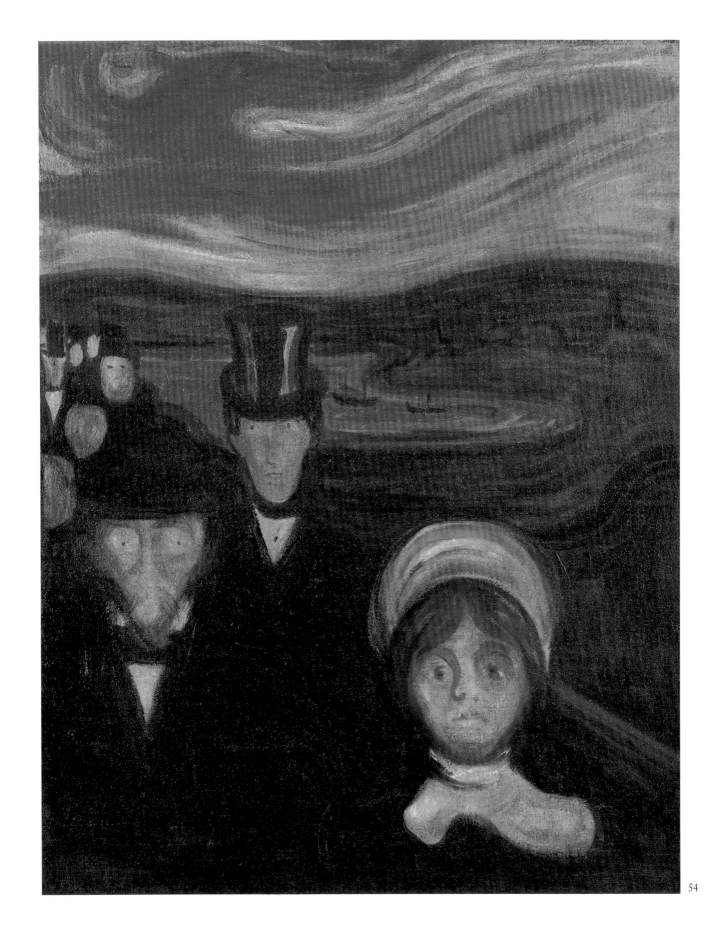

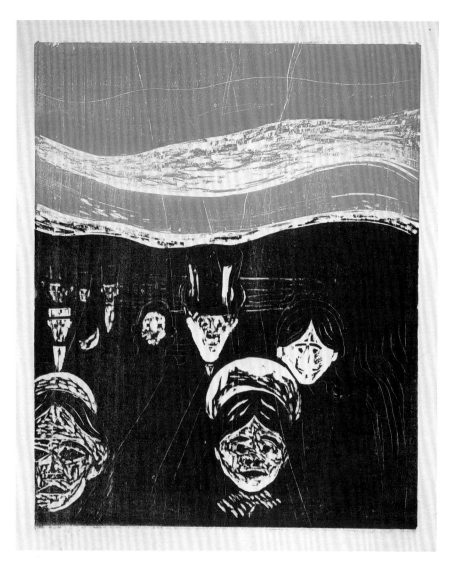

directly onto the stone, and the clothes are rendered as opaque black surfaces.

Munch also made a woodcut of this subject (cat. 55), probably some months after the lithographic version; the composition is similar to the painting except that the people are dispersed across the foreground, filling the lower part of the picture plane. The woodcut exists as a monochrome print in black or red, and as a two-colour print in red and black similar to the lithograph in the Vollard portfolio.

GW

55 Anxiety 1896
Woodcut
46.5 x 37.5 cm (18¼ x 14¾ in.)
Oslo, Munch Museum.

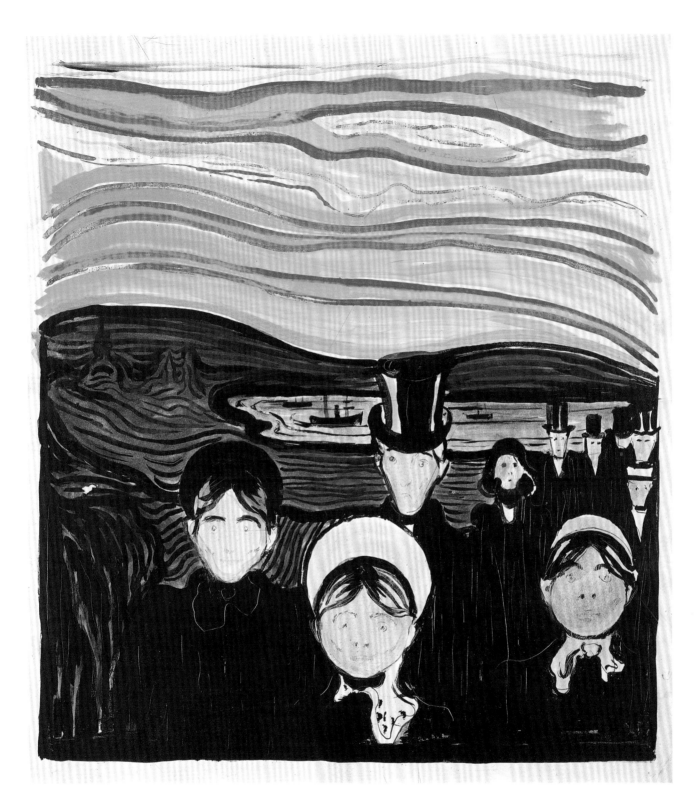

56 Anxiety 1896
Lithograph
42 x 38.7 cm (16½ x 15¼ in.)
Oslo, Munch Museum.

Fig. 30 Garden Sculpture 1896
Watercolour
52.8 x 53.4 cm (20¾ x 21 in.)
Oslo, Munch Museum.

57 Red Virginia Creeper

1898-1900

Oil on canvas
119.5 x 121 cm (47 x 47½ in.)
Oslo, Munch Museum.

Red Virginia Creeper has a more open
composition than earlier motifs in the
Frieze of Life. The large house that
towers in the background has been
given a strong, spacious perspective.
But the male figure in the foreground is
not integrated in this space; he seems to
inhabit his own plane close to the pic-
ture's surface. This principle of
composition had its clearest forerunner
in the painting *Jealousy* of 1895 (cat.
32). There the figure inhabits the bor-
der between the world of the viewer
and the world of the painting, at the
point where the viewer 'enters' the pic-
ture. The staring face with the pointed
beard carries with him a vision of the
scene depicted in the background – to
paraphrase Werner Hofmann.[1]
 The house can be identified as the

Kiøsterud building in Åsgårdstrand,
which Munch also used in his painting
of *Girls on the Bridge*. However, in *Red
Virginia Creeper* the house is transmogri-
fied from architecture to psychology. It
seems as if the house is being strangled
by the flaming, blood-red creeper. 'To
[Munch] a house is a spiritual creature,
Curt Glaser wrote; 'The windows are
the eyes...'[2] The two accentuated win-
dows on the ground floor can be
interpreted as a veiled reflection of the
staring expression of the figure in the
foreground. A covered veranda in the
middle of the wall heightens the anthro-
pomorphic effect of the claustrophobic
atmosphere.
 There are interesting associations
between *Red Virginia Creeper* and a
watercolour of 1896 (fig. 30). In the
foreground of the watercolour the torso
of a man in pain is being grabbed from
behind by a dark creature emerging
from the ground. The two other ele-
ments in the picture can be interpreted
as metaphors for the same drama: to the
right a dying tree is being choked by a
luxuriant bush, and in the background a
house is stifled by red Virginia creeper.
In the painting, too, the bare tree is for-
mally linked to the man's head. Thus
Red Virginia Creeper represents a strik-
ing illustration of the inner consistency
of Munch's intricate personal symbol-
ism. Anxiety and horror are conveyed,
however, by the composition and by the
articulation of colour, without the need
of overt symbolic references.
FH

1. Hofmann 1954.
2. Glaser 1917.

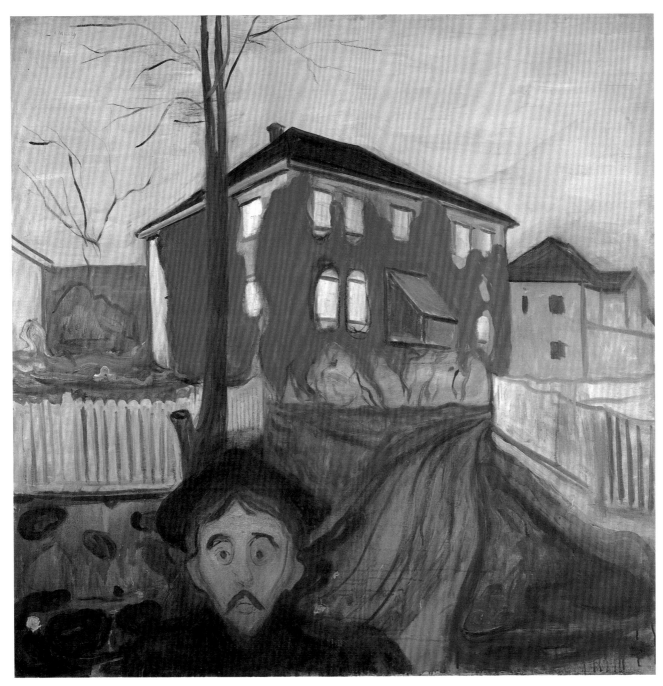

57

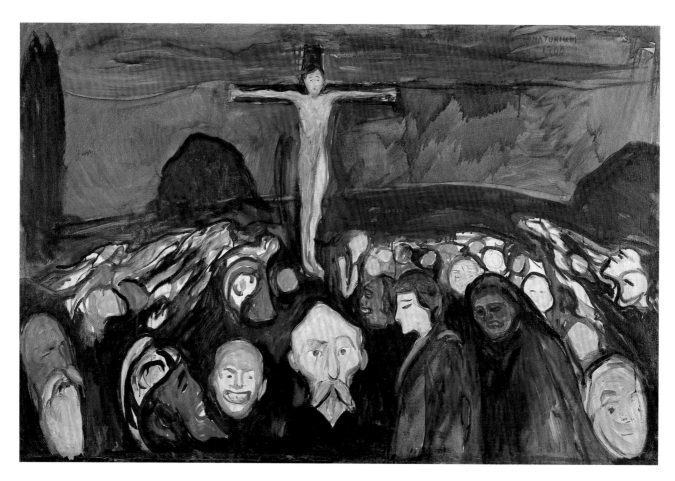

58 Golgotha

1900

Oil on canvas
80 x 120 cm (31½ x 47¼ in.)
Oslo, Munch Museum.

In *Golgotha* Munch used Christian
iconography to describe his situation as
an artist at the beginning of the new
century. A strenuous decade lay behind
him, mainly spent abroad seeking
artistic recognition.

The painting was created in the Korn-
haug Sanatorium where Munch went in
the autumn and winter of 1899 to regain
his physical and mental strength. The
crucified yellow body standing amid and
yet above the crowd glows against a
gloomy blue sky. The blood-red cloud
that drifts across the sky, parallel with
the figures' outstretched arms, high-
lights the dramatic scene. In the middle
ground of the composition only the
heads and arms of the angry, surging
crowd are clearly visible, as they stretch
out towards the crucified figure. Several

faces in the foreground are distinctly rec-
ognisable. The man with the beard on
the left resembles Munch's former
teacher Christian Krohg. To his right,
next to a helmeted bailiff, the malevo-
lently grinning face of Gunnar Heiberg
and the more thoughtful features of
Stanislaw Przybyszewski confront the
viewer. The latter's emaciated face with
its pointed beard recurs in *Red Virginia
Creeper* (cat. 57) of the same year and
Jealousy (cat. 32). To his right is Munch
as a young man, his pale face depicted
in profile. The woman dressed in black
behind him could be Munch's aunt,
Karen Bjølstad. Her weary face and the
consoling hand placed upon his shoulder
may express her premonition of her
nephew's future unhappiness in his
struggle to be accepted as an artist. Her
apprehension seems to be confirmed as
the bailiff turns towards the young
Munch with a malicious grin and the
crucified victim is handed over to the
surging mass as a sacrifice.

It is likely that Munch identified him-
self with the Christ figure. There was

rarely any serious critical discussion of
his work and the typical reaction of the
press, the public, and many of his artist
colleagues, was one of derision, vilifica-
tion and the accusation of madness. His
despair is expressed in a letter, presum-
ably written at Kornhaug, to Tulla
Larsen: 'I have neither the moral nor
physical strength left to exhibit my own
paintings – my work of the last three
years – for me, whose home is else-
where rather than on this earth – that is
a serious matter.' His despair is under-
lined in the painting by the expressive
technique. At the turn of the century
many artists experienced a similar feel-
ing of alienation from the world. When
Munch secularised Christian ideas in
Golgotha, he aligned himself with artists
such as Ensor and Gauguin, who com-
pared their role as outsiders with that of
Christ.[1]

I M-W

1. See Hougen 1968.

59 Puberty

1894-5

Oil on canvas
151.5 x 110 cm (59½ x 43¼ in.)
Oslo, The National Gallery.

Puberty depicts a young adolescent girl sitting tensely on the edge of her bed. Her legs are pressed tightly together, and she hides part of her slender, immature body behind thin, crossed arms. One hand is pushed between her knees, the other lies on her thigh. She stares straight ahead with wide-open, terrified eyes. The gaze is directed outwards but at the same time has a look of introspection. The small mouth is tightly closed and her long, dark hair falls down over her shoulders.

The young girl is the focal point of the picture. Unimportant details around her are treated simply, whereas her body receives greater attention. There is a sharp contrast between the horizontal lines of the bed and the girl's vertical position. The light falls from the left of the picture, and a dark menacing shadow looms on the wall behind her, accentuating the feeling of anxiety that emanates from her body. It is possible to interpret the shadow as a phallic symbol, representing the threshold of sexual life; but it could also be the impending shadow of death. Whatever the interpretation, the shadow – menacing and intangible – symbolises anxiety and fear, as in several of Munch's paintings in the Frieze of Life. This theme is probably based on Munch's recollections of his sister Sophie's first years of puberty, before her death. The picture was painted when Munch frequented the Black Piglet café in Berlin, where death and sexuality were frequently the subjects of discussion.

Although the theme of puberty is not traditionally associated with the Frieze of Life, the picture is nevertheless a pivot for the major themes: anxiety, awakening sexuality, and love.
TS/EL

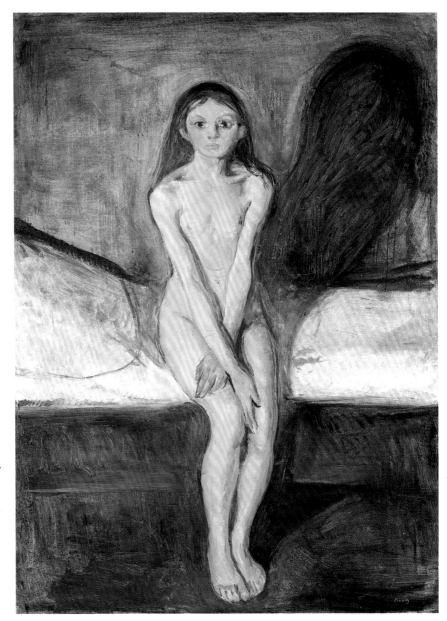

Death

Disease and madness and death
were the black angels
standing over my cradle

60 Death and the Maiden

1893

Oil on canvas
128 x 86 cm (50½ x 33¾ in.)
Oslo, Munch Museum.

Munch's childhood was coloured by a pious Lutheran upbringing strongly oriented towards the afterlife. From an early age, he distanced himself from Christian dogma and the 'over pious spirit' at home, though a persistent metaphysical inclination is often apparent in his art. An earthbound and steadfast element of his view of the world, however, can be linked to the popular scientific watchword of the 1800s – 'monism'. Biology provided the source of the apostates' credo: eternal life in eternal mass. Each of us takes part in nature's eternal cycle, and death means only that our atoms adopt new forms. 'From my rotting body, flowers shall grow and I am in them and that is eternity', wrote Munch.

When Munch talked about the painting *Madonna* (cat. 26), he described conception as the moment when 'Death holds out its hand to Life': intimately interlinked, Eros (Love) and Thanatos (Death) are the main poles in his pictorial world. This is the territory of the Symbolists. Related images can be found particularly in the work of the Belgian artist Félicien Rops. But whereas Rops demonstrates coquettish decadence in his paintings, Munch's work is characterised by unyielding gravity.

Death and the Maiden (cat. 60) depicts a voluptuous, naked woman and a skeleton in an intense embrace, but the picture lacks perspective and depth. The elements on either side function as decorative framing. To the left, red-brown lines move upwards in waves – they are the sperm cells representing life's beginning. To the right are two thin, foetal figures with their arms crossed over their breasts – the new life signalling that death is already close at hand. The sperm cells, moving determinedly in one direction, create the impression of a circular movement and thus highlight life's cyclical course.

These elements were also used in the

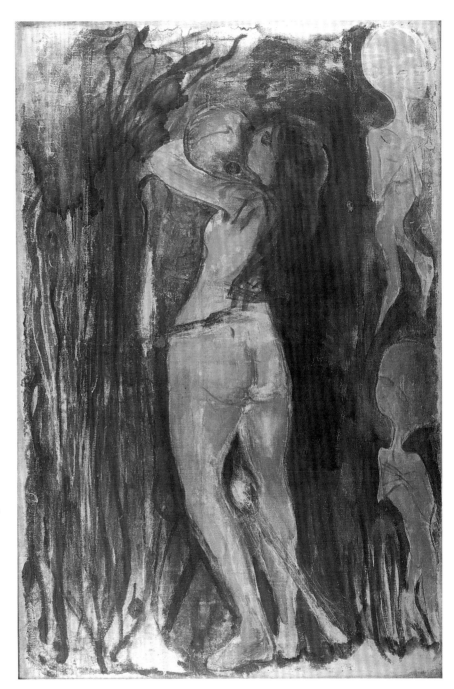

lithographic version of *Madonna* (cats. 27 and 28), and a lithograph from 1899 depicts the same female head kissing a skull. The gradual transformation of the theme as it appears in *Madonna* and *Death and the Maiden* focuses attention on love and death respectively.
FH

62 By the Deathbed (Fever)

1895

Oil on canvas
90 x 120 cm (35½ x 47¼ in.)
Bergen, Rasmus Meyer Collection.

Death was always a predominant feature of nineteenth-century bourgeois art – the dying person pictured in the bosom of the family, that smallest but most important institution of the bourgeoisie. Munch's death motifs are no exception in this respect. The numerous cases of serious illness within his immediate family were typical rather than atypical of the general state of public health at the time. Nevertheless, Munch's deeply personal exposure of private lives, in which agony, sorrow and despair were mediated through his own childhood memories, had not been seen before. In his own words: 'I painted only what I remembered without adding anything – without details I no longer saw. – Hence the simplicity of the pictures – the apparent emptiness.'[1]

By the Deathbed, also called *Fever*, reflects his memories of the death of his sister Sophie. Barely visible, she is lying in bed, seen from behind, her hands

61 Fever 1894

Gouache and pencil
31.6 x 34.8 cm (12½ x 13¾ in.)
Oslo, Munch Museum.

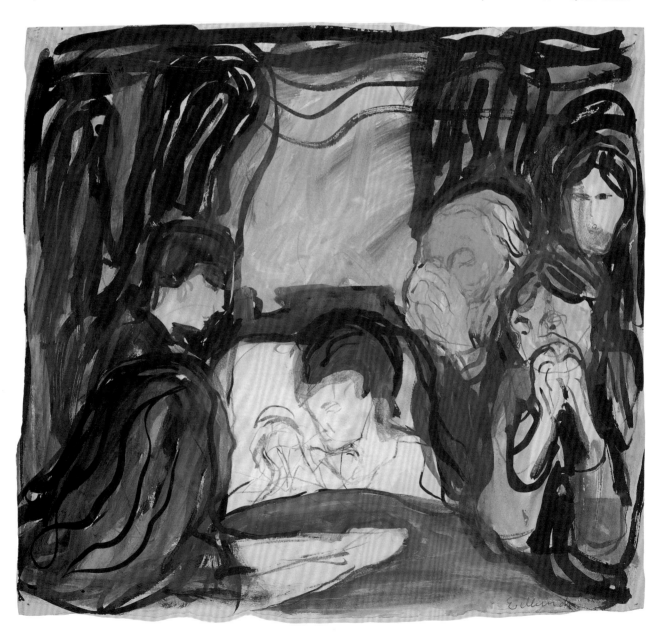

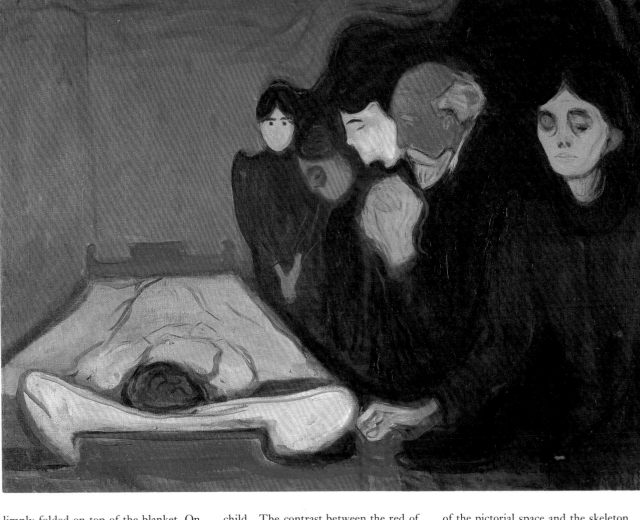

62

limply folded on top of the blanket. On the right, the whole family is standing together in a group – except Munch himself. Through the artist's eye, we see what she sees; we are forced to identify with the dying girl. The father's intense prayers are indicated by his folded hands, clasped together so as to form a sphere in which the fingers are barely distinguishable. The woman in the foreground can be identified as the long-dead mother. With her hand firmly gripping the bedpost, she is turning away from her sick child, her pale contemplative face presaging impending death.

This simple but highly effective composition is an expression of Munch's restrained mastery of his craft. The strongly foreshortened perspective leads the viewer's eye into the depth of the pictorial space, along the bed and towards the empty space above the sick child. The contrast between the red of fever and the pale green of disease dominates the colouring. The family, dressed in black as if in mourning, is unified by a dark shadow. Their faces alternate between deathly pale and agitated red, underlining the emotional and *angst*-laden impact of their inevitable meeting with death.

The painted version of the subject dates back to 1895. Munch had been working on the scene since 1893, sometimes as sketch-like pictures recalling his own childhood illness at the age of thirteen, and sometimes as impressions of the illness and death of Sophie. The 1894 gouache, *Fever* (cat. 61), depicts a tense family scene in which Edvard is lying in bed, with his father and three sisters fervently praying around him.

When Munch exhibited the 1893 pastel (cat. 63), reviewers thought the demon-like masks hovering at the back of the pictorial space and the skeleton behind the mother figure were fantasies caused by high fever. These elements were omitted from the painted version (cat. 62).

In the lithograph of 1896 (cat. 64), however, the masks reappear as part of the play of lines in the passage above the bed. Munch, writing in 1891-2 of his memories of his sister's death, has little Maja (Sophie) telling Karleman (Edvard) about her feverish dreams: 'Do you see that head there – that's Death.'[2] The ghost-like heads were thus woven into Munch's strongly subjective memory of his sister's death. In the lithograph the figure in the foreground resembles Karen Bjølstad, the aunt who adopted the maternal role in the Munch family after their mother's death.

IY

1. Eggum 1990.
2. Eggum 1990.

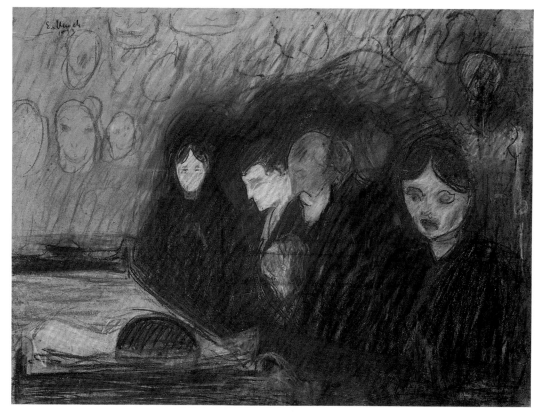

63
**By the Deathbed
(Fever)** 1893
Pastel on board
60 x 80 cm
(23½ x 31½ in.)
Oslo, Munch Museum.

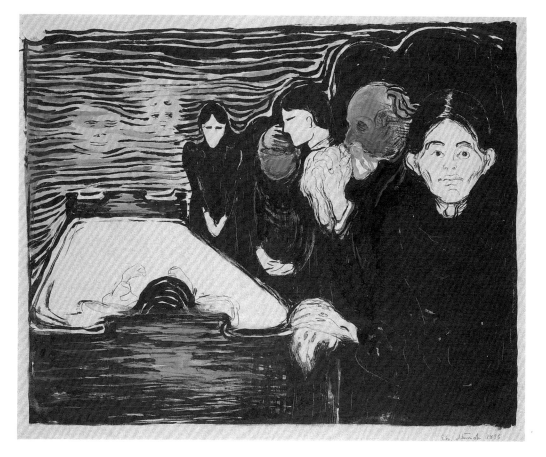

64
**By the
Deathbed** 1896
Lithograph
39.7 x 50 cm
(15½ x 19¾ in.)
Oslo, Munch Museum.

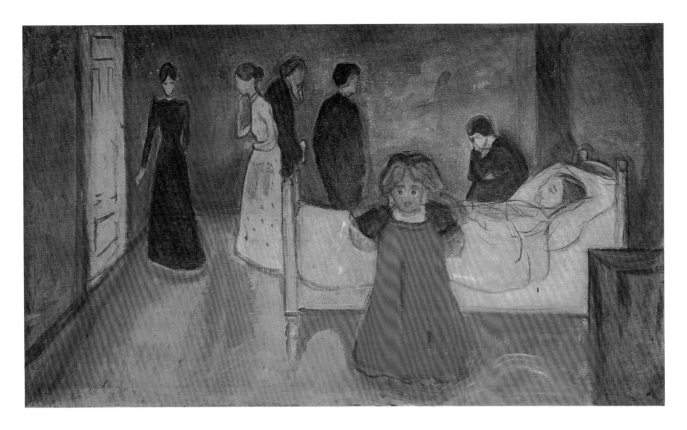

65 The Dead Mother and Child

1897-9

Oil on canvas
105 x 178.5 cm (41¼ x 70¼ in.)
Oslo, Munch Museum.

The original sketch for *Dead Mother and Child* was probably a small pen drawing dating from about 1889. The mother's head is shown in profile in the foreground, while in the background are the contours of a distressed child, whose wild eyes and wide-open mouth are clearly defined. In the late 1890s Munch completed the first painted version of the motif, using a thin casein technique that gives the picture a transparent, dreamlike appearance. The horizontal canvas creates the impression of a wide, deserted stage.

The child dressed in red in the foreground is at the centre of the composition. The vivid colour of the dress and the frontal position immediately draw attention to this figure. The terracotta-red floor against the greenish background, and the general colour harmonies of the picture, are typical of other death motifs, for example *Death in the Sickroom* (cat. 67). The 'action'

takes place in a confined, bare room where the only piece of furniture, apart from the bed, is the bedside table in the foreground, which contributes to the suggestion of depth.

On the bed behind the child lies the dead mother; her colourless profile outlined against the whiteness of the bedclothes. The figures in the background are recognisably members of the Munch family depicted in adulthood: his youngest sister Inger, Aunt Karen, his father, Munch himself and, sitting farthest to the right, his brother Andreas. They have been drawn in their characteristic postures, recalling pictures such as *Death in the Sickroom*. Inger faces us, Aunt Karen and Munch's father stand together but back to back, while Edvard, too, has partially turned away. Andreas is shown in almost the same pose as the figure in the foreground of *Melancholy* (cat. 42), and, as elsewhere, he is isolated from the

other members of the family. All the figures have an appearance of weightlessness, as if they are floating around the room, like participants in a dream play.

In contrast to the people in the background, the child has authority and presence, and she functions as a spokesman for the other members of the family. By placing the child with the 'adults', two different periods of time are simultaneously represented. Thus the painting conveys both the tragedy of the death and its effect on the remaining members of the family. Seen in this light the child's pose, with her hands over her ears, as in *The Scream* (cat. 52), can be interpreted as a manifestation of Munch's anguished attitude to life. This interpretation becomes particularly clear if one refers to earlier sketches of the motif, where the child's mouth is shaped like a petrified scream.
ML

66 The Dead Mother

1893

Oil on canvas
73 x 94.5 cm (28¾ x 37¼ in.)
Oslo, Munch Museum.

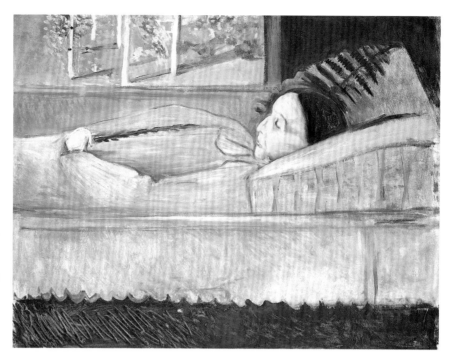

When Munch's young, consumptive
mother died between Christmas and
New Year in 1868, Munch was five
years old. *The Dead Mother and Child*
(cat. 65) is clearly autobiographical, but
The Dead Mother (cat. 66) seems less
dependent on personal references. Two
versions of the motif were shown in
Munch's exhibition in Berlin in Decem-
ber 1893.

While it is generally accepted that
Max Klinger's etching *The Dead Mother*
of 1889 (fig. 31) is the forerunner of
Munch's image, the differences are
nevertheless striking. Klinger's motif is
aesthetic and rich in intricate detail,
recalling a romantic gravestone.
Munch's stark composition is stripped
of detail, distorted and simplified with a
two-dimensional effect. Klinger's dead
mother is young and beautiful with a
crown of flowers around her head and
flowing hair. Munch presents a green-
ish, pale corpse of an unidentifiable age
whose skin is realistically taut over her
crooked, pointed nose. Death's destruc-
tive forces have already left their mark.
The interior, the death clothes and
coffin are confined to cool shades of
blue. Munch wanted to depict the cold-
ness of death itself. The picture lacks
Klinger's superficial realism. As Stanis-
law Przybyszewski observed, Munch is
'the spiritual phenomena's naturalist par
excellence'.[1] Outside, the trees cast long
shadows, creating an impression of a
sunny spring morning. Munch contrasts
life's perpetual revitalisation with death.
In 1894, Willy Pastor described his use
of colour:

The three layers of colour – the pale green
in the background, the deep blue in the fore-
ground and between them the poisonous
green-blue of decay – harmonize well with
each other... it is striking how any monotony
in the central area's screaming hues is
avoided... by adding a stronger shade with a
colourful fern leaf on the coffin.[2]

FH

1. Przybyszewski, Meier-Graefe, Pastor, Ser-
vaes 1894.
2. op. cit.

Fig. 31
MAX KLINGER
The Dead Mother 1889
Etching, 45.5 x 34.7 cm (17½ x 13¾ in.)
Hamburg, Kunsthalle.

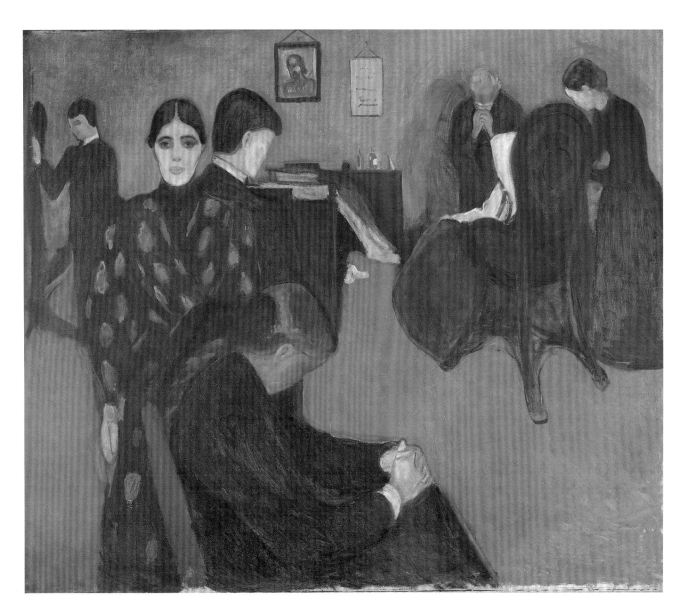

67 Death in the Sickroom

1893

Oil on canvas
134.5 x 160 cm (53 x 63 in.)
Oslo, Munch Museum.

Death in the Sickroom recalls the death of Sophie, Munch's beloved sister. Our attention is focused on the individual members of the family, who give an impression of isolation, creating a complex portrait of loneliness and helplessness in the face of death. The foreground of the sparsely furnished room is dominated by a compact group consisting of the artist and his two sisters, Inger and Laura. Laura is sitting in profile, her head bent and her hands clasped. Standing behind her is Inger, facing the viewer. Inger's pose represents a recurring feature in Munch's work, where the motif in the background may be interpreted as the preoccupation of the person in the fore-

ground. Her expressive face with its staring eyes and pale, hollow cheeks can be compared to Ensor's masked figures. Behind Inger, Munch stands facing the empty space of the room, looking towards the wicker chair where Sophie is sitting hidden by its high back, which forms a 'hypnotic eye' in the picture; all we see is a limp arm resting on the blanket. Our attention instead is drawn to the 'accessories of death' – the medicine bottle, the bedpan and the bed itself. The aunt (who had adopted the mother's role in Munch's family) is bending over the chair, and the father, echoing Inger's pose, lifts his clasped hands to his face. The empty floor space between the two focal planes and

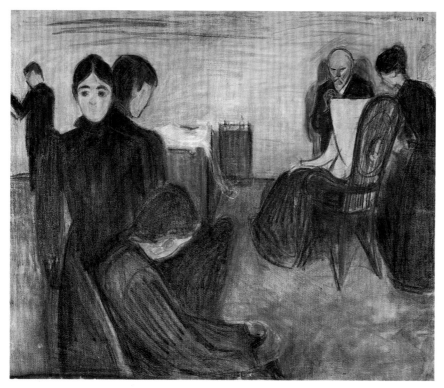

68 Death in the Sickroom 1893
Crayon and pencil on canvas, 91 x 109 cm (35¾ x 43 in.). Oslo, Munch Museum.

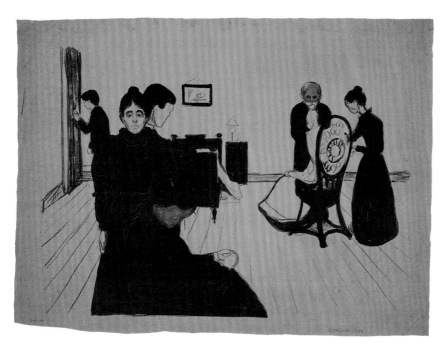

69 Death in the Sickroom 1896
Lithograph, 40 x 54 cm (15¾ x 21¼ in.). Oslo, Munch Museum.

the mask-like faces of the characters add to the impression of a death-like silence.

The composition of *Death in the Sickroom* is characterised by bold contours defining and delimiting the different areas of the picture. Lines and curves are repeated from one figure to the next, creating a formal and emotional continuity; this work most simply and immediately evokes Munch's relationship with the Symbolist and Synthetist movements.

The event takes place in a sparsely furnished room. The high viewpoint gives an impression of a stage scene in a play. This representation of the nature of death, as personified by the surviving family members, is often compared to Maeterlinck's drama *l'Intruse* (*The Intruder*). In this play, the dying person is in the room next door, whereas in Munch's picture she is hidden by the back of a chair. Death is present in everyone's mind; the episode is an entirely psychological experience.

The rigidity of the scene hints that Munch wished to freeze a particular instant in time. He did in fact exhibit this motif under the title 'The Moment of Death', and according to Munch's notes describing Sophie's death it would seem that this picture represents precisely that moment.

Was she then really to die – for this last half hour she had been feeling almost better than before – the pain had gone. She tried to sit up – pointed to the armchair beside her – I should like to sit up, she whispered – how strange she felt – the room seemed different – as if seen through a veil – her arms and legs leaden – how tired.

Death in the Sickroom, with its figures looking rigidly ahead, in profile and diagonally, can be seen as embodying Munch's formula of human relations. His characters are depicted at the age they were when he conceived the idea of the motif, rather than their age when Sophie died. Munch may have intended to add a contemporary dimension – in that Sophie's death had made an indelible mark on the family, leaving them forever present in her sickroom.

Munch painted two versions of *Death in the Sickroom*, which are housed respectively at the Munch Museum (cat. 67) and the National Gallery in Oslo (fig. 32). Both of these monumental representations are characterised by a

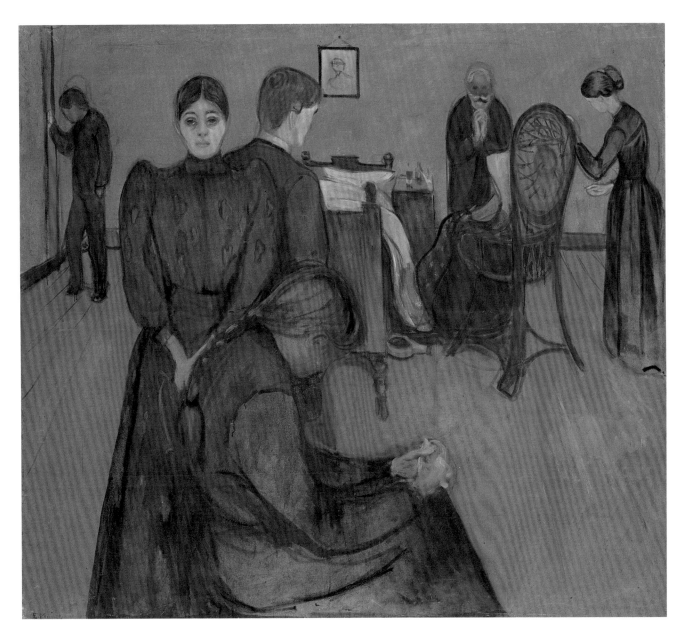

Fig. 32 Death in the Sickroom
1893
Oil on canvas
150 x 167.5 cm (59 x 66 in.)
Oslo, The National Gallery.

consistent colour symbolism, featuring a combination of maroon, deep green and bluish black. The dry, transparent casein technique used in the National Gallery's version emphasises the emblematic significance of the motif – the absence of shadows and the exaggerated broad floorboards create a sense of perspective but also underline the emptiness of the room and the silence of death. The Munch Museum's version, with its saturated colours and shadows that seem to attach the characters to the room, is an expression of the ineffable finality of death – death as a force, as a void strongly felt by the surviving family members.

AE/SB

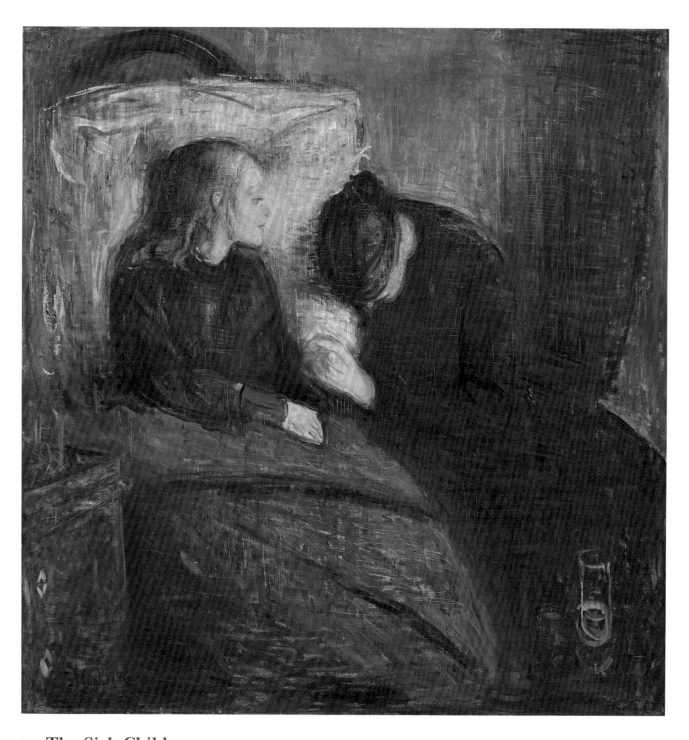

70 The Sick Child

1896

Oil on canvas
121.5 x 118.5 cm (47¾ x 46½ in.)
Gothenburg, Museum of Art.

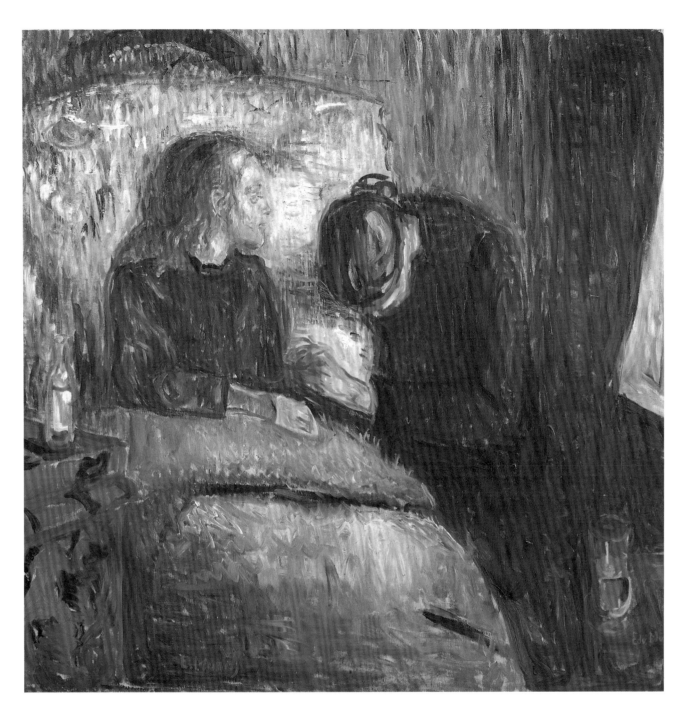

71 The Sick Child 1907
Oil on canvas
119 x 122 cm (46¾ x 48 in.)
London, The Tate Gallery.

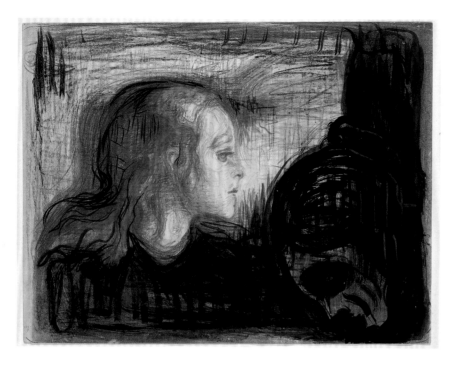

72 The Sick Child 1896
Lithograph, 42 x 56.5 cm (16½ x 22¼ in.). Oslo, Munch Museum.

73 The Sick Child 1896
Lithograph, 42 x 56.5 cm (16½ x 22¼ in.). Oslo, Munch Museum.

When the annual Autumn Exhibition of Norwegian artists opened its doors to the public in Christiania on 18 October 1886, it was Edvard Munch's 'Study', now known as *The Sick Child* (National Gallery, Oslo), that caused the most interest. The public reacted with indignation and ridicule. A journalist yelled, 'What a daub... It's a scandal that such rubbish should be allowed to hang here. This is bloater paste in a lobster sauce!' Among the artists, reactions were mixed. Munch's teacher, Christian Krohg, had forced the picture past the jury, and Munch subsequently expressed his gratitude by giving it to him. Munch reported:

No painting has ever caused such disapproval in Norway – On the opening day, when I came into the room where it was hanging, people were crowding in front of the picture – there was laughter and shouting – When I went into the street again, the young naturalist painters were standing there with their leader Wentzel – They were the most celebrated artists of the day ... Humbug painter he shouted into my face.

Emile Zola had defined naturalism in art as 'a corner of nature seen through a temperament'. Munch's art in the 1880s may be said to be even more radical, in that he was one of the first to emphasise the artists's emotional experience through his motif. Representations of sickbed and deathbed scenes were very common in the naturalist epoch. But with *The Sick Child* Munch takes the subjective and existentialist aspect to an extreme; above all, he wanted to express the painful, traumatic feelings surrounding his memory of his sister Sophie's illness and death when she was fifteen and he thirteen. But according to his own recollections, his childhood memories of his dying mother and his own fear of death as a sickly child were also implicit in the subject:

I daresay not one of these painters had lived and relived his motif right up to the last cry of agony as I had done in *The Sick Child*. For it was not just myself who was sitting there – it was all my loved ones ... In that same chair in which I painted the sick child, I and all my dearest ones from my mother on have been sitting there longing for the sun.

In *The Sick Child*, Munch breaks the boundaries of what it was possible to

express within a naturalistic idiom.

I painted the picture time and time again during the year – scratched it out – smudged the paint – trying again and again to obtain that first impression – that opaque quality – the pale face against the canvas – the quivering lips – the trembling hands ... I also discovered that my own eyelashes had contributed to the impression. I have therefore hinted at their presence as shadows above the picture.

Munch came to regard this experiment as the key to his major works.

Ten years later, in Paris, Munch was commissioned by his Norwegian patron Olaf Schou to paint a replica of *The Sick Child* (cat. 70). The result was a colouristically free version of the original. Whereas the first version is characterised by thick layers of paint, the 1896 version is painted in a light fluid manner, the colours glowing and transparent. The refined colouring is mirrored in the long series of lithographs which he had printed in Paris at the same time (cats. 72-5). Different combinations of the various lithographic stones (now in the Munch Museum, Oslo) provide an almost unlimited number of different colouristic expressions. This manifest need for variation also speaks volumes for the fascination the motif held for Munch.

In 1907 Munch again received an order for a replica of *The Sick Child*, this time from Ernest Thiel, the well-known Swedish patron of the arts. As so often, Munch was working simultaneously on two versions of his motif. One of them is today at the Thielska Gallery, Stockholm, and the other at the Tate Gallery, London (cat. 71). Both versions are in line with his other experiments of that period. The hasty, dissolved brushstrokes and the strong colours, which we recognise from other works painted that summer in Warnemünde (see the Green Room, for example), are also a feature of these new free versions. It is as if Munch's reaction to the motif itself can be seen in the painting technique. Later versions were also to reflect his various styles during the different periods of his life. Munch himself called them 'experimental copies'.

AE/SB

74 The Sick Child 1896
Lithograph, 42 x 56.5 cm (16½ x 22¼ in.). Oslo, Munch Museum.

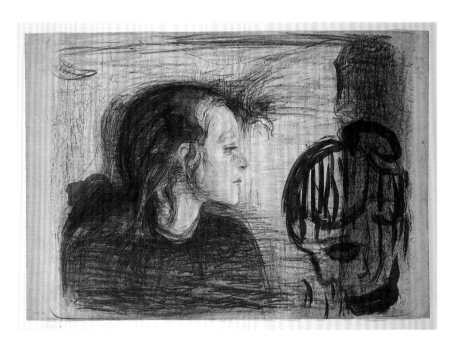

75 The Sick Child 1896
Lithograph, 42 x 56.5 cm (16½ x 22¼ in.). Oslo, Munch Museum.

76 Self Portrait with Skeleton Arm

1895

Lithograph
45.5 x 31.7 cm (18 x 12½ in.)
Oslo, Munch Museum.

The lithograph *Self Portrait with Skeleton Arm* is probably Munch's most frequently exhibited and best-known self portrait. It can be compared to the painting *Self Portrait with Cigarette* (cat. 1), which was also produced in 1895, but in the lithograph the hand of the artist has evolved into a skeletal arm against a space which has become an all-absorbing flat blackness.

The artist's illuminated head appears in the centre of the black area, as if drifting disembodied in darkness. The stiff white collar and earnest expression give Munch a priest-like appearance. The wholly frontal face establishes a link with the viewer that is at once negated by the direction of Munch's gaze. He is not concerned with any person opposite him but rather with his own thoughts.

The skeletal arm represents the transience of human life, while the head drifting above it becomes a metaphor for the eternal ideas that manifest themselves in works of art. They keep alive the memory of the artist beyond his own death: they are his epitaph.

Munch was only 31 when he produced this self portrait, but as his work makes evident death was ever present for him — not just the deaths of his relatives but his own too. Coincidentally, Munch's brother Andreas died in December 1895.

Munch had used the motif of the skeletal arm earlier in an unfinished portrait of his bohemian friend from Berlin, Stanislaw Przybyszewski (fig. 33), who published the first book on the work of Munch in 1894.

Munch employed the technical possibilities of lithography in this self portrait with considerable refinement. Lithographic crayon was used on the stone for the face, the armbone and his name, and lithographic ink for the black middle area, thus achieving a flatness that turned the background into a symbol of nullity and emptiness.

I M-W

Fig. 33 Stanislaw Przybyszewski with Skeleton Arm *c*.1894
Tempera on canvas
75 x 60 cm (29½ x 23½ in.)
Oslo, Munch Museum.

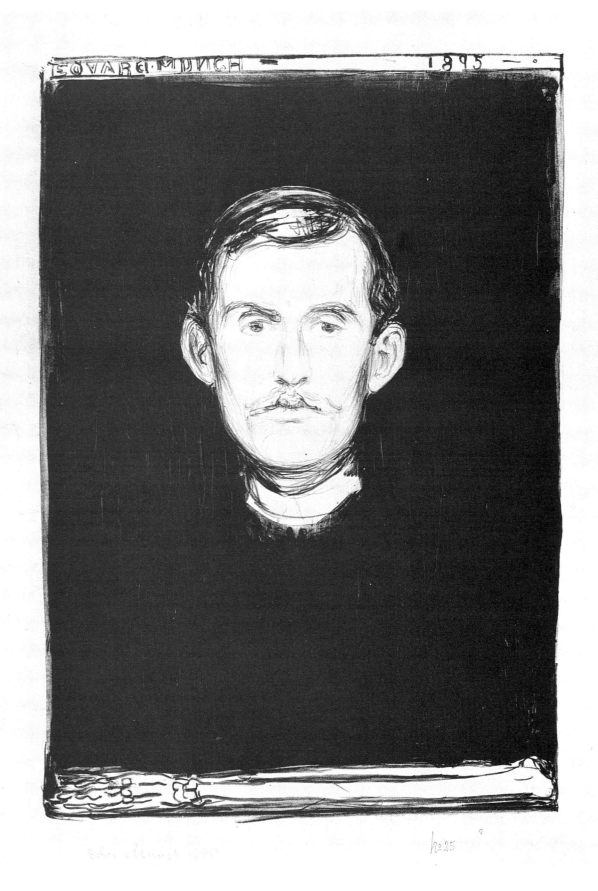

76

The Green Room

Far away his eye fell upon a couple
A red-headed woman and a man
walking along pressed close together
A shock passed through him
the blood – rushed in his ears
and the dreadful suspicion was there again

The Green Room

In the summer of 1907 Edvard Munch arrived at Warnemünde, a fishing village and resort on the Baltic coast. He went there to escape from the many temptations of city life in Berlin and to seek a cure for his nervous disorders. Since 1902, he had spent most of his time on the Continent. There had been many unsettling years of travel, exhibitions and various commissions – 'the wild years', as Munch later described them. He was plagued with bad nerves which he only seemed able to control with the help of alcohol. The crisis culminated in a breakdown in 1908, when he was admitted to Dr Jacobson's Copenhagen clinic for nervous diseases. However, he did not go to Warnemünde merely to live a healthy life and calm his nerves, he was also looking for artistic inspiration, and for new directions for his art.

Quite early on, he erected his canvas on the beach to paint the monumental *Bathing Men* (Ateneum Taidemuseum, Helsinki), using himself and the lifeguards as models. The painting is constructed by means of a system of strong diagonal brushstrokes, a technique that brings a powerful new vitality to his art. He also painted realistic motifs with spontaneous impastoed strokes similar to the early works of Matisse, often using thick layers of oil paint squeezed directly from the tube. In contrast to the decorative refinement of Matisse, however, Munch continued to consolidate his expressionistic ideas.

At the same time he also produced another series of paintings, which he called the Green Room. In this new and bitter interpretation of the Love motifs in the Frieze of Life, the elegiac shoreline of Åsgårdstrand has been replaced by the garishly coloured interior of a brothel. The remarkable resemblance of this interior to a stage set may partly be due to Munch's work at the time designing sets for Ibsen's play *Hedda Gabler* for Max Reinhardt's theatre in Berlin.

Thematically, the series reflects Munch's feelings of bitterness and aggression towards Tulla Larsen, a rich, beautiful and spoiled woman with whom he had a difficult relationship from 1899 until 1902, when there was an irrevocable break-up between them. She

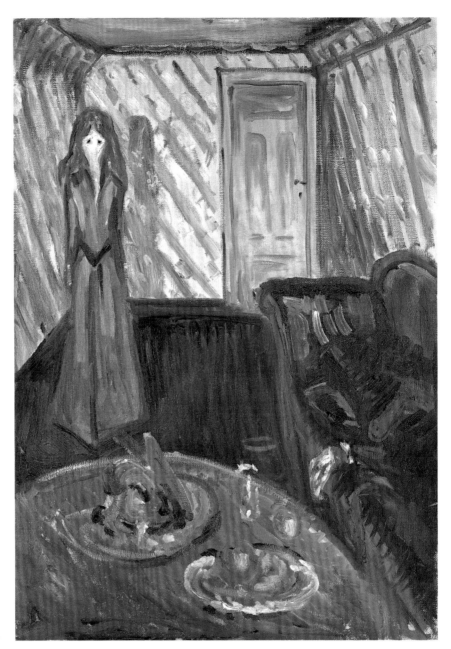

77 The Murderess 1907
Oil on canvas, 88 x 62 cm (34¾ x 24½ in.). Oslo, Munch Museum.

belonged to the moneyed aristocracy of Christiania, whereas he was a poor artist of the town's bohemian circle, descended from an impecunious family rich in clergymen, poets and academics. She had a strong desire to marry; he had reservations.

In a draft letter to Tulla, Munch wrote: '...you must understand – that I am in a unique position here on earth –

the position imposed by a life filled with illness – unhappy relationships – and my position as an artist – a life in which there is no room for anything resembling happiness and which does not even desire happiness.' And in another draft letter he observed: 'Your gospel is that of joie de vivre – mine is that of pain.'

In the autumn of 1902 at his cottage

Fig. 34 **Salome** 1905
Etching, 13.2 x 9.3 cm (5 x 3½ in.)
Oslo, Munch Museum.

Fig. 35 **Ghosts** 1905
Etching, 6.5 x 9.5 cm (2½ x 3¾ in.). Oslo, Munch Museum.

in the small town of Åsgårdstrand on the Oslo Fjord, Munch accidentally shot and wounded his hand during a moment of great tension following an argument with Tulla Larsen. He ended up in hospital and was bitterly disappointed when Tulla did not visit him. Later he was overwhelmed with jealousy when he discovered that she had gone to Paris with the painter Arne Kavli, who was eight years her junior, and whom she married the following year. According to persistent gossip, Munch was supposed to have been living off Tulla's money. His bitterness towards her assumed an almost pathological character which, combined with a feeling of being persecuted by his fellow Norwegians for the sake of his art, finally culminated in his breakdown of 1908.

During the years 1902 to 1908, Munch expressed his hatred and bitterness in a number of caricatures, prints and paintings. One of these is an etching of Tulla as Salome with the artist's bloodstained head between her hands (fig. 34); another shows her seated on a throne with Munch's head being served to her on a plate accompanied by a bottle of wine (fig. 35). In the background two of Munch's bohemian friends, the writers Gunnar Heiberg and Sigurd Bødtker, are represented by a toad and a dog respectively. Munch regarded these friends as Tulla's collaborators in what he saw as a plot against him. He even wrote a play, *The City of Free Love* in Tulla's 'honour': in this city one can marry for a few days without any kind of formality; no marriage is permitted to last for more than three years, and it is compulsory to play all night and sleep all day. The Artist comes to town and is looked after by the Rich Woman. There follows a number of scenes in which the Artist is humiliated and then eventually brought to trial in a court of law.

There are obvious visual reasons for considering the five paintings in the Green Room series – *The Murderess* (cat. 77), *Zum Süssen Mädel* (*At the Sign of the Sweet Girl*) (cat. 78), *Hatred* (cat. 79), *Desire* (cat. 80) and *Jealousy I* (cat. 81) – as one. In all of them the scene is set in the same tiny, suffocating room so reminiscent of the small room in

78 Zum Süssen Mädel (At the Sign of the Sweet Girl) 1907
Oil on canvas, 85 x 131 cm (33½ x 51½ in.). Oslo, Munch Museum.

Munch's cottage at Åsgårdstrand where the shot was fired. All the walls have the same characteristic green-checked wallpaper. The room has no windows, only a simple, narrow door in the background. All the pictures feature the same round table and the Biedermeier sofa. The scene is shown in close-up as if photographed with a wide-angle lens. The oppressive, enclosed stage-like room is thus dramatically widened, which adds to the impression of unease.

The colour of love – red – is complemented and contrasted by the green of jealousy, to express a mockery of love. The strong contrast between red and green, and the broken line-drawing technique, which is found in all five pictures, are used to suggest a nervous unease rather than to define the subjects. In both *Zum Süssen Mädel* and *Desire*, Munch uses the round table as a space-creating device as well as an aggressive element. In *Desire*, the table serves to squeeze the couple together on the sofa, apparently locking them into a psychologically inescapable situation. The man's desire seems unrequited as the woman's staring eyes look towards the lonely bottle, its shape echoing her stiff figure. Similarly, the eyes of the characters in *Zum Süssen Mädel* are not looking at each other but seem to be concentrating on the centrally placed bottle. Man and woman are lonelier than ever in Munch's art but their loneliness is now more desperate, more aggressive and more directly formulated than ever before.

The motif of *Hatred* may be said to reflect that of the print *Man's Head in Woman's Hair*, 1896 (cat. 37). However, whereas the latter has a feeling of melancholy and destiny about it, so typical of Munch's work during the 1890s, *Hatred* imparts a raw brutality that renders the very essence of hatred. This is the key work in the series. Hatred and disgust combine to form the basic theme that runs through the entire series of 'love motifs' from Warnemünde. In *Hatred* it is also obvious that Munch has copied Tulla's physical features. The tall figure, the shape of the face, and the pointed nose are all clearly recognisable (fig. 36).

In *The Murderess* Munch uses the surface of the table to separate the two figures, as well as to squeeze the stiff female figure with the staring eyes further back into the room. We realise that the motif refers to the notorious shooting incident in 1902. The extravagant hat lying on the table in the foreground of *The Murderess* is an indirect reference to Tulla, who was known for her numerous hats, and the fruit bowl alludes to the fruit she was in the act of serving him as the shot was fired.

79 Hatred 1907
Oil on canvas
47 x 60 cm (18½ x 23½ in.)
Oslo, Munch Museum.

Munch's *alter ego* is lying stretched out on the sofa with his bleeding hand hanging down. Our attention is focused on the hand because the head is outside the canvas. The woman appears to be staring as if hypnotised at the blood streaming from the wound.

The shooting incident made a deep impression on Munch; he was later to refer to it frequently in his artistic work and in his written notes. He often seems to have been writing under a heavy mental strain or under the influence of alcohol; the handwriting in his notebooks and sketchbooks is almost illegible in parts and is difficult to date. However, there is much evidence to suggest that Munch was planning to write an autobiographical novel about his relationship to Tulla, rather like August Strindberg's *In Defence of a Fool*, in which Strindberg gives an intimate portrait of his first wife, Siri von Essen. In these 'fragments from a novel', probably written in or around 1906, Munch describes his own experience of the episode:

The door opens and M. is standing in the doorway – he looks distraught – she stands there stiffly – staring at him – A spasm passed through M's body – she is staring straight ahead ice cold and rigid – He staggers into the room – throws himself on a chair by the table – rests his head on his hand – Would you like something to eat? –
I've prepared – some food
He does not answer
She puts out the food
He pushes it away
His back shakes in a violent spasm.

After a long silence, still staring at his back, she says – Listen – if I can, I will go to a far away place – where you will never see me – far away over the sea – His entire body is shaking in a violent convulsion, he stares wildly at her, bends down, stretches out his arms – She is still standing rigidly in the doorway to the kitchen
She comes towards him
His head sinks forward
What will you do with the revolver? she says
He does not answer – holds the revolver tight in his hand
Is it loaded?
A loud shot, filling the room with smoke
M. stands up – blood is dripping from his hand – he looks – uncomprehendingly around him and lies down on the bed

Of all the paintings in the Green Room series *Jealousy I* (cat. 81) refers most directly to one of the Love motifs

Fig. 36 Edvard Munch and Tulla Larsen *c*.1899
Photograph
Oslo, Munch Museum.

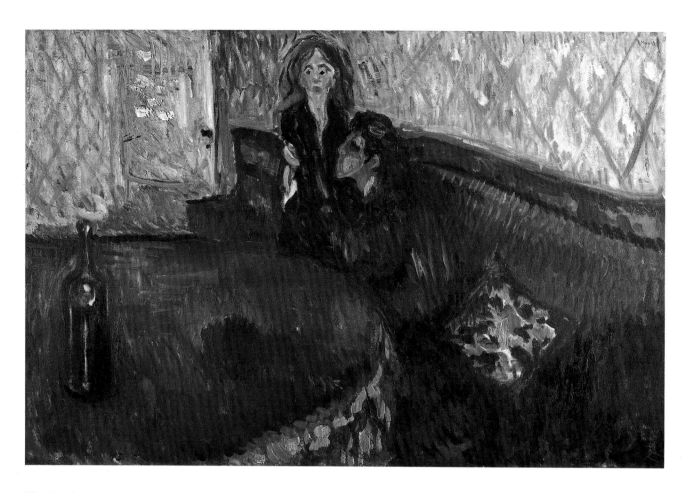

80 Desire 1907

Oil on canvas, 85 x 130 cm (33½ x 51¼ in.). Oslo, Munch Museum.

of the Frieze of Life. As in the original *Jealousy* (cat. 32) the man's pale, frightened face is in the foreground, and the couple – whom we must assume to be the object of his jealousy – are in the background. But again, the originally ill-fated, universally human expression in this painting is replaced by raw aggression and brutality. The way Munch uses a work of art here to express such a naked feeling of hatred and disgust without any moral considerations is an entirely new idea in pictorial art; it is a form of 'bad taste' more readily appreciated in painting today. Although Munch draws on his own experience – as he so often does – he manages to elevate the most complex of themes beyond the individual to the general to become universally understood.

As in the case of the Frieze of Life, it is difficult to draw a completely clear distinction between the pictures that actually belong to the Green Room. *Jealousy II* (cat. 82) does not share the characteristics of the rest of the series. Nevertheless, Munch himself appears to have included it. In *Jealousy I* the composition, showing an older man, a posing woman, and younger man, appears to derive from a large drawing in the Munch Museum's collection that probably dates back to 1905 (fig. 37). Here the three people are placed in a room that is reminiscent of the enclosed, windowless room of the Green Room, though it is not charged with the same pent-up intensity. In the drawing, the woman, who bears a strong resemblance to Tulla Larsen, stands next to an unmade bed, whereas the younger and the older man merge into one shape in the foreground. *Jealousy II* is also an example of how Munch uses strong colours for the faces in what we might call his 'symbol-and-sign-language'.

However, it is not a question of providing a simple guide to interpretation. A green face may characterise a passive attitude, in contrast to a red one, which shows an active, somewhat choleric, temperament. In his Love motifs, Munch often represents the woman as powerful and full-blooded, and the man as pale and introverted.

AE/SB

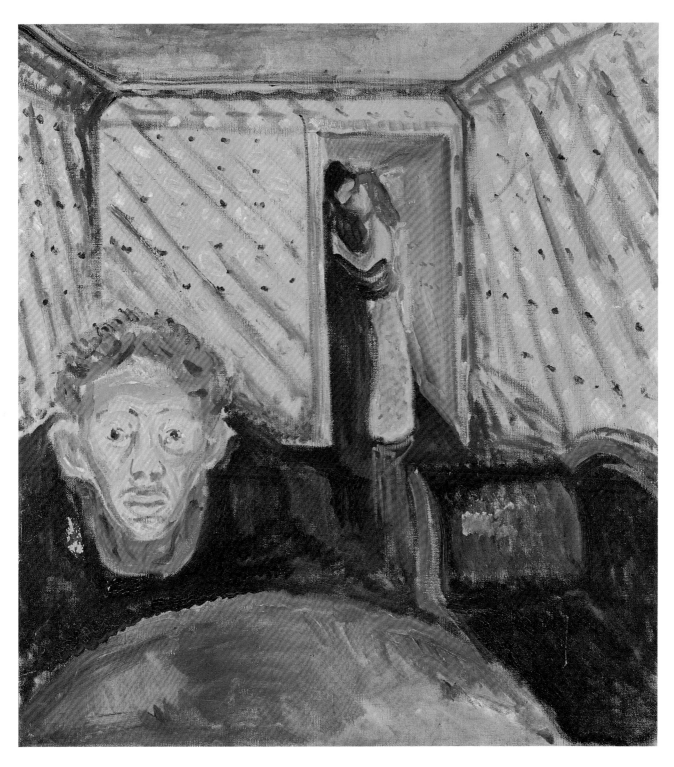

81 Jealousy I 1907
Oil on canvas
89 x 82 cm (35 x 32¼ in.)
Oslo, Munch Museum.

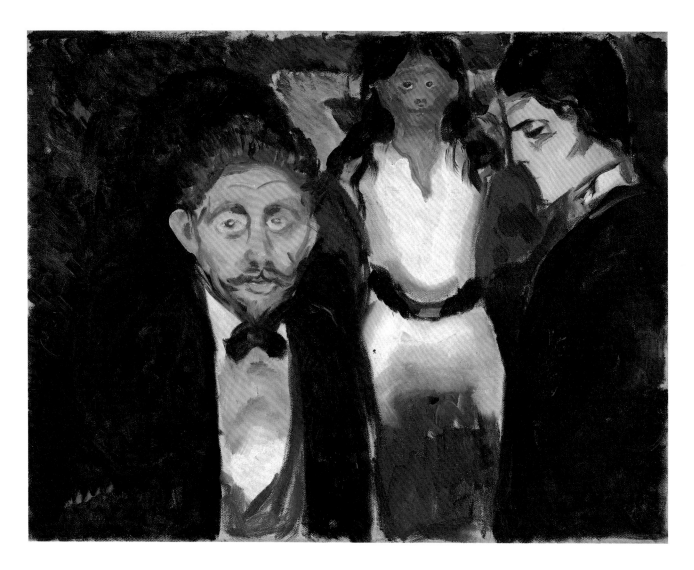

82
Jealousy II 1907
Oil on canvas
76 x 98 cm (30 x 38½ in.)
Oslo, Munch Museum.

Fig. 37
In the Bedroom
(Two Men and a Woman) c.1905
Crayon and watercolour
108 x 151 cm (42½ x 59½ in.)
Oslo, Munch Museum.

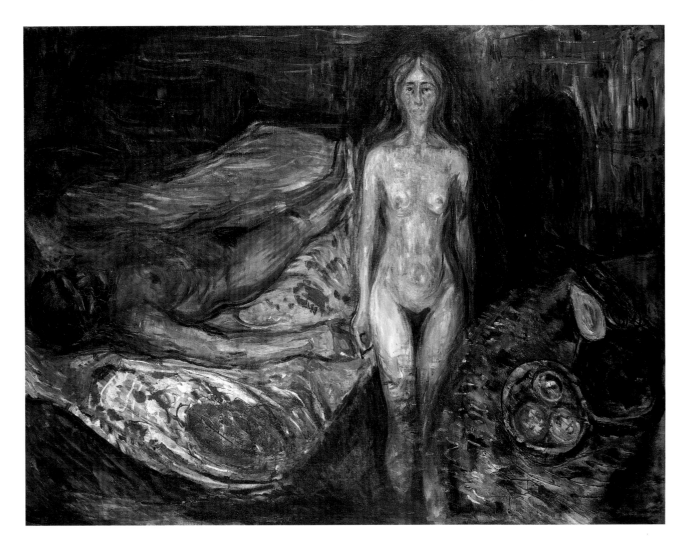

83 The Death of Marat I

1907
Oil on canvas
150 x 200 cm (59 x 78¾ in.)
Oslo, Munch Museum.

When Charlotte Corday assassinated the French revolutionary leader Jean Paul Marat in the summer of 1793 the incident provided the inspiration for numerous works of art, the most notable, of course, being Jacques-Louis David's *Death of Marat*.

By calling his painting *The Death of Marat I*, Munch pointedly acknowledged this precedent. In a more general sense he was also reviving an old theme in his art – woman's destructive power over man. On a personal level, however, the motif, according to Munch himself, refers directly to the notorious incident which took place in his cottage at Åsgårdstrand in 1902, when he accidentally shot and wounded his hand after an argument with his fiancée, Tulla Larsen. The event left a deep scar on his personality. According to hospital records, Munch had requested a local

rather than a full anaesthetic so that he could closely follow the operation on his hand, despite being in great pain. He depicted this episode in his painting *The Operation* (fig. 38), in which he is shown lying on the operating table. His many variations on the theme of *The Death of Marat I* and *The Murderess* (cat. 77), are all based on this painting.

The Death of Marat I shows Munch's *alter ego* stretched out on the bed, which projects at an angle into the pictorial space. The radical foreshortening of the man creates an aggressive diagonal. The woman/Tulla stands frontally in the foreground, as rigid as a pillar of salt. Judging from Munch's own notes about the Åsgårdstrand incident, it is evident that certain details from the sequence of events were preserved intact in the painting: the table in the foreground with one of

Tulla's extravagant hats on it, for instance, and the bowl of fruit she was offering Munch as the shot was fired.

In 1906, Munch had painted two other versions of the subject. One of them, which he called *Still Life (The Murderess)* (fig. 39), shows the man lying on the bed on the left-hand side, and the woman, bearing an unmistakable resemblance to Tulla, standing on the right. It was probably this version he had in mind when he declared, 'I have painted a still life as good as any Cézanne, except that in the background I have painted a murderess and her victim.'

The Death of Marat I was painted in the spring of 1907 in Berlin. During this period Munch developed a powerful impasto technique similar to Fauvism. Six months later, however, he produced a new monumental version, *The Death of Marat II* (fig. 40). In it we perceive an entirely new orientation of his art, which he himself considered his last attempt at finding a way to express himself.

AE/SB

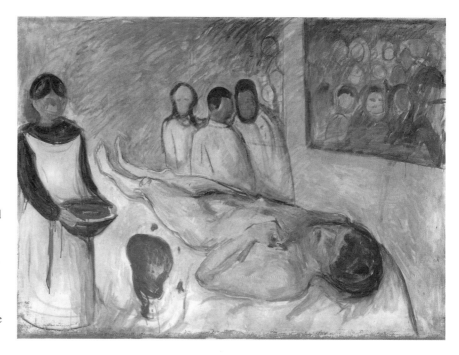

Fig. 38 The Operation 1902
Oil on canvas, 109 x 149 cm (43 x 58¾ in.). Oslo, Munch Museum.

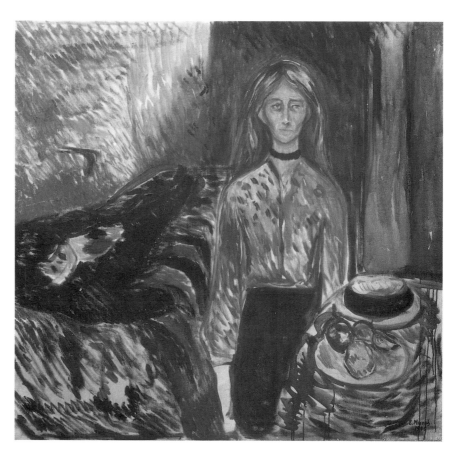

Fig. 39 Still Life (The Murderess) 1906
Oil on canvas, 110 x 120 cm (43¼ x 47¼ in.). Oslo, Munch Museum.

84 Self Portrait with Bottle of Wine

1906

Oil on canvas
110.5 x 120.5 cm (43½ x 47½ in.)
Oslo, Munch Museum.

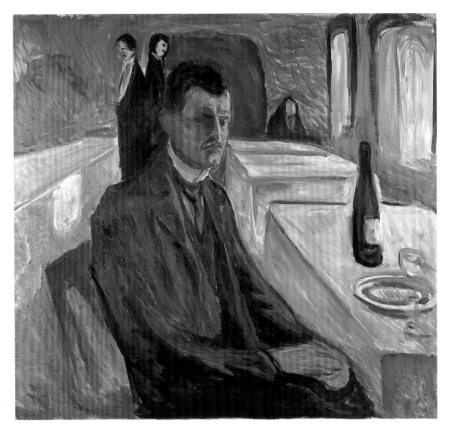

The years between the shooting incident of 1902, which marked the end of his relationship with Tulla Larsen, and Munch's breakdown in 1908 represent a period of prolific creativity – with increasing recognition in Germany and many portrait commissions. But these years are also marred by the deepening crisis wrought by the injury to his hand, culminating in his nervous breakdown in 1908. His sense of loneliness and inner tension were expressed in *Self Portrait with Bottle of Wine*, painted in Weimar in 1906. Munch is portrayed close to the picture plane, squeezed in between two rows of tables in an acutely receding pictorial space. On the table in front of him are a wine bottle, a glass and an empty plate. The only other customer in the café is sitting in the farthest corner of the room.

There is a perceptible imbalance between the body of the artist and his head. While his posture appears feeble – with helpless-looking hands – his head, set against a blood-red background, seems to be inwardly seething. His anguished state of mind is also expressed through the contrasts of reds and greens that dominate the painting. The orange-coloured area that rises like tongues of fire behind Munch's back – interrupted only by the row of tables on the left – mirrors his inner tension that cannot – at least not yet – be released.

The waiters are shown back to back and seem to grow out of Munch's body, suggesting a metaphor for the contending spiritual powers of the artist. In a draft letter to Dr Max Linde, Munch wrote in 1905: 'This remarkable condition became uncontrollable after an unnerving shock three years ago. It is the division of the two parts of the soul – the negative (the reflective) and the positive (the instinctive or animal). Like chemicals reacting these conditions are good when combined but when separated become dangerous. I only realise this now, three years later.'

In March 1909 Munch wrote to his friend Jappe Nilssen that he considered this self portrait, which so pitilessly revealed his extremely dangerous condition and the depth of his despair, to be one of his most successful 'self examinations in difficult years'.

I M-W

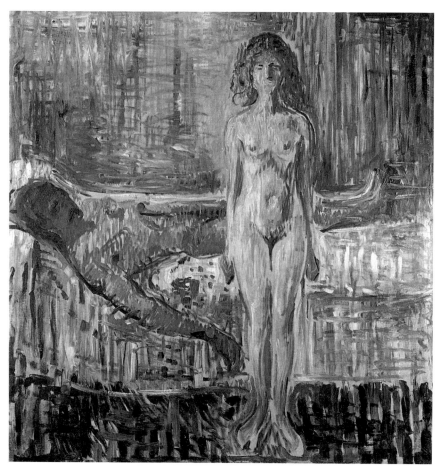

Fig. 40
The Death of Marat II 1907

Oil on canvas
152 x 149 cm (59¾ x 58¾ in.)
Oslo, Munch Museum.

85 Self Portrait in Copenhagen

1909

Oil on canvas
100 x 110 cm (39¼ x 43¼ in.)
Bergen, Rasmus Meyer Collection.

Self Portrait in Copenhagen was painted in 1909 after Munch's breakdown, while he was convalescing at Dr Jacobson's clinic, which specialised in treatments for nervous disorders.

In this work, as in *Self Portrait with Bottle of Wine* of 1906 (cat. 84), Munch sits on a chair turned towards the viewer. However, in the later painting he sits upright and looks towards the onlooker. The face is painted in detail with a fine brush, while the body and the room are composed of broad horizontal and vertical strokes. This self portrait has always been regarded as evidence of the recovered artist, who has acquired new strength and faces the future with optimism. Indeed, Munch does seem 'stronger' than in *Self Portrait with Bottle of Wine*, but the paint ing technique makes his condition appear unstable. He did paint some pictures around 1907 that have similar broad horizontal and vertical strokes, including *The Death of Marat II* (fig. 40) and *Amor and Psyche*, in order, as he put it, 'to break up planes and lines'.[1] But in his use of this technique he is noticeably inconsistent, particularly in the area of the face and the view from the window. Pictorially, the painting can be interpreted as a metaphor for the convalescing artist who, brushstroke by brushstroke, is painstakingly reconstructing his body and his environment after regaining his sanity. The view beyond the window is bright but only vaguely recognisable, as though he is not yet fully reconciled with the outside world. On 12 November 1908, Munch wrote from Copenhagen to his friend Jappe Nilssen: 'My powers steadily return to me. I have driven out twice with the nurse – it is a strange feeling to return to the noisy world – I have almost come to terms with my monastery-like existence. Even that has its charm – to have some distance from the world...'

The months in the clinic were productive: Munch created drawings for

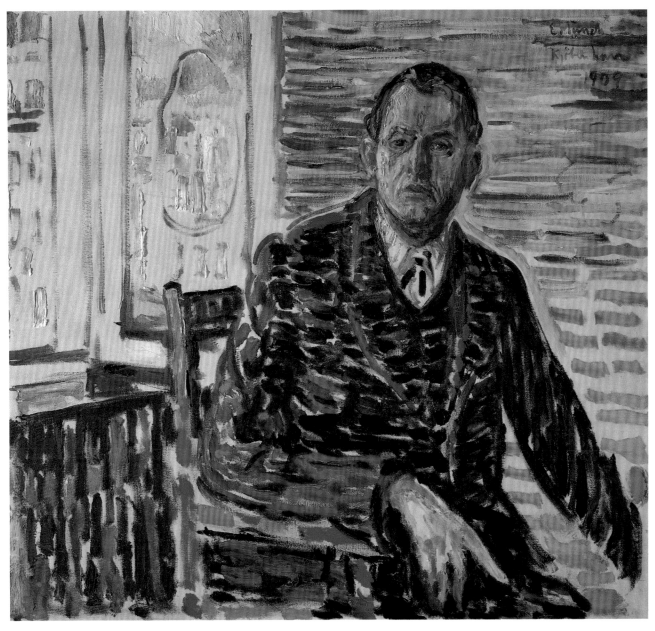

85

his portfolio of lithographs titled *Alpha and Omega*, produced a portrait of Dr Jacobson, organised exhibitions in Copenhagen and Christiania, and received the Order of St Olaf.

He left the clinic in May and returned to live in Norway, where he rented a house in Kragerø and thenceforward led a secluded life, preoccupied with his health.

Self Portrait with Bottle of Wine and *Self Portrait in Copenhagen* mark the period from Munch's crisis to his convalescence. This is also the period of the Green Room series, in which the artist's accumulated psychological tensions found a partial release.

I M-W

1. Eggum 1984.

Chronology

1861 Marriage of Laura Catherine Bjølstad and Dr Christian Munch.

1862 Their first child Johanne Sophie is born.

1863 December 12 Birth of Edvard Munch at Engelhaug Estate, in Løten, Hedmark. Karen Bjølstad, his mother's sister, joins the family.

1864 The family move to 9 Nedre Slottsgate, Christiania (now Oslo), where Dr Munch is appointed army surgeon at the Arkershus Castle.

1865 Peter Andreas is born.

1867 Laura Catherine is born.

1868 December 29 Munch's mother dies of tuberculosis at the age of 30, shortly after giving birth to a third daughter, Inger Maria. Karen Bjølstad assumes responsibility for the children's upbringing.

1875 The family move to Grünerløkka, a working-class district on the outskirts of Christiania, where Dr Munch establishes a private practice to supplement his captain's salary.

1877 Sophie dies of tuberculosis at the age of 15. The family move to 7 Fossveien, near the Aker river.

1879-80 Edvard passes the Technical College entrance examination to become an engineer. Frequent bouts of illness interrupt his studies. He decides to leave college to become a painter.

1881 Enrols at the Royal School of Art and Design. Paints his first self portrait and sells two paintings. Receives tuition from the sculptor Julius Middelthun.

1882 Shares a studio with other students in Stortings Plass, where Christian Krohg supervises their work. Exhibits at the Industries and Art Exhibition.

1883 Attends Fritz Thaulow's improvised open-air studio at Modum. Participates in the Autumn Exhibition. Gunnar Heiberg favourably reviews his work. The family move to Olaf Ryes Plass.

1884 Meets the anarchist and author Hans Jaeger and other members of the Christiania-Bohème, a group of avant-garde writers and artists who meet at the Grand Café on Karl Johan Street. Participates in the Autumn Exhibition. Through Fritz Thaulow he receives a travel grant to study abroad. Meets Millie Ihlen Thaulow, 'Mrs Heiberg', the wife of Captain Carl Thaulow, Munch's cousin.

1885 Exhibits a portrait of Inger at the World Exhibition in Antwerp. Visits the official Salon and the Louvre during a three-week visit to Paris. Summer in Norway at Borre. Works on *The Sick Child*, *The Morning After* and *Puberty*. Hans Jaeger's book *From the Kristiania-Bohème* is confiscated and Jaeger is sentenced to 60 days imprisonment.

1886 Exhibits four paintings in the Autumn Exhibition. *The Sick Child*, under the title 'Study', is reviled by the press.

1887 Exhibits six paintings at the Autumn Exhibition.

1888 Exhibits three paintings in Copenhagen. Meets the Danish painter Johan Rohde.

1889 April/May. Organises a retrospective exhibition of 110 works at the Student Organisation in Christiania. Receives a two-year state fellowship. Summer at Åsgårdstrand with Inger Munch, Christian and Oda Krohg, Gunnar Heiberg, Sigurd Bødtker and Hans Heyerdahl. Exhibits one painting at the Autumn Exhibition.

October In Paris attends Léon Bonnat's drawing classes. Meets the Danish poet Emanuel Goldstein. Exhibits at the World Exhibition and has an opportunity to see the Volpini Exhibition of Impressionists and Synthetists; he probably also sees work by Van Gogh, including his *Starry Night*, Signac, Seurat and Gauguin. Moves to St-Cloud to avoid an outbreak

Fig. 41

Åsgårdstrand July 1889
Munch is at his easel, Laura stands in the doorway and Inger is by the gate, holding a kitten.

Photograph. Oslo, Munch Museum.

Fig. 42 Edvard Munch painting on the beach at Warnemünde 1907
Photograph. Oslo, Munch Museum.

of cholera in the city. His father dies suddenly. Continues working on his illustrated diaries to which he adds his St-Cloud Manifesto.

1890 Returns to Norway. Summer at Åsgårdstrand. Exhibits ten paintings at the Autumn Exhibition, five of which are destroyed in a fire.
November En route to the continent he develops rheumatic fever and is hospitalised; spends two months at Le Havre.

1891 January Travels to Paris and Nice.
April Rents a studio in Paris at Rue Lafayette 49. Maeterlinck's drama *L'Intruse* is presented at the nearby Théâtre de Vaudeville, where Gauguin's paintings are on exhibition. Summer at Åsgårdstrand, where he witnesses Jappe Nilssen's unhappy affair with Oda Krohg. Munch's health deteriorates through ex-

cessive drinking. Receives another state fellowship to study in Paris or Florence. The National Gallery of Oslo buys a painting. Travels with Christian Skredsvig to Nice via Copenhagen where he visits Goldstein and Johan Rohde; to Hamburg where they see Böcklin's paintings at the Kunsthalle; to Frankfurt, Basle and Geneva. Goldstein commissions a vignette for his collection of poems, *Alruner*.

1892 Returns to Christiania. Produces (unpublished) illustrations for Wilhelm Krag's book. Summer at Åsgårdstrand.
October Exhibits 50 paintings at the Tostrup Building. Receives an invitation to exhibit in the Verein Berliner Künstler.
November 5 His retrospective opens at the Berlin Artists' Association. Within days of its opening the Association's members vote to close the show. The 'Munch Affair' makes him a celebrity overnight.

Signs a contract with Eduard Schulte to show the exhibition in Düsseldorf and Cologne. Meets and paints a portrait of August Strindberg.
December Rents the Equitable Palace and reopens the exhibition in Berlin. Receives 1800 marks from admission fees.

1893 Tours the exhibition to Copenhagen, Breslau, Dresden and Munich. Rents a studio and concentrates on the Frieze of Life motifs. In Berlin joins the international circle of writers, artists and critics, including Ola Hansson, Richard Dehmel, Stanislaw Przybyszewski, Holger Drachmann, Jens Thiis and Gunnar Heiberg, who meet at the Black Piglet Café (Zum Schwarzen Ferkel).
March 9 Munch introduces Dagny Juel to the circle.
June Munch and Strindberg exhibit at the Freie Vereinigung Künstler Berliner.
September Przybyszewski and Dagny marry.
December 5 Munch's exhibition in Berlin, at Unter den Linden 19, includes six paintings from the Love series. Strindberg's unsuccessful one-act play, *Playing with Fire*, opens on the same night at the Lessing Theatre. Produces his first prints. Returns to Nordstrand in Norway. *Das Werk des Edvard Munch* is published.

1894 Strindberg leaves Berlin for Paris. Munch returns to Norway with Dagny and Przybyszewski. Laura Munch is institutionalised, diagnosed as suffering from schizophrenia.
March Rents rooms at Albrechtstrasse in Berlin.
May Receives commissions for illustrations for the periodical *Pan*. Exhibits at the Art Association in Stockholm. The catalogue includes an article by Przybyszewski which is published by *Freie Bühne* and reprinted in *Das Werk des Edvard Munch*. With the exception of a favourable review in *Le Figaro* the exhibition is a critical failure.

1895 March The same exhibition opens at the Ugo Barroccio Gallery in Unter den Linden.
June Meier-Graefe and Bodenhausen release a portfolio of eight engravings by Munch.
October The press urge a boycott of his exhibition of paintings and prints at Blomquist's gallery in Christiania. The National Gallery (of Oslo) buys *Self Portrait with*

Fig. 43 'Professor Jacobson electrifies the famous painter Munch' 1908/9
Indian ink, 13.7 x 21.2 cm (5½ x 8½ in.)
Oslo, Munch Museum.

Cigarette. Meets Henrik Ibsen. His brother Andreas Munch dies.

1896 February In Paris exhibits ten paintings at the Salon des Indépendants and at Bing's Salon de l'Art Nouveau. Strindberg's review is published in *La Revue Blanche*. Meets Frederick Delius. Produces colour lithographs at Auguste Clot's as well as woodcuts. A full-page reproduction of *Madonna* appears in the periodical *L'Aube*. A commission to illustrate Baudelaire's *Les Fleurs du Mal* is abandoned when the publisher dies. Contributes to Vollard's first album of *Les Peintres-Graveurs*. Designs the programme for *Peer Gynt* at the Théâtre de l'Oeuvre. His mental and physical health deteriorates. Goes to Knokke-sur-mer.
Autumn Completes his first mural, a panel for Axel Heiberg's house in Sandvika.

1897 Exhibits one print in the French section of the international exhibition at Blomquist's; seven prints at La Libre Esthétique in Brussels; and ten paintings at the Salon des Indépendants in Paris. Designs posters for Ibsen's *Peer Gynt* and *John Gabriel Borkman* for the Théâtre de l'Oeuvre. Purchases a house at Åsgårdstrand. Exhibits 180 works at the Diorama Hall in Christiania and rents a studio in Universitetsgaten. Meets Tulla Larsen through Gunnar Heiberg.

1898 Travels to Copenhagen, Berlin and Paris. Exhibits at the Salon des Indépendants. Illustrates Strindberg's texts in the periodical *Quickborn*.

1899 Travels to Berlin and Paris. Tulla follows. Travels with Tulla to Florence, where he falls ill. Tulla returns to Paris. Munch continues to Rome. En route to Norway visits Meier-Graefe in Paris. Exhibits at the Venice Biennale and in Dresden. Summer at Åsgårdstrand with Tulla. Suffers from recurring bouts of influenza and bronchitis and exhaustion. Commits himself to the Kornhaug Sanatorium in Gudbrandsdalen, Norway.

1900 Leaves Kornhaug. Meets Tulla in Berlin. Together they travel south.
July In Como. Munch ends their relationship. Enters a sanatorium in Switzerland.
December Exhibits at the Diorama Hall and shows the same work at the Vienna Secession. Receives excellent reviews of his exhibition at Arno Wolfframm's Gallery.

1901 Summer at Åsgårdstrand. The painting *The Lonely Ones* is destroyed en route to Munich. Dagny Juel is murdered in Tiflis by a Polish student and disciple of Przybyszewski.

1902 May Exhibits the Frieze of Life at the Berlin Secession. Meets Albert Kollmann and Dr Max Linde of Lübeck. Summer at Åsgårdstrand. Tulla attempts a reconciliation. During an argument Munch suffers a gunshot wound and loses two finger joints in his left hand. Tulla leaves for Paris with Gunnar Heiberg, Sigurd Bødtker, and Arne Kavli whom she later marries.
September Exhibits at Blomquist's.
December Meets Kollmann in Germany and goes on to Leipzig with the Frieze of Life exhibition. Gustav Schiefler starts cataloguing his graphic works.

1903 Exhibits at Paul Cassirer's Gallery in Berlin where Dr Linde's book *Edvard Munch and the Art of the Future* is launched.
March Exhibits eight paintings at the Salon des Indépendants. Sells a painting to the Russian collector Morozov. Meets Eva Mudocci, an English violinist and friend and model of Matisse. Summer at Åsgårdstrand. Arranges exhibitions in Christiania, Hamburg, Berlin and Vienna. Receives a state grant and income from his German dealers.
November Exhibits at Paul Cassirer's. Visits Delius at Grèz-sur-Loing. Becomes a member of the Société des Artistes Indépendants.

1904 January Through Schiefler sells 800 prints. Signs a contract with Bruno Cassirer to sell his prints. Exhibits five paintings at the Salon des Indépendants. Becomes a member of the Berlin Secession. Exhibits twenty paintings at the Vienna Secession. Summer at Åsgårdstrand. Drinking heavily. Receives many portrait commissions from German bankers, industrialists and aristocrats. Exhibits mostly portraits at a one-man show in Copenhagen. Writes *The City of Free Love*.

1905 Exhibits portraits at Cassirer's in Berlin and 75 paintings at the Manes Art Association in Prague. Signs a contract with Commeter in Hamburg to sell his paintings.
June 7 The union between Norway and Sweden is dissolved. Civil War imminent. Summer at Åsgårdstrand. Continues to drink heavily. Paints the Esche children and then in Weimar works on a portrait of Nietzsche.

1906 Receives more portrait commissions.
September Works on designs based on the Frieze of Life for the interior of Max Reinhardt's new Kammerspiel Theatre in Berlin. Designs sets for Reinhardt's productions of Ibsen's *Ghosts* and *Hedda Gabler*. Attempts health cures at various spas near Weimar at Bad Elgersburg and Bad Kösen. Travels to Berlin, Weimar and Jena.

1907 January Returns to Berlin, where he receives more portrait commissions and continues work at Reinhardt's Theatre. Exhibits at Cassirer's. Summer at Warnemünde. Paints large-scale paintings and the Green Room series. Health improves. Terminates contracts with Cassirer and Commeter.
October Exhibits at Cassirer's with Cézanne and Matisse.
December Completes the Reinhardt Frieze.

1908 March Exhibits at the Salon des Indépendants in Paris. Meets Nolde at Reinhardt's Theatre. Thiis becomes Director of the National Gallery (of Oslo) and purchases more work.
March At Warnemünde. Under considerable mental and physical stress. Exhibits with the Brücke in Dresden.
September From Warnemünde goes to Hornbaek in Denmark. Excessive drinking in Copenhagen.
September 29 Goes to Taarboek to Goldstein. Suffers a complete nervous breakdown.
October Enters Dr Jacobson's clinic where he remains for the next eight months. Continues to paint and arrange exhibitions.
November 22 Exhibits over two hundred works at the Art Association as well as other exhibitions in Denmark, Sweden and Germany. Develops the Alpha and Omega series. Made a Knight of the Royal Norwegian Order of St Olaf.

1909 Sells paintings from the Frieze of Life to Olaf Schou (who gives them to the National Gallery) and Rasmus Meyer. Thiis and Nilssen hang his exhibition at Blomquist's. Before leaving Dr Jacobson's clinic paints a self portrait.
April Returns to Norway accompanied by his cousin, the painter Ludvig Ravensberg. Rents a house at Skrubben near Kragerø and builds an open-air studio. Works on sketches for the Oslo University

mural competition. Isolates himself from the art world.

1910 Participates in the Berlin Secession.

1911 August Wins the Oslo University Aula competition.

1912 January 30 Exhibits 32 paintings at the Sonderbund exhibition in Cologne which includes works by Van Gogh, Gauguin and Cézanne. Meets Curt Glaser.

1913 August 5 Resigns from the Berlin Secession. Exhibits new versions of the Frieze of Life paintings at the Autumn Exhibition in Berlin with Picasso. Travels widely in Europe and visits London. Exhibits eight graphic works at the Armory Show in New York.

1914 Outbreak of war.
February Exhibits at the Gurlitt Art Gallery, Berlin.
May 29 Receives the commission to design murals for the University Festival Hall. Winter in Berlin and Paris. *Kunst og Kultur* records his 50th birthday.

1915 Exhibits graphic works at the Panama-Pacific International exhibition in San Francisco. Adapts the Aula images for the Nordic Art Exhibition in Copenhagen.

1916 Buys a house at Ekely and takes up residence there.
September 19 The Aula murals are unveiled.

1917 Curt Glaser's book *Edvard Munch* is published in Berlin.

1918 Writes about the Frieze of Life in a leaflet that accompanies his exhibition at Blomquist's. The newspaper *Tidens Tegn* publishes two separate articles by Munch.

1920-2 Travels to Berlin, Paris, Wiesbaden and Frankfurt. Is commissioned to decorate the workers' canteen at the Freia Chocolate Factory in Oslo. Exhibits at the Kunsthaus in Zurich. Supports German artists by buying their work.

1923 Becomes a member of the German Academy of Fine Art.

1925 Kristiania, formerly Christiania, is renamed Oslo.

1926 In Rome paints the grave of his uncle P.A. Munch. Represented at the Carnegie International Exhibition in Pittsburgh. His sister Laura dies.

1927 Exhibits over 223 works at his retrospective exhibitions at the National Galleries in Berlin and Oslo.

1928 Plans to build the Oslo City Hall are renewed with a room reserved for a mural by Munch. Builds a winter studio. Exhibits in Munich, San Francisco, London and Stockholm. Suffers from cysts in his right eye.

1929 Major graphics exhibition at the National Museum in Stockholm.

1931-2 His aunt Karen Bjølstad dies. Exhibits in Zurich.

1933 Celebrates his 70th birthday. A broken blood-vessel in his right eye causes almost total blindness. Receives the grand Order of the Cross of the Order of St Olaf.

1934 Presents his portrait of Strindberg to the National Museum in Stockholm.

1937 Gives financial support to the German artist Wilhelm Nay to travel to Norway. Eighty-two 'degenerate' paintings in German museums are confiscated and sold in Norway.

1940-1 Germany invades Norway. Munch refuses contact with the Nazis and cultivates fruit and vegetables at Ekely and Hvitsten.

1944 January 23 Dies peacefully at home in Ekely. Bequeaths his estate to the city of Oslo.

Fig. 44 Edvard Munch just before his 75th birthday 1938
Photograph. Oslo, Munch Museum.

Bibliography

Amann, P., *Edvard Munch*, W. Germany 1987.

Alpha and Omega, Munch Museum exhibition catalogue, Oslo 1981. Newcastle Polytechnic Gallery 1989.

Askeland, J., 'The Fear Motif in Edvard Munch's Art', *Kunsten idag*, 20:4, 1966.

Bang, E. H., comp. and ed., *Edvard Munch og Jappe Nilssen: Efterlatte brev og Kritikker*, Oslo 1946, rev. edn., *Edvard Munchs kriseår. Belyst i brever*, Oslo 1963.

Benesch, O., *Edvard Munch*, Cologne and London 1960.

Berman, P. G., *Edvard Munch: Mirror Reflections*, Norton Gallery and School of Art, West Palm Beach 1986.

Bischoff, U., *Edvard Munch 1863-1944*, W. Germany 1988.

Bøe, A., *Edvard Munch*, Barcelona 1989.

Boe, R. A., '"Jealousy", an Important Painting by Edvard Munch', *The Minneapolis Institute of Arts Bulletin*, Jan.-Feb. 1956.

Boe, R. A., *Edvard Munch: His Life and Work from 1880 to 1920*, 2 vols., dissertation, New York University 1971.

Boime, A., 'Van Gogh's "Starry Night": A History of Matter and a Matter of History', *Arts Magazine*, 59, no. 4, Dec. 1984.

Bowness, A., *French Symbolist Painters*, exhibition catalogue, Hayward Gallery, London 1972.

Causey, A., 'Edvard Munch: An Artist in Torment', *Illustrated London News*, 225, 1969.

Crockett, C., 'Psychoanalysis in Art Criticism: Description of the Cry', *Journal of Aesthetics*, 17, Sept. 1958.

Dedichen, J., *Tulla Larsen og Edvard Munch*, Oslo 1981.

Dittmann, R., *Eros and Psyche: Strindberg and Munch in the 1890s*, Ann Arbor 1982.

Dorra, H., 'Munch, Gauguin and Norwegian Painters in Paris', *Gazette des Beaux-Arts*, 6th ser., 88, no. 1294, Nov. 1976.

Dreams of a Summer Night: Scandinavian Painting at the Turn of the Century, exhibition catalogue, Hayward Gallery, London 1986.

Edvard Munch: A Collection of Paintings, Etchings and Lithographs, exhibition catalogue, Arts Council of Great Britain, London 1951.

Edvard Munch 1863-1944: An Exhibition of Paintings, Etchings, Lithographs and Woodcuts, exhibition catalogue, Hayward Gallery, London 1974.

Edvard Munch 1863-1944, exhibition catalogue, Liljevalchs Konsthall and Kulturhuset, Stockholm 1977.

Edvard Munch: Symbols and Images, exhibition catalogue, National Gallery of Art, Washington D.C. 1978.

Edvard Munch: Liebe. Angst. Tod, exhibition catalogue, Kunsthalle Bielefeld 1980.

Edvard Munch: Paintings from the Munch Museum, exhibition catalogue, Newcastle Polytechnic Gallery 1980.

Eggum, A., *James Ensor and Edvard Munch: Mask and Reality. James Ensor, Edvard Munch, Emile Nolde*, exhibition catalogue, Norman McKenzie Art Gallery, Regina, Canada, 1980.

Eggum, A., *Der Linde-Fries: Edvard Munch und sein erster deutscher Mäzen, Dr Max Linde*, Lübeck 1982.

Eggum, A., *Edvard Munch: Paintings, Sketches and Studies*, New York and London 1984.

Eggum, A., *Munch og fotografi*, Oslo 1987. English edn., *Munch and Photography*, London 1989.

Eggum, A., *Munch as Photographer*, exhibition catalogue, Newcastle Polytechnic Gallery 1989.

Eggum, A., *Edvard Munch: Livsfrisen fra maleri til grafikk*, Oslo 1990.

Elderfeld, J., and Eggum, A., *The Masterworks of Edvard Munch*, Museum of Modern Art, New York 1979.

Engstrom, C., 'The Life Frieze', *Kunsten idag*, 89, Aug. 1969.

Epstein, S. G., *The Prints of Edvard Munch: Mirror of his Life*, Oberlin College, Allen Memorial Art Museum 1983.

Esswein, H., 'Edvard Munch', *Moderne Illustratoren*, 7, Munich and Leipzig 1905.

Gauguin, P., *Edvard Munch*, Oslo 1933, rev. edn. 1946.

Glaser, C., *Edvard Munch*, Berlin 1917, 2nd edn. 1920.

Gloersen, I. A., *Lykkehuset: Edvard Munch og Åsgårdstrand*, Oslo 1970.

Haftmann, W., *Painting in the Twentieth Century*, London 1961 and Munich 1965.

Hals, H., 'Edvard Munch og Åsgårdstrand', *Vestfold Minne*, Vol. 5, Tonsberg 1946.

Hansson, O., *Sensitiva Amorosa*, Halsingborg 1887.

Heller, R., *Edvard Munch's Frieze of Life: Its Beginnings and Origins,* unpublished dissertation, Indiana University 1968.

Heller, R., 'Affaeren Munch, Berlin 1892-1893', *Kunst og Kultur,* 52, 1969.

Heller, R., 'The Iconography of Edvard Munch's Sphinx', *Artforum,* 9:2, Oct. 1970.

Heller, R., 'Edvard Munch and the Clarification of Life', *Allen Memorial Art Museum Bulletin,* 29, 1972.

Heller, R., 'Edvard Munch's Vision and the Symbolist Swan', *Art Quarterly,* 36:3, Autumn 1973.

Heller, R., *Munch: The Scream* (Art in Context), London 1973.

Heller, R., 'Edvard Munch's "Night", the Aesthetics of Decadence and the Content of Biography', *Arts Magazine,* 53:2, Oct. 1978.

Heller, R., *Munch: His Life and Work,* Chicago and London 1984.

Hodin, J. P., 'A Madonna Motif in the Work of Munch and Dali', *Art Quarterly,* 16, 1953.

Hodin, J. P., 'Edvard Munch and Depth Psychology', *The Norseman,* 14, 1956.

Hodin, J. P., *Edvard Munch,* London 1972.

Hofmann, W., 'Zu einem Bildmittel Edvard Munchs', *Alte und neue Kunst: Wiener Kunstwissenschaftliche Blätter,* 3:1, 1954.

Hofmann, W., *Turning Points in Twentieth Century Art: 1870-1917,* London 1969.

Hougen, P., 'Kunstneren som stedsfortreder', *Höjdpunkter i norsk kunst. Årsbok, Svenska statens Konstsamlingar,* 15, Stockholm 1968.

Hougen, P., *Farge pa trykk,* exhibition catalogue, Munch Museum, Oslo 1968.

Jaeger, H., *Fra Kristianiabohemen,* American reprint in Norwegian, Minneapolis 1893.

Kingsbury, M., *The Femme Fatale and her Sisters. Woman as Sex Object: Studies in Erotic Art 1730-1970,* New York 1972.

Kokoschka, O., 'Edvard Munch's Expressionism', *College Art Journal,* Vol. XIII, no. 4., New York 1953.

Krieger, P., *Edvard Munch. Der Lebensfries für Max Reinhardts Kammerspiele, Berlin,* exhibition catalogue, Nationalgalerie, Berlin 1978.

Langaard, I., *Edvard Munch, Modningsår,* Oslo 1960.

Langaard, J., and Revold, R., *Edvard Munch: Masterpieces from the Artist's Collection in the Munch Museum in Oslo,* New York 1964.

Langaard, J., and Revold, R., *Edvard Munch: A Year by Year Record of the Artist's Life,* Oslo 1961.

Lathe, C., *Edvard Munch and his Literary Associates,* exhibition catalogue, University of East Anglia, Norwich 1979.

Lathe, C., 'Edvard Munch's Dramatic Images 1892-1909', *Journal of the Warburg and Courtauld Institutes,* 46, 1983.

Lathe, C., 'Edvard Munch and Modernism in the Berlin Art World 1892-1903', *Facets of European Modernism,* ed. J. Garton, University of East Anglia, Norwich 1985.

Leistikow, W. (pseud. of Walter Selber), 'Die Affare Munch', *Freie Bühne,* Berlin, 31 Aug. 1982.

Lippincott, L., *Edvard Munch: Starry Night,* J. P. Getty Museum, Malibu 1988.

Lucie-Smith, E., *Symbolist Art,* London 1972.

Meier-Graefe, J., *Introduction to a portfolio of prints by Munch,* Berlin 1895.

Messer, T., *Edvard Munch,* New York 1973.

Moen, A., *Edvard Munch: Woman and Eros,* Oslo 1958.

Munch, E., *Alfa og Omega,* Copenhagen 1908.

Munch, E., *Livsfrisen,* Kristiania *c.*1918.

Munch, E., *Livsfrisen tilblivelse,* Oslo *c.*1929.

Munch, E., Archive material: EM/C4, EM/B8 25.5.99, 1899/1900 EM/C39, 1900 EM/C50, EM/C11, T2847d.

Munch, I., ed., 'Edvard Munchs brev: Familien', *Munch museets skrifter,* I, Oslo 1949.

Natanson, T., 'Correspondance de Kristiania', *La Revue Blanche,* Paris, 15 Nov. 1895.

Nergaard, T., 'Edvard Munchs Visjon: Et bidrag til Lifsfrisens historie', *Kunst og Kultur,* 50, 1967.

Neve, C., 'Echoes of Munch's Scream', *Country Life,* 155, Feb. 1974.

Obstfelder, S., 'Edvard Munch: Et forsøg', *Samtiden,* 7:1-2, 1896.

Plather, L. E., 'Det syke barn og Vär: En røntgenundersøkelse av to Munch-bilder', *Kunst og Kultur,* 57, 1974.

Prelinger, E., *Edvard Munch: Master Printmaker,* New York and London 1983.

Przybyszewski, S., *Totenmesse,* Berlin 1893.

Przybyszewski, S., 'Psychischer Naturalismus', *Freie Bühne,* 5, 1894.

Przybyszewski, S., Meier-Graefe, J., Pastor, W., and Servaes, F., *Das Werk des Edvard Munch: Vier Beiträge,* Berlin 1894.

Przybyszewski, S., *Erinnerungen au das literarische Berlin,* Munich 1965.

Quickborn, No. 4, Berlin 1897.

Rapetti, R., *Munch et la France,* 1991, exhibition catalogue, Musée d'Orsay, Paris 1991. Norwegian and German edns. 1992.

Rosenblum, R., *Modern Painting and the Northern Romantic Tradition: Friedrich to Rothko,* New York 1975 and London 1983.

Schiefler, G., *Verzeichnis des graphischen Werks Edvard Munchs bis 1906,* Berlin 1907; repr. Oslo 1974.

Schiefler, G., *Edvard Munchs graphische Kunst,* Dresden 1923.

Schiefler, G., *Edvard Munch, das graphische Werk 1906-1926,* Berlin 1928; repr. Oslo 1974.

Skedsmo, T., 'Tautrekking om Det syke barn', *Kunst og Kultur,* 68, No. 3, 1985.

Skredsvig, C., *Dager og naetter blandt Kunstnere,* Kristiania 1908.

Smith, J. B., *Edvard Munch 1863-1944,* Berlin 1962.

Smith, J. B., 'Strindberg's Visual Imagination', *Apollo,* 92, Oct. 1970.

Smith, J.B., *Frederick Delius and Edvard Munch. Their Friendship and their Correspondence,* London 1983.

Stang, R., *Edvard Munch: The Man and his Art,* New York 1977.

Stenersen, R., *Edvard Munch: Close-Up of a Genius,* Oslo 1969.

Sutton, D., 'Edvard Munch: Master of Anguish and Light', *Country Life,* 16, 1951.

Thiis, J., *Edvard Munch og hans samtid: Slekten, Livet og Kunsten,* Oslo 1933. Berlin 1934.

Thue, O., 'Edvard Munch og Kristian Krohg', *Kunst og Kultur,* 57, 1974.

Timm, W., *The Graphic Work of Edvard Munch,* Greenwich, Conn. 1969.

Varnedoe, J. K., 'Christian Krohg and Edvard Munch', *Arts Magazine,* 53:8, April 1979.

Whitford, F., 'Edvard Munch: Scene, Symbol and Allegory', *Studio,* 187, Feb. 1974.

Winkler, G., *Max Klinger,* Leipzig 1984.

Woll, G., *Edvard Munchs arbeiderfrise,* University of Oslo 1972.

Woll, G., *Munch and the Workers,* exhibition catalogue, Newcastle Polytechnic Gallery 1984.

Index of Works

Picture Credits